Thoughts about Paintings Conservation

Personal Viewpoints

Thoughts about Paintings Conservation

A Seminar Organized by the J. Paul Getty Museum,
the Getty Conservation Institute, and the Getty Research Institute
at the Getty Center, Los Angeles, June 21–22, 2001

EDITED BY Mark Leonard

THE GETTY CONSERVATION INSTITUTE
LOS ANGELES

© 2003 J. Paul Getty Trust

Getty Publications
1200 Getty Center Drive, Suite 500
Los Angeles, CA 90049-1682
www.getty.edu

Christopher Hudson, *Publisher*
Mark Greenberg, *Editor in Chief*

Tobi Levenberg Kaplan, *Manuscript Editor*
Jeffrey Cohen, *Designer*
Elizabeth Chapin Kahn, *Production Coordinator*

Typeset by G&S Typesetters, Inc., Austin, Texas
Printed in Hong Kong by Imago

Library of Congress
Cataloging-in-Publication Data

Personal viewpoints : thoughts about paintings
conservation : a seminar organized by The J. Paul
Getty Museum, the Getty Conservation Institute,
and the Getty Research Institute at the Getty Center,
Los Angeles, June 21–22, 2001 / volume editor,
Mark Leonard.
 p. cm.
 Includes index.
 ISBN 0-89236-698-2 (pbk.)
 1. Painting—Conservation and restoration—
Congresses. I. Leonard, Mark, 1954– .
II. J. Paul Getty Museum. III. Getty Conservation
Institute. IV. Getty Research Institute.
 ND1630. P47 2003
 751.6'2—dc21

 2002013972

Front cover:
Gerard ter Borch (Dutch, 1617–1681), *The Music
Lesson*, ca. 1668. Oil on canvas, 67.6 × 54.9 cm
(26 ⅝ × 21 ⅝ in.). Los Angeles, J. Paul Getty
Museum, 97.PA.4 (detail).

Back cover:
The Music Lesson during treatment in the paintings
conservation studio at the J. Paul Getty Museum.
Photo: Tom Bonner, © J. Paul Getty Trust

Contents

vii Foreword

viii Introduction

SESSION 1 1 The Conservator as Narrator:
Changed Perspectives in the Conservation of Paintings
DAVID BOMFORD

13 *Croce e Delizia*
ANDREA ROTHE

26 Comments JOHN WALSH
30 Comments ASHOK ROY

31 Panel Discussion

SESSION 2 41 The Artist's Voice
MARK LEONARD

59 Ravished Images Restored
JØRGEN WADUM

73 Comments PHILIP CONISBEE

79 Panel Discussion

SESSION 3 83 Embracing Humility in the Shadow of the Artist
CAROL MANCUSI-UNGARO

95 Episodes from a Pilgrimage
ZAHIRA VÉLIZ

104 Comments SCOTT SCHAEFER

110 Panel Discussion

116 Closing Remarks JOHN WALSH
120 About the Authors
123 Index
126 Photograph Credits

Foreword

Publications about the conservation and treatment of paintings are not rare. What makes this publication unique is that a group of distinguished conservators agreed to reconsider one or two treatments that they had done in the past and reflect in public on why they approached the work the way they did and what, if anything, they might do differently today. Furthermore, an equally distinguished group of curators responded to their thoughts. The presentations, as well as the dialogue that ensued, provide a remarkable and privileged glimpse into the minds of these professionals. We know this publication will be of interest to conservators, curators, and academic art historians. We also hope it will help young conservators and conservation students find their own approaches to their work.

The presentations and discussions reported here took place during a two-day seminar held at the Getty Center on June 21 and 22, 2001. The seminar was jointly organized by three programs of the J. Paul Getty Trust: the Museum, the Conservation Institute, and the Research Institute.

We would like to take this opportunity to thank all those who participated in the seminar for their candid presentations and their thoughtful discussions.

THOMAS CROW
Director, Getty Research Institute

DEBORAH GRIBBON
Director, J. Paul Getty Museum
Vice President, J. Paul Getty Trust

TIMOTHY P. WHALEN
Director, Getty Conservation Institute

Introduction

MARK LEONARD

The work of a paintings conservator involves intimate contact with works of art. The work is based upon a deep commitment to aesthetic values and understanding, and proceeds in partnership with the most advanced scientific tools and concepts. Few, if any, conservators believe that they are bringing the painting back to its original state, but many, if not all, strive to make it possible for viewers to encounter the work of art as closely as possible to the way in which the artist may have intended it to be seen. This volume of essays and commentaries explores some of the practices of paintings conservators in hope of articulating the values, concepts, and theoretical commitments that animate the best work in conservation today.

The contents of this volume were originally presented as part of a two-day seminar at the Getty Research Institute in June of 2001. Ten people had been invited to participate: six conservators, three curators, and a conservation scientist. The conservators were asked to prepare an article-length essay that told the story of conservation work they had done on a painting that was successful as well as conservation work they had done that either was unsuccessful or, with the benefit of hindsight, they might have approached differently. Although some technical descriptions might be necessary, it was understood that the essays should focus on the conservators' underlying motivations and thought processes during the course of their work. Any discussion of material or technical issues should ultimately lead to highly personal articulations of the conservator's basic philosophies and beliefs concerning his or her own encounters with works of art.

The seminar was divided into three sessions. At each session, two of the conservators made their presentations, and a curator then presented a commentary (prepared in advance, as the curators had been given the papers prior to the seminar). The trio then engaged in conversation, joined by the conservation scientist; eventually, the discussion was opened to include the small invited audience. Summary remarks by John Walsh, Director Emeritus of the J. Paul Getty Museum, brought the

seminar to a close. Our goal for this publication has been to maintain as much as possible the atmosphere and dynamic of the two-day seminar. To that end, the book follows the original framework, including edited transcripts of the lively discussions.

The concept for this seminar was somewhat experimental, and we realized from the beginning that it would require a certain leap of faith on the part of those who were asked to contribute. In developing our initial wish list of participants, we tried to assemble a diverse group of strong voices, yet a group that would share a common passion for works of art. Their contributions proved to be, as we had hoped, both thoughtful and provocative, and I am personally very grateful to everyone who participated for their generous efforts.

I would like to thank Michael Roth, the former Associate Director of the Getty Research Institute, who initiated our discussions about this seminar and oversaw its early organization. I am also grateful to my co-organizing colleagues, Marta de la Torre, of the Getty Conservation Institute, and Charles Salas, of the Getty Research Institute, for their efforts in bringing both the symposium and this publication to fruition. A debt of gratitude is owed also to Rosa Lowinger for her thoughtful and informed editing of the discussion transcripts.

This volume is not intended to provide an exhaustive investigation of all of the complex philosophical issues related to the field of paintings conservation. Instead, it is a modest but sincere effort by a dedicated group of professionals to explore some of their often-unarticulated thoughts concerning their work with each other and with works of art. These thoughts bring us closer to understanding the relationship between conservation, the conservator, and the original work of art. In that light, this volume does, I think, make a new contribution to the literature in our field and will, I hope, sow the seeds for similar publications. And for a broader audience, it may add a new layer of understanding to their grasp of why the works of art that they welcome into their lives look the way they do.

SESSION 1

1 The Conservator as Narrator:
 Changed Perspectives
 in the Conservation of Paintings
 DAVID BOMFORD

13 *Croce e Delizia*
 ANDREA ROTHE

26 Comments
 JOHN WALSH

30 Comments
 ASHOK ROY

31 Panel Discussion

The Conservator as Narrator:
Changed Perspectives
in the Conservation of Paintings

DAVID BOMFORD

This is a brief account of one paintings conservator's changing perspectives in a career spanning more than three decades at the National Gallery, London. It charts a trajectory that begins with restoration practices developed at the Gallery in the post-war era and brings us to the present day, in which this conservator's role has become something quite different. It is a role that is still rooted in practice and the physical exploration of works of art, but one that gives very different emphasis to the ways in which conservators interact with the paintings in their care.

When asked to discuss a painting that was treated unsuccessfully or, in retrospect, might have been done differently, a conservator is placed in a difficult position. What aspects of past treatments qualify for an acceptable revisionism? The aesthetic judgments informing a selective, partial, or total cleaning? The decisions involved in reconstructing (or not reconstructing) lost areas of paint? The selection or rejection of a particular picture varnish? Framing or display? All these are issues that conservators of paintings grapple with daily. It would be foolish to pretend that the solutions arrived at, in many cases, are anything other than subjective—and it is certainly reasonable to look back and speculate that a different, preferable outcome might have been achieved within the parameters of that subjectivity.

I want to concentrate on two issues that seem to me particularly significant: first, the idea of the historical object—our attitudes toward the physical integrity of a work of art; and, second, an awareness of the changing academic role of the conservator of paintings. I hope to show that these two notions are firmly linked and that a reconsideration of the first leads inevitably to the development of the second. The idea of the historical object—a concept of material authenticity—has progressed significantly in recent years through technical studies. Comparative studies of nineteenth- and twentieth-century paintings have been particularly revealing, because these works have a greater chance of having remained relatively untouched. It is the area

1

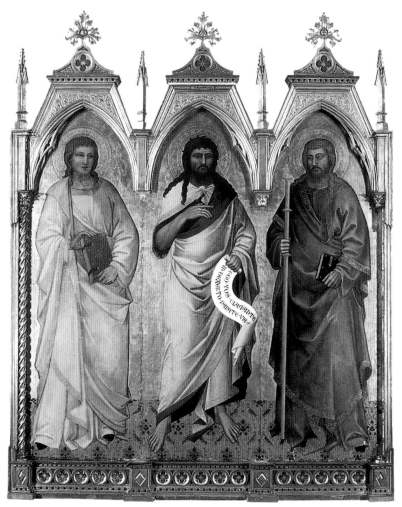

FIG. 1 Before treatment.

of nineteenth-century paintings that I will discuss here, but, as an introduction to my theme, let us first consider a much older work.

A particularly difficult area for museum conservators lies in how we deal with the very different ideas of presentation that our predecessors imposed on works stripped from their original contexts. A case of this kind that I have reflected on since its treatment was completed in 1983 is Nardo di Cione's *Altarpiece: Saint John the Baptist with Saint John the Evangelist and Saint James*. Originally this would have been elaborately framed with a predella [a base with small painted panels], columns, tracery, pinnacles, and crockets. However, almost all of this superstructure was lost— perhaps when it was removed from its setting in Florence, or perhaps later. In the Victorian era, a frame imitating some of the presumed elements of the original was constructed around the panel in a somewhat crude but effective pastiche (fig. 1). As a piece of functional framing, it was generally ignored until the removal of dirt and a thick yellow varnish in the early 1980s led to a reassessment of the altarpiece. It was

FIG. 2 After treatment.

noted then that the nineteenth-century framework was affecting the poplar panel, causing incipient splitting. Some sort of remedial treatment to relieve these strains was clearly necessary, but, in the event, a more radical step was decided upon. Mainly on aesthetic grounds, the removal of the entire frame was proposed, which would have the additional benefit of allowing the panel to be repaired.

This was carried out and was more drastic than might be supposed, since the Victorian frame had been built piecemeal, glued and screwed onto the panel itself. In other words, the frame could not be removed as a whole but had to be chipped away piece by piece—obviously an irreversible process. The panel was repaired and a new display frame was devised: a plain gilt molding that barely acknowledged the original Gothic form of the altarpiece, an exercise in discreet modern presentation that contained the panel but made no aesthetic statement whatsoever (fig. 2).

So could this process, which aided the conservation of the original work but destroyed a characteristic Victorian addition, be described as an improvement? What

had been gained and what had been lost? Is the impact of the work today, in its tidy 1980s gilt surround, less or more authentic than it had been within its rough but exuberant pastiche frame? At the time, we were in no doubt that a minimal display allowed the painted panel to tell more significantly on the Gallery wall, but today we might value the Victorian intervention more than we were inclined to then.

From this discussion, we might suppose that this is simply a question about aesthetic choice, about appearances. How do we want this object to look now, when it is in a state much altered from its original condition? Do we see it as something approximating its first function as an altarpiece or as an independent work of art without context? Whichever we want (and we may want both) determines the way we might present it in a museum. But there is more than that simple question of interpretation and display. We also have to decide what it is that we value in the long, complex, and precarious lives of these works that we care for. Conservation and restoration are, I suppose, forms of triage—not just in deciding which works to treat and which to leave alone, but also in choosing which aspects of their forms and histories to suppress and which to make evident. By action or inaction, the conservator edits the visible history of a work of art, selects particular narratives of the genesis, survival, and later embellishment of a work of art, and presents them for interpretation.

The Nardo di Cione forms a fitting introduction to my subject of the conservator as narrator, but it is the study of attitudes toward nineteenth-century paintings that I want to concentrate on here. Selecting examples of conservation case histories about which one might have second (or third) thoughts is not straightforward. Each treatment should be the result of a considered process of weighing options, but conservators are naturally susceptible to and conditioned by prevailing practices and current philosophies. Certainly it is to be hoped that no conservator will have to reflect on physically damaging a painting under treatment. That would be revisionism that begins with an unacceptable premise. Yet it is an action that might be equated with inflicting physical damage that forms the starting point of the following account. At the time, what was done seemed normal, prudent, even beneficial—but with hindsight it takes on an entirely different character.

The nineteenth-century painting in question is Camille Pissarro's *Fox Hill* (fig. 3), one of twelve works painted during the artist's stay in London while fleeing the Franco-Prussian War. It depicts a winding hill in the south London suburb of Upper Norwood during the snowy winter of 1870 to '71. It was painted on a small standard-size canvas supplied by Pissarro's regular artist's colorman in London, Charles Roberson & Co., whose stamp was on the back. Acquired by the National Gallery in 1964, the picture remained untreated until 1976. In that year, I examined the painting. Its condition was stable but certainly not robust: the canvas was somewhat slack and slightly distorted by stretcher-bar marks, and it had a very small puncture at the lower right. I consulted with colleagues and concluded that the painting was structurally weak; I wax-lined the painting on a vacuum hot table and remounted it on its original stretcher.

This was a treatment that was completely in line with normal practice in the mid-1970s. It was a routine operation that took just a few hours to carry out. We were, of course, aware of the possible drawbacks of wax lining—darkening of exposed areas of priming and unwanted texture changes—but *Fox Hill* appeared unaffected

FIG. 3

Camille Pissarro
(French, 1830–1903).
*Fox Hill, Upper
Norwood*, 1870. Oil
on canvas, 35.3 ×
45.7 cm (13⅞ × 18
in.). London, National
Gallery, NG 6351.

by its treatment. The lined painting was superficially identical to its previous state and, happily, it was stronger, flatter, and more stable (or so it seemed). In 1976, it appeared we had achieved a modest but satisfactory piece of structural conservation.

So why, when asked for a personal viewpoint, does this brief episode from twenty-five years ago stay in my mind? The simple answer is that we now avoid lining a painting for the first time, unless disastrous circumstances make it unavoidable. The unique, memorable fact about *Fox Hill* is that it was the last occasion we lined a previously unlined painting at the National Gallery. But behind the simple answer lie more complex issues and altered perspectives.

The first striking feature of this case is its timing. Two years before, in April 1974, the Conference on Comparative Lining Techniques had taken place at the National Maritime Museum, Greenwich, England. This was the first time that an international group of conservators had gathered together to discuss the structural treatment of paintings. It was ostensibly an exploration of the great variety of methods and materials that picture liners had used and were using in their craft. It was an extraordinary experience to meet almost everybody in the Western world (and beyond) who specialized in all the variants of this one process. The conference had two profound and contradictory effects, one immediate and practical, the other slow burning and philosophical.

The first effect was to open the eyes of many of those present to the advances in the technology of lining and the new materials that had been introduced, both adhesives and supports. At the National Gallery, we had one of the most experienced liners in the world, who taught all the young restorers (including me) the technique of

lining with hand irons. Normally we used traditional glue and flour-paste adhesives, which were highly effective and capable of producing beautiful results, but were difficult and occasionally dangerous to manipulate—certainly not a technique for the fainthearted or untrained. For nineteenth-century canvases, which were sometimes problematic and prone to shrinkage with water-based glues, we hand-lined with wax-resin, which was safer but less effective at correcting distortions. We had long been content with these methods at the Gallery, but the Greenwich conference convinced us that we must embrace some of the new technology. We started by acquiring our first small vacuum hot table, and it was on this that *Fox Hill* was proudly lined.

The second effect of the Greenwich conference was to set in motion a debate that questioned the whole basis of lining. A keynote paper by the convenor of the conference, Westby Percival-Prescott, entitled "The Lining Cycle," conjured up a graphic picture of the spiral of repeated treatment and deterioration in which canvas paintings become trapped once they are lined for the first time. The barely concealed subtext of this important paper was that, although *re*-lining often could not be avoided, lining for the first time was unacceptable except *in extremis*. The theme was taken up again at the ICOM-CC [International Council of Museums—Committee for Conservation] triennial meeting in Venice in 1975, where a moratorium on lining was explicitly called for. That plea was largely ignored by the major museums, as evidenced by the fact that *Fox Hill* was lined in the following year.

It is difficult now to recapture the mixture of reactions that this call for non-intervention had in the mid-1970s. At first it seemed irrelevant, even impertinent. Museums knew what was best for the paintings in their care: we knew where we stood. Restorers were in the business of intervention: that is what we were there for. Lining made paintings stronger and therefore must be good. But here was one of our number calling for a halt to this apparently beneficial process, and we were confused. Suddenly, we had to grapple with the concept that *to do nothing at all* might be the best treatment for a painting. The sense of shock was palpable. Remember that this was eight years before John Richardson's "Crimes Against the Cubists" appeared in the *New York Review of Books* in 1983. In that famous article, Richardson was to draw attention to the widespread wax lining and varnishing of Cubist paintings, by which their delicate, silvery, matte surfaces became saturated, shiny, and solid. He would write of Braque's horror at the changed color values caused by the glossy varnish and, as a result of lining, the "awful tautness . . . that stretched the canvas tight as a drum."

So what was the result for *Fox Hill*, and how would we treat it differently today? Fortunately, its surface texture remained intact and its ground and paint layers were sufficiently opaque for the darkening of the canvas by the wax to be invisible. As I have said, the painting appeared unchanged by the lining, even though its structure was in fact profoundly altered by it. If this painting were to be treated today, we would simply mend the small hole with the thinnest of patches and probably reinforce the tacking edges locally with a gossamer-like fabric to enable the canvas to be tightened as necessary. The difference in philosophy between now and then is significant. Now we treat a painting in separate, controlled interventions only for what is actually wrong with it; then we would try and cure all its existing and potential ills in one major operation. A colleague in another museum once described to me how a painting in perfect condition was wax-lined in order to "preserve" its perfection. This rueful reminis-

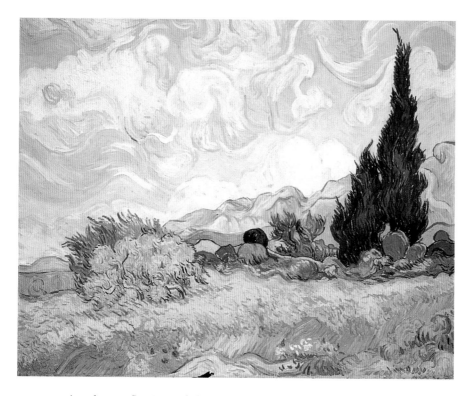

FIG. 4

Vincent van Gogh
(Dutch, 1853–1890).
*A Wheatfield, with
Cypresses*, 1889. Oil on
canvas, 72.1 × 90.9 cm
(28⅜ × 35¾ in.). Lon-
don, National Gallery,
NG 3861.

cence conjured up reflections of the embalmer's rather than
the conservator's art. Our definition of perfection has under-
gone a sea change since then.

Since the 1970s, there has been a dramatic re-evaluation
of the way canvas paintings are treated structurally. True, re-
lining by hand with aqueous adhesives is still expertly practiced
—when necessary—at the National Gallery and elsewhere. But
it now represents one end of a continuum of possibilities that
were undreamed of before that generation of conservators
gathered at Greenwich to rethink the lining process. A whole
range of treatments, semi-treatments, and almost nontreat-
ments has been made possible by developments in materials
and equipment. After Greenwich, research into low-pressure
suction tables took off in Europe and the United States. These
devices, together with gentle heat and moisture, could assist in
the flattening and consolidation of fragile paintings without lin-
ing them and without the risk to their surfaces that the fierce
pressures of the old vacuum hot tables posed.

FIG. 5

Van Gogh's *A Wheat-
field, with Cypresses*
on low-pressure table.

A notable early success at the National Gallery with this
type of equipment was the treatment in 1986 of Van Gogh's *A
Wheatfield, with Cypresses* (fig. 4). Carried out by my colleague
Tony Reeve on a suction table he had designed (fig. 5), it was a
remarkable achievement, unthinkable even a few years before.

In common with other paintings by Van Gogh, *A Wheatfield, with Cypresses* was exceptionally delicate, both physically and optically. Painted on a fine, rather weak canvas, it had some areas of thick, spiky impasto, some of thinner, smoother paint that was beginning to crack, curl, and detach, and some parts where there was no paint at all—just the rather lean ground and the glimmer of the canvas beneath. It had never been lined and never varnished. The first task was to remove a heavy dirt layer that had accumulated on the unvarnished surface. This was done with tiny swabs, taking care not to disturb any of the loose paint, the invisible consolidation of which was the aim of the exercise.

Consider for a moment the traditional options that were available for treating a flaking canvas painting and how disastrous they would have been in this case. Lining with hand irons, face up or face down, would have destroyed the impasto, even if carried out through thick padding (an old precaution for heavily textured paint). Impregnation with adhesives on a hot table would have had two negative effects. First, the heat and pressure associated with a hot table would have endangered the impasto; second, any hot-melt adhesive would have blackened the visible canvas and lean ground, irreversibly disfiguring the overall light tonality with dark, greasy patches.

Happily, the new low-pressure apparatus avoided these outcomes. Instead, with controlled heat, humidity, and mild suction, the flaking paint was relaxed and gently pushed down and reattached with small amounts of sturgeon glue brushed individually under each flake. This was truly invisible mending. The painting was stabilized and consolidated, but outwardly unchanged. It remained unlined and it was even possible to leave it unvarnished and exhibit it behind low-reflect glass. How different the treatment was from the wax lining of *Fox Hill:* the old idea of curing all ills with a single major intervention had been abandoned for an approach that identifies separate weaknesses, treats them, and does nothing else.

All this seems commonplace now; indeed, the notion of minimal intervention, tentatively wished for in the mid-1970s, had become rooted in conservation practice by the 1980s. A painting such as Monet's *Gare St.-Lazare*—acquired by the National Gallery in 1982, unlined, on its original stretcher, with the colorman's and stretcher-maker's stamps clearly visible on the back—was relieved of a yellow varnish but otherwise left untouched (figs. 6–8). It is a celebrated example of an Impressionist picture in near-original condition, with its exposed thin ground barely covering the canvas and the pin holes in the corners where Monet placed spacers for carrying the wet paintings home after his day's work at the station.

With another acquisition, Købke's *The Northern Drawbridge to the Citadel in Copenhagen*, bought in 1986, the desire to preserve original information resulted in a more complex approach. The painting had been lined in some earlier period, but it was now felt that the lining could be safely removed and that, with strengthened tacking edges, the picture would be strong enough without it. The great reward of this treatment was that the painting was signed and dated on the back of the original canvas, and this is now fully visible again.

Is the decision not to line a nineteenth-century painting (the problem, alas, seldom arises for earlier works) simply a pragmatic one, therefore? Is it merely an anticipation of probable darkening or possible texture change, the concealment of documentary evidence on the back of the canvas? Or is it something more profound

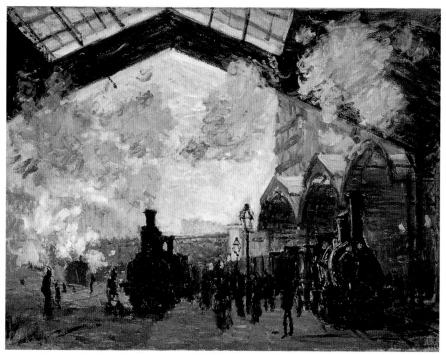

FIG. 6

FIGS. 6-8

Claude Monet (French, 1840-1926). *The Gare St.-Lazare*, 1877. Oil on canvas, 54.3 × 73.6 cm (21 3/8 × 29 in.). London, National Gallery, NG 6479.0

FIG. 7 Back of painting.

FIG. 8 Macro detail.

than that? Is it the dread of irreversibility—the sense that the canvas will never be the same again, that it is being sent down an avenue of no return? Well, yes, it is all these negative things, but it is something positive above all. An untouched picture speaks of a direct journey from the hand of the painter to this moment, an unbroken historical narrative in which it falls to the conservator to act as the narrator.

This, then, is the crux of the matter. A museum conservator (or at least the type of conservator that I represent) does not have the same narrow function as a conservator of thirty years ago. Yes, we are still responsible for the physical welfare

of the paintings in our care. Yes, we still clean and restore and treat the pictures that need it. But, whereas that was all we did in the 1970s, now it is the vital basis of much more. These days, many museum conservators are required to use the knowledge that they have gained through their intimate contact with works of art in the service of the broad area of study that has become known as technical art history.

I am currently part of a team engaged in writing a new edition of the National Gallery's nineteenth-century catalogue. It is a collaboration between curator, conservator, and scientist, and our approach is to look at some three hundred paintings literally and figuratively from every angle. This sort of teamwork is not new, but it is something to which the National Gallery has made a significant contribution in its *Art in the Making* and *Making and Meaning* exhibitions and catalogues of the late 1980s and 1990s. What emerges in such an enterprise is a shared experience in looking at paintings of a particular type—an almost unspoken agreement of the way an untouched painting looks, a measured appreciation of all the dimensions of authenticity.

In the specific context of nineteenth-century painting, we have developed a sensibility to appearance—to condition and past treatment—that is somehow different from our attitude to older works. Enough nineteenth-century paintings have survived more or less intact to make us regret the majority that have not. We can make direct comparisons that tell quite different stories of survival and change. Two paintings by Seurat now in the National Gallery—*The Channel of Gravelines, Grand Fort-Philippe* (1890) and *Le Bec du Hoc, Grandcamp* (1885, reworked 1888)—offer a telling contrast. Both appear in fine condition when seen in their frames on the gallery wall, but out of their frames they make a very different impression. *Gravelines* is in perfect condition—unlined, in plane, on its original stretcher, unvarnished, the texture of every paint stroke pristine and undisturbed (figs. 9, 10). The canvas of *Le Bec du Hoc*, by contrast, has been ironed down onto a synthetic fabric with a wax adhesive and stretched over a rigid aluminum sheet, giving the surface a slightly dead, crushed look. This was done presumably with the aim of removing any possible movement or future instability of the thin canvas.

The difference in impact of these two works on the viewer is subtle but profound. In each case, the picture that Seurat painted is intact and fully visible. But, in the first [*Gravelines*], the whole object that the artist made is thrillingly complete: that unique journey from the hand of the painter continues undisturbed. In the second [*Le Bec du Hoc*], our experience of the original has been reduced simply to the image itself. The original flexible, breathing structure behind the image has been eliminated and replaced with a stable but alien metal plate. The pleasure of looking at the painting has become diminished, the experience somehow inauthentic. Significantly, in this case, Seurat is documented as having restretched the canvas three years after first painting it in order to make room for its painted border, but the structural clues that might illuminate this change are no longer visible.

In our investigations and treatments of nineteenth-century paintings, we have sometimes come across examples of paintings in which the structure implies a more complicated genesis than usual—some, in fact, in which the process of lining has played an original part. Manet's *Waitress* (fig. 11), for example, is the result of cutting up a larger work (the adjoining part became *Au Café*, in the Reinhardt collection, Winterthur, Switzerland) and adding a new section of canvas at the right side.

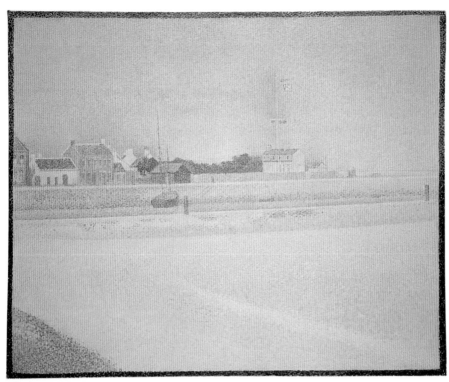

FIG. 9

FIG. 10 Detail.

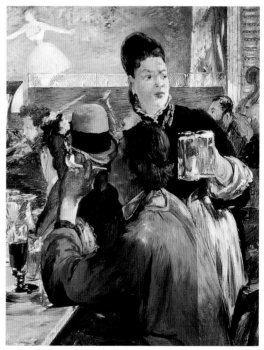

FIG. 11

FIGS. 9–10

Georges-Pierre Seurat
(French, 1859–
1891). *The Channel
of Gravelines, Grand
Fort-Philippe*, 1890.
Oil on canvas, 65 ×
81 cm (25⅝ × 31⅞ in.).
London, National
Gallery, NG 6554.

FIG. 11

Édouard Manet
(French, 1832–1883).
*Corner of a Café-
Concert (The Waitress)*,
probably 1878–80.
Oil on canvas,
97.1 × 77.5 cm (38¼ ×
30½ in.). London,
National Gallery,
NG 3858.

Manet had both paintings lined in order to join the pieces together, then painted the added section and partly repainted the existing areas after lining. When I restored this painting in 1983, it was important to understand the significance of this original lining and also to accept the fact that Manet painted the added section differently from the earlier part that it adjoined. There was a pronounced discontinuity of color density along the join. We debated at the time whether we should try and reduce the disparity by retouching, on the possible grounds that Manet could not have intended it. However, an early photograph showed that the difference must have always been clearly visible and so, happily, we were able to justify leaving the painting as it was.

The role of the conservator in all this has become clear. By examining paintings and interpreting physical evidence, we are able to suggest narratives of the making of works of art by virtue of the understanding of materials and structure that our practical experience gives us. The narrative continues with cumulative events in the subsequent history of the work—aging, deterioration, accident, repair, intervention, adaptation, reinterpretation—positive and negative events, as the restorer, art historian, and critic Cesare Brandi classified them, some valued, some regretted. The conservator as practitioner then has to decide which elements of these histories of creation and survival are most important: which aspects of the historical object must be maintained and kept visible, and which may be, for the time being, concealed. The conservator as narrator inevitably both interprets and intervenes in the narrative. The difference between attitudes of today and those of fifty years ago is that there is now a much greater acceptance of visible aging—a more benign view of the past and a less active role for the present.

At the National Gallery there has been a radical shift in the role of the conservator (although, out of nostalgia, most of us still call ourselves "restorers"). In the late 1960s, I was an apprentice in an expert department whose sole function was to repair, clean, and restore pictures. It was a time when restorers seldom published, lectured, or had opinions about art history. In retrospect, it can be seen as the closing era of an old system that had carried the Gallery through the twentieth century to the post-war years. In 1977, with the advent of the National Gallery's *Technical Bulletin*, we started to write articles about our work with scientific and curatorial colleagues and to explain publicly what we were engaged in. It was the beginning of a process that resulted in the broad-based interdiscliplinary approach that we enjoy today. We still work directly on paintings—although not nearly as many as thirty years ago—and that practical interaction with works of art remains the basis of the technical and art-historical research that we carry out. The difference with our younger selves is that we are more and more conscious of the complex historical narratives of these paintings that we care for. It is both inevitable and understood that everything we do (whether to an early Italian altarpiece like the Nardo di Cione or an Impressionist picture like *Fox Hill*) or everything that we do *not* do (to a painting like Seurat's *Gravelines*) is, to quote Brandi again, an act of critical interpretation.

Croce e Delizia

ANDREA ROTHE

Philosophical criteria often lead restorers to transform paintings to conform to contemporary tastes in the field of restoration. Such concerns affect approaches to cleaning, retouching, and the application of surface coatings and thus fundamentally influence the appearance of a work of art. Some modern conservation theories provide strict guidelines that should be followed to achieve an "honest" result. Unfortunately, well-intentioned practices can be totally foreign to the nature of the painting. By calling attention to themselves, these techniques often compete with the artist's original intention.

While visiting an exhibition with paintings that have been loaned from various institutions and collectors, it is fairly easy to identify the diverse conservation approaches that have been used, and even to date them. Some paintings might stand out because they are overcleaned and raw-looking, retouched following different philosophical criteria, over-varnished, lined with all of the impasto pressed out of them, darkened by a wax lining, or just plain neglected. As Gerry Hedley pointed out in his 1985 lecture series, depending on how it is restored, "a painting would be seen differently in different museums." [1] This is still true today. Paintings may require very individual conservation approaches even if they have the same origin. With the panels from a Gothic polyptych, for instance, many factors may be at play, such as the use of different woods in its construction; the possibility that more than one artist was involved, each using somewhat different techniques; and the possibility that sections may have been housed in different collections. In the latter case, the climatic conditions, the exposure to different light levels, and the previous modifications and restorations can all be factors that could significantly affect the outcome of a contemporary restoration. Today, all of these conditions combined with one or more of the following interventions can further modify our perception of the painting.

CLEANING

Cleaning can produce a disturbing effect when the natural graying of paint films and glazes are not taken into account. Apart from being a grave health hazard, unnecessarily harsh solvents such as dimethylformamide, pyridine, and ammonia,[2] which are still being used today, can seriously damage the paint surface and destroy the original "skin" of the painting, or what is left of it. The practice of making cleaning tests in the form of neatly defined windows in the dirty varnish does not help in understanding the complexities of a painting, and it can further distance the work of art from the restorer. Leaving little squares of discolored varnish to document the condition before cleaning is just as disturbing; such squares can also leave an indelible mark on the surface, making it difficult to remove them evenly in the future.[3]

A good example of a "well-intentioned" conservation approach can be seen in the large collection of early Italian paintings at the Yale University Art Gallery.[4] In the 1950s and '60s, most of the paintings were systematically cleaned and left largely in a raw, unretouched, and unvarnished state.[5] The approach was dictated by the honest intent to remove the heavy-handed over-paint that had been applied in the nineteenth century and leave the painting "as a fragment, in its authentic state."[6] The term "authentic state," which can be a very subjective one, includes what we believe to be what the artist intended plus the changes that have occurred to the dimensions, the surface, and the colors. Yet the systematic removal of all those layers not considered original can further destroy some of the unity of a work of art, even unity that may have been obtained by some over-painting and the darkening of varnishes applied later. This search for the "archaeological fragment" not only distorts the work of art but also can inadvertently lead to the removal of original varnishes. Some of the paintings in the Yale collection have further deteriorated in the last fifty years because they were left in such a vulnerable state of untreated decay.

The existence of layers of glazes and varnishes whose originality were sometimes questioned in the past has been confirmed. Just to mention three examples: Original varnishes were found on Orazio Gentileschi's *Lot and His Daughters*,[7] the *Ecce Homo* by Carlo Crivelli, in the National Gallery in London,[8] and the triptych of the *The Virgin Mary and Saints Thomas Aquinas and Paul* by Bernardo Daddi, in the Getty collection, about which I will speak later. In some cases, traces of original glazes and varnishes have even been found on paintings that had been radically cleaned in the past, such as the Pacino di Buonaguida *Madonna and Child* from the Yale University Art Gallery.[9]

Unfortunately, such drastic cleaning methods are still being practiced today, and remnants of original varnishes as well as thin glazes are being removed. Often paintings are treated like patients, laid out flat on the "operating table." After having worked for many years in Italy on paintings laid out in a horizontal position, I was easily converted by John Brealey [the former chairman of Paintings Conservation at the Metropolitan Museum of Art in New York] to cleaning paintings in a vertical position. This gives me much better control and affords the possibility of every now and then stepping back and observing what I am doing. Careful observation, and "living with a painting," as John Brealey said, is important. Through careful observation, telltale indications of color relationships and remnants of original glazes, for ex-

ample, can be discovered. These subtle changes can give an idea of what a painting originally may have looked like and guide the restorer through the process of cleaning and retouching. Naturally, if all one does is observe and interpret a painting, one's approach may be warped by personal viewpoints. The use of scientific examinations such as X-rays, nondestructive analysis of paint films, color cross-sections, UV, and infrared reflectograms can corroborate these observations and become important tools that help us gain a deeper insight.

Today we have broadened our knowledge of the effect of solvents on paint-films. The possibility of leaching out the binding media has been proven,[10] even with the use of milder aqueous solvents. Consequently, it has become the primary concern for many restorers to leave the topmost layer, so appropriately called "the skin of the painting" by Laura Mora, as intact as possible. Despite all the conclusions that we can draw from better understanding the structure of a painting, we can never pretend to bring it back to its original state, but we can at least strive for a more pleasing aesthetic balance.

When cleaning a painting that has uneven areas of damage, I like to use what I call "negative inpainting" or "spot cleaning," in which I leave more of the discolored varnish or patina on the more damaged areas. Early on in my career, I learned this approach from Leonetto Tintori, when he restored Piero della Francesca's *Cycle of the True Cross* in the Church of S. Francesco in Arezzo, and from Alfio del Serra. It was especially successful in del Serra's cleaning of the *Maestà of Ognissanti* by Giotto in the Uffizi, Florence, where the vestments of the angels in the lower left and right corners were practically gone, and the old varnishes and dirt layers were left to compensate for the losses.

PATINA

"Patination," literally the dirty word in conservation, is often avoided because it evokes the image of repainting. Patina can consist of the original "skin" of the painting (the transparent, very topmost, minute layer with the natural graying of the paint film), or it can consist of the original varnish or traces of it (the natural graying of the paint film and/or the fine accumulation of dirt imbedded in the original varnish). "Wear of the patina causes a discontinuity of the surface which alters . . . the depth of tones and the spiritual unity of the image" as the Moras and Philippot write.[11] It is often essential that this minuscule layer be taken into account and reconstructed, if necessary, in order to tie together the jarring effects of aging and invasive cleanings. Reconstructing this patina is called glazing or toning.

Although I don't advocate the indiscriminate use of toning, I find it indispensable for paintings that have been damaged by drastic cleanings that have left the colors in a raw state. Obviously, the destroyed paint films cannot be reconstructed, but they can be made to be less jarring, such as by using light toning to compensate for the lost copper-resinate layers.

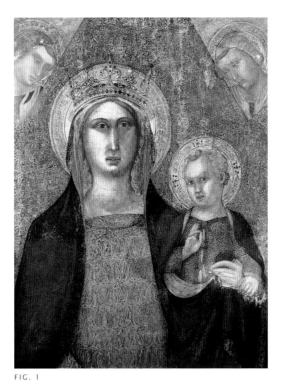

FIG. 1

FIG. 2

RETOUCHING

Certain methods of retouching call more attention to themselves than to the painting. Many of these were developed in Italy. The so-called *neutro* method (retouching in watercolors using only sepia, with a little ocher, burnt sienna, and natural umber) was used to cover larger areas of loss. The *tratteggio* technique, employing very small vertical and color-matching brushstrokes, is still being used today in Rome (figs. 1, 2). The more recently developed *astrazione cromatica* [chromatic abstraction] technique deals with the reconstruction of large areas of loss by abstractly combining all the colors surrounding the loss, while *selezione* or *integrazione cromatica* [chromatic integration] deals with smaller losses by following the dynamic movement of the original brushstrokes (fig. 3).

　　Another approach (see fig. 4) leaves the areas of loss without any retouching by just showing the underlying texture of the support. Charles Seymour sums up one of these honest attempts to not interfere with the original in his introduction to the 1970 catalogue of early Italian paintings in the Yale University Art Gallery. He writes that "damage to an important painting may be so slight, yet at the same time so disfiguring, that it has been found advisable to inpaint the losses in such a way that the additions are clearly differentiated in tonality and texture from the authentic portions." [12]

　　After having for over twenty-five years used two different approaches, *neutro* retouching for early Italian paintings and total integration on Baroque paintings, I became progressively uncomfortable with this, to me, illogical distinction between centuries, and I readily adopted John Brealey's approach of fully retouching all

FIG. 3

FIG. 4

losses. Artists did not intend for their finished works to be seen in a fragmented state, and even though this runs contrary to Cesare Brandi's *Carta del Restauro* (from 1972),[13] I believe that it is very important for the viewer to first see the painting as a complete image. Subsequently, if the viewer wishes, he can study the condition. Modern retouching should be scrupulously confined to the area of loss and should not be difficult to identify when viewed from close up.

On the other hand, I have observed in some cases that the reconstructions in the Florentine *selezione cromatica* method actually interfere with the original, sometimes creating the effects of fur or fingerprints.

SURFACE COATINGS

Varnishes have a very important function in the viewing of paintings. Some paintings need to be saturated, others need very little varnish, and many need no varnish at all. The choice of varnish is important. Some of the synthetic, high-molecular-weight varnishes that are still being used can turn gray over time and lose transparency. Many of these varnishes do not properly "wet" the surface; dark areas seem dull, without any differentiation, and the paintings retain none of their original sense of depth. One of the varnishing methods still used today strives for a very shiny finish by using very thick solutions.[14] Not only are the darks accentuated this way, but the reflections in the thick varnish actually make it more difficult to look at a painting.

I also would like to add a note about the use of glass to protect paintings and the artificial lighting used in most museums. These two elements also function very much like unsympathetic surface coatings, with the only difference that they are easily reversible. The color distortion caused by exhibiting paintings, particularly those by Impressionists, in artificial light can be very dramatic. Placing them under glass can be even worse, particularly if they are under thick plate glass, like Botticelli's *Birth of Venus* in the Uffizi, in which the warmer tonalities are perceived as having a greenish hue.

Any one of the elements mentioned above, such as cleaning, retouching, varnishing, and lighting, can seriously transform a painting, and not necessarily for the better. If all of these are put together poorly they can completely distort the emotional impact, and the intended effect, of the painting.

With this premise, I would like to share some of my conservation approaches, frustrations, and joys by discussing the following two paintings.

THE ECSTASY OF SAINT CATHERINE, BY FEDERICO BAROCCI

Having previously worked on two paintings by Barocci in Urbino, I grew to love and admire his work. So I was very excited when I was commissioned by the Soprintendenza in Arezzo to restore *The Ecstasy of Saint Catherine* (1609) from the Sanctuary of Saint Margaret in Cortona (fig. 5). Unfortunately, because of its condition and the decisions that were made to reconstruct the losses, it eventually became a very frustrating and unsatisfying project for me. The painting was in such bad condition that it had been overlooked until recent times. The severe losses of color may have been caused by Barocci's use of resinous materials for his grounds instead of the traditional gesso. This resinous material was also found by Lorenzo Lazzaroni on Barocci's *Entombment* from Senigallia.[15] Although mentioned by Bellori and Baldinucci, *The Ecstasy of Saint Catherine* was considered a lost painting.[16] Even the exhaustive exhibition catalogue from 1975 did not include it and mentions it as lost.[17] Ultimately, the cleaning revealed it to be the original by Barocci—not a copy, as had previously been believed. Unfortunately, the losses were deemed too extensive to justify a reconstruction.

In order to distinguish the areas of original paint from the losses, it was decided to place the fills at about 2 mm below the original paint layer (fig. 6), as proposed by Cesare Brandi in the *Carta del Restauro* from 1972.[18] Although I carried out the retouching well beyond the traditional neutral toning of the losses, the result is far from satisfactory (fig. 7). Instead of the desired effect of making the original remnants stand out, the different levels between the original and the losses only add to the confusion and make it very difficult to read the painting. I find the result especially frustrating since the figure of the saint is relatively well preserved and would have been easy to reconstruct, while the other areas of loss, although somewhat extensive, required no fanciful inventions (figs. 8, 9).

You might say that, in this condition, this great painting is still lost and unknown. Others that were once in similar condition and have been carefully retouched are now

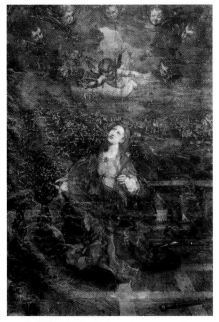

FIG. 5 Before restoration in 1978.

FIG. 6 After cleaning with the fills.

FIGS. 5–9

Federico Barocci
(Italian, 1526–1612).
*The Ecstasy of Saint
Catherine,* 1609.
Oil on canvas, 287 ×
199 cm (90 × 78⅜ in.).
From the Sanctuary
of Saint Margaret in
Cortona.

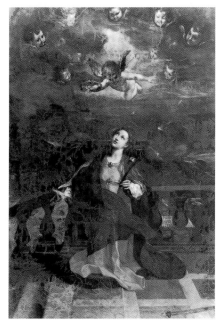

FIG. 7 After restoration.

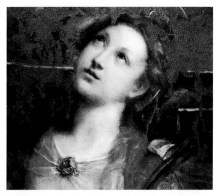

FIG. 8 Detail of the saint after restoration.

FIG. 9 Detail of balustrade after restoration. Note
difference in level between the original layer and the
reconstructed areas.

ANDREA ROTHE
Croce e Delizia

19

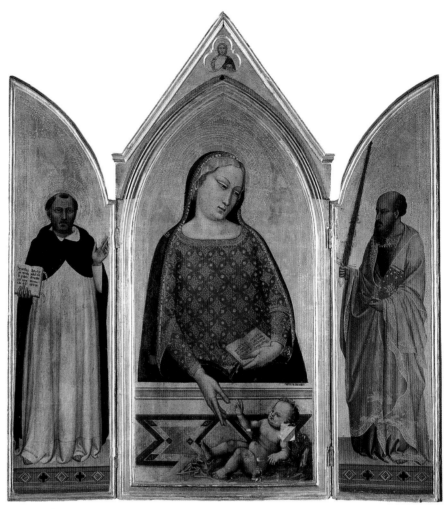

FIG. 10 Before restoration.

more readily enjoyed. Today, working at the Getty Museum, I would have filled the losses, created a surface texture similar to that of the original, and retouched them. If that kind of total reconstruction were not acceptable, I could even envision a *tratteggio* or *selezione cromatica* made to match the original color as close as possible (see fig. 3 for the Florentine *selezione cromatica;* see fig. 2 for the Roman *tratteggio*). Both *tratteggio* and *selezione cromatica* are carried out on fills that are level with the original surface.

THE VIRGIN MARY WITH SAINTS THOMAS AQUINAS AND PAUL, BY BERNARDO DADDI

A much more satisfying restoration was the triptych by Bernardo Daddi, *The Virgin Mary with Saints Thomas Aquinas and Paul*, in the J. Paul Getty Museum (fig. 10). It is one of the most remarkably well preserved trecento paintings I have ever seen. The *Virgin and Child* by Jacopo del Casentino in S. Stefano at Pozzolatico near Florence is

FIG. 11 The back of the painting before restoration.

one of the few comparable examples that I can think of.[19] I attribute the Daddi's wonderful condition in part to the way the triptych was presumably kept. Most likely it was in a private chapel without windows and natural light, and thus it was not exposed to fading and the fluctuations of outside air. There are examples of private chapels in the Florentine *palazzi* that have no natural light. One of the most famous is in the Palazzo Medici-Riccardi, with the frescoes there by Benozzo Gozzoli among the best-preserved fresco cycles. Because of the lack of natural light, the colors have maintained a brilliancy that is quite unusual.

The three individual panels of the Daddi triptych are made of poplar. There are a few woodworm holes, and there is a vertical lip on the right panel with Saint Paul that has been replaced. Otherwise, the three panels are in very good condition.

The original, well-preserved decoration on the back of the two side panels had been totally repainted to hide the reconstruction of the lip (fig. 11). The hinges (*gangherelle*) had been replaced, while the original ring (*campanella*) on top used to

FIG. 12

FIG. 12

Bernardo Daddi,
*The Virgin Mary with
Saints Thomas
Aquinas and Paul.*

Detail of the added
Christ Child, parts
of which had been
removed before
the painting came to
the Getty.

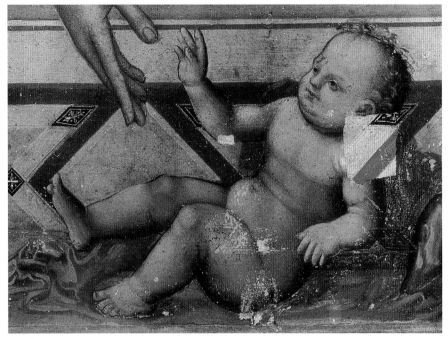

FIG. 12

fasten the painting is still in place. Over time, the painting, which dates from around 1330 to 1343, had accumulated layers of dirt, discolored varnish, and flyspecks. About 150 years later, a Christ Child was added to the lower right-hand corner of the central panel (fig. 12). It was painted in oil on top of the already discolored varnish. Judging by the X-radiograph and the infrared reflectogram, there was no indication that a Christ Child was there originally. Since the Virgin's hand is reaching beyond the parapet, the suggestion has been made that she is gesturing outside, perhaps to the altar or to a tomb below. The acquisition of the painting was contingent on the assurance that the later addition could be safely removed (parts of it had already been removed by a previous restorer).

Nevertheless, even after the acquisition, the decision to remove the rest of the Christ Child was made only after long deliberations and was certainly one of the most difficult of my career. I will never feel totally convinced that it was the right one. From the aesthetic point of view, there never was a doubt in my mind that the added Child was clumsily painted and out of proportion. As an alternative solution, John Walsh, Director Emeritus of the J. Paul Getty Museum, suggested leaving the baby and masking it with repainting. This would have been the ideal solution because it would have been reversible and would have preserved the addition. Unfortunately, the rough surface of the brushstrokes with which the Christ Child was painted would have remained quite visible in relief, however carefully the section was repainted, placing it in sharp contrast with the pristine surface of the rest of the painting.

There was one area of damage on the cloak of Saint Paul, probably caused by the repeated rubbing of some abrasive object hanging in front of it (fig. 13). The top glazes had been worn down to the bright lead-tin yellow preparation underneath. It

FIG. 13

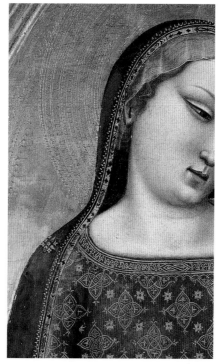

FIG. 14

FIG. 15

was interesting to be able to observe how much the original glaze on top had discolored
in sharp contrast to the bright yellow substrate. This is a clear demonstration that most
of the bright colors on these early trecento paintings were toned, and that often these
subtle glazes darkened with time and were removed. The loss of these glazes becomes
painfully clear when the yellow cloak of Gaddi's Saint Paul is compared with the leather
armor of Saint Michael in the Getty's polyptych by Cenni di Francesco (fig. 14). Here the
preparatory layer of lead-tin yellow has been exposed and little or none of the original
glazes have survived.

　　More mysterious than the added Christ Child was the total over-painting of the
blue robe of the Virgin with a dull, dark-brown color, which was probably done at the
same time that the Christ Child was added. The reason for this was not clear, because
the cleaning revealed an unusually well preserved and intense natural ultramarine
layer with painted folds (fig. 15).

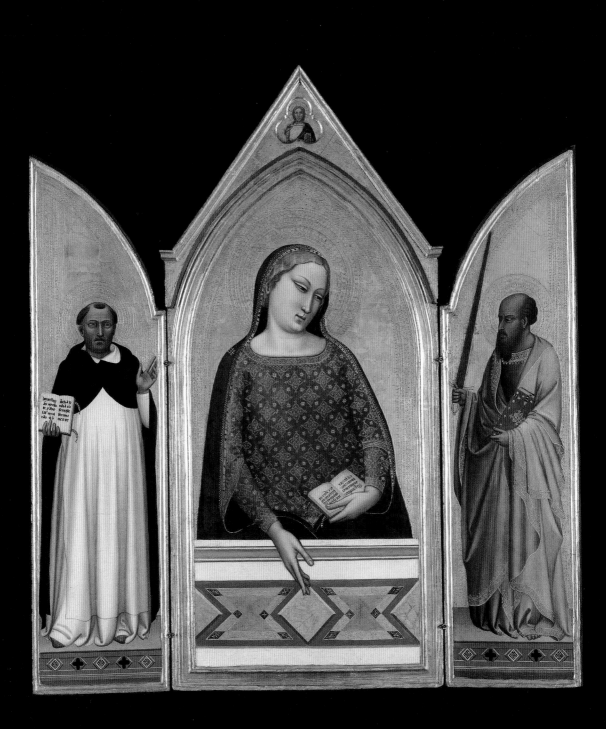

The restoration not only enhanced the painting's wonderful condition but also helped bring to life its immensely refined qualities (fig. 16). This inspires one to think that perhaps the disparaging term "primitive" is not so appropriate for all of trecento painting.

FIG. 16

Bernardo Daddi,
*The Virgin Mary with
Saints Thomas
Aquinas and Paul.*

After restoration.

I have not chosen these as examples of ideally successful restorations. Nor did I go into lengthy details about cleaning tests, cross-sections, and scientific analysis. What I wanted to share with you were the conflicts, doubts, and joys that are part of many restoration procedures. I hope they may provide stimulating material for thought and discussion. Perhaps they can help pave the way for approaching conservation a little less dogmatically, treating each painting independently, and letting the painting guide the restorer to what needs to be done.

NOTES

1. Gerry Hedley, "On Humanism, Aesthetics and the Cleaning of Paintings," reprint of two lectures presented at the Canadian Conservation Institute, February 26 and March 5, 1985, p. 1.

2. Mariagiulia Burresi, *Luca Signorelli a Volterra: il restauro dell'Annunciazione*, in La ricerca e il restauro, Soprintendenza per i Beni AAAS-Pisa (Volterra and Pisa, 1998), p. 9.

3. Cesare Brandi, *Teoria del restauro, Carta del Restauro 1972*, Art. 8 (Torino, Piccola Biblioteca Einaudi, 1977), p. 137.

4. See Charles Seymour, *Early Italian Paintings in the Yale University Art Gallery* (New Haven: Yale University Press, 1970), pp. 1–8.

5. Patricia Sherwin Garland and Elisabeth Mention, "Loss and Restoration: Yale's Early Paintings Reconsidered," *Yale University Art Gallery Bulletin* (1999), pp. 33–43.

6. Seymour (note 4), p. 7.

7. Mark Leonard, Narayan Khandekar, and Dawson Carr, "'Amber Varnish' and Orazio Gentileschi's 'Lot and His Daughters,'" *The Burlington Magazine* 143 (January 2000), pp. 4–10.

8. Jill Dunkerton and Raymond White, "The Discovery and Identification of an Original Varnish on a Panel by Carlo Crivelli," *National Gallery Technical Bulletin* 21 (2000), pp. 70–76.

9. In a recent restoration at the J. Paul Getty Museum's paintings conservation studio, Yvonne Szafran found remnants of an original varnish under a repainted area of the cloak of the Madonna that had been overlooked in the previous restoration.

10. Narayan Khandekar, Alan Phenix, and Julia Sharp, "Pilot Study into the Effects of Solvents on Artificially Aged Egg Tempera Films," *The Conservator* 18 (1994), pp. 62–72.s

11. Paolo Mora, Laura Mora, and Paul Philippot, *Conservation of Wall Paintings* (London: Butterworths, 1984), p. 306.

12. Seymour (note 4), p. 8.

13. Cesare Brandi, *Teoria del restauro, Carta del Restauro 1972*, Art. 7, no. 1 and no. 3 (Torino, Piccola Biblioteca Einaudi, 1977) p. 136. Brandi states that reconstructions are admissible if they are clearly distinguishable from the original.

14. Burresi (note 2), p. 10. The author mentions a 30-percent solution of dammar in essence of turpentine.

15. Lorenzo Lazzaroni, "Federico Barocci, 'Trasporto di Cristo al Sepolcro,' Senigallia, Esame tecnico scientifico di alcuni sezioni di colore," in *Restauri nelle Marche: testimonianze, acquisti e recuperi*, exh. cat., Palazzo Ducale, June 28–September 30, 1973 (Urbino: Ministero della Pubblica Istruzione, Soprintendenza alle Gallerie e Opere d'Arte delle Marche), pp. 422–28.

16. Anna Maria Maetzke, ed., *Arte nell'Aretino: seconda mostra di restauri dal 1975 al 1979: dipinti e sculture restaurati dal XIII al XVIII secolo*, exh. cat., Arezzo, Church of San Francesco, November 30, 1979–January 13, 1980 (Florence: Editrice EDAM, 1979), p. 73.

17. Andrea Emiliani, ed., *Mostra di Federico Barocci*, exh. cat., Bologna, Museo Civico, September 14–November 16, 1975 (Bologna: Edizioni Alfa, 1975).

18. Brandi (note 13), p. 136. Brandi states that the reconstructions must be clearly visible with the naked eye, done in neutral retouching, and on a lower level.

19. Alfio del Serra, "A Conversation on Painting Techniques," *The Burlington Magazine* 127 (January 1985), pp. 4–11.

Comments

JOHN WALSH

*Response to the papers of David Bomford
and Andrea Rothe*

I suppose it's only fair at the start of two days of recollections and confessions to speak for a moment about my own experience.

Two threads have been woven into my work in museums: an intense interest in what paintings conservators do, and a belief that visitors deserve to see pictures under optimum conditions. Most recently I have been very lucky to have the chance here at the Getty to weave these threads into the Museum's fabric of its collection, staff, and new galleries.

I am a conservation groupie. I've been that way since my first visit as a graduate student to the apartment of my teacher Julius Held on Claremont Avenue in New York. It wasn't the great man's surroundings that enthralled me; it was meeting his charming, taciturn Swedish wife, Pim, at work in her studio in the maid's room. She was cleaning a picture. It wasn't much, a grimy eighteenth-century American portrait belonging to a dealer, but I had never seen a restorer at work, and as the varnish came off the transformation was pure magic. I wanted to know everything I could learn about why and how it was happening.

Later, each of my jobs as a curator put me close to an excellent paintings conservator. At the Frick Collection it was the legendary William Suhr, master inpainter. At the Metropolitan Museum, it was Hubert von Sonnenburg and the young Alain Goldrach, whom I later asked to come to Boston when I eventually went there to be curator at the Museum of Fine Arts.

During my seven years at the Met, I'd taken to visiting John Brealey, who had marvelous pictures to work on and a lot to teach me, at his studio in London. While I was still at the Met and briefly in charge of European paintings, von Sonnenburg left for the Doerner Institute. I was clear about who should succeed him, and I was the one who went to Brealey in London and invited him to New York to take over paintings conservation at the Metropolitan and— I hoped—to make his influence felt where it was most needed, in the United States.

I have had the habit of bothering each of these people incessantly. At the Getty, Andrea Rothe and Mark Leonard, and their colleagues Elisabeth Mention and Yvonne Szafran, have had countless hundreds of interruptions as I went on struggling to understand the decisions painters made and the methods they used to produce their subtlest effects. It was not just the condition of the paintings, in other words, that I needed to learn about.

Like many art historians, I was never trained to draw or paint. I was never taught materials and processes. I should have been—it continues to amaze me that it isn't obligatory in graduate school—but I wasn't, and after I became a curator, I lacked the sense or courage to pull back and do remedial work. But at least I realized that conservators could teach me, and they did. Judging the state of pictures was only part of what I learned; the best part was understanding the logic of their buildup, the difficulty or ease of creating various optical effects, the special skills of certain artists that distinguish them from others. The goal was deducing the artist's intentions, and, of course, gauging how much those intentions have been thwarted by inevitable change, by damage, and by the wrongheadedness of our predecessors.

My timing was fortunate. I was a graduate student in the '6os during the Cleaning Controversy, Part Two, triggered by brilliant articles in *The Burlington Magazine* by [Ernst] Gombrich and [Cesare] Brandi, which had us enthralled (not a state of mind I attained very often in the periodical room). I was a young curator during the time when the grip of doctrinaire "scientific conservation" was loosening. The particular hubris of its American practitioners was being

recognized, as well as the harsh effects on paintings to which it had led. Though there was acrimony and resistance, I saw the white lab coats gradually disappear, and, like Andrea Rothe, I saw pictures move from prostrate on the table to upright on the easel. I followed the lining conference in Greenwich, and I stopped asking for pictures to be lined so I could lend them to exhibitions. I even helped conspire to bring sturgeon glue back from Leningrad.

Science became less of a fetish and assumed an essential supporting role. I saw paintings conservators hold themselves responsible for learning much more about artists whose works they were treating and getting more art-historical education. No longer did they assume that they would be guided mostly by curators' knowledge. I saw them take on responsibility for firsthand familiarity with comparative examples by traveling and studying them. And the literature became richer, especially through the 1980s and '90s, and we nonspecialists could read more and more descriptions of how painting and technique and physical history affect our judgment. You conservators are not only better nowadays at analysis and treatment, you're much better at explaining what you do and why it matters.

David Bomford and Andrea Rothe both picked revealing examples of what they have learned. David chose to talk about a Victorian frame that was destroyed in the process of creating a more "neutral" kind of presentation in the gallery, a decision that, as he says, would now be debated. He spoke about first linings and the now-general reluctance to perform them that is the product of many changes in what we value in paintings. Not least of these is the premium we put on a painting that has made a "direct journey," when we can find it, from artist to us. And he pointed to the function of "narrator," reconstructing the history of a painting, which represents a broader role for the conservator than mere analysis and treatment.

Andrea reminded us of how a conservator's work can affect how we see pictures, and he gave a summary of the dangers of cleaning in the context of the actual complexities of glazes and varnishes. He spoke about retouching within the particular traditions of early Italian pictures. He described his own conversion from "neutro" fills to fully retouching losses after realizing that an artificial distinction had been made between the taboos attached to early Italian pictures and the more liberal rules for Baroque paintings. Today he would reconstruct the missing parts of the Barocci so they would be much less visible, or not visible at all. In his second example, he used a Daddi triptych to stress the importance of studying the best-preserved examples of a type, and also to argue for the value of removing a later addition in order to restore Daddi's intended design.

Let me come back to a question that you both raise. Under what circumstances do you destroy a later addition to a picture? I don't only mean remove it, I mean remove it and destroy it in the process. No matter how carefully you've documented the addition, it's still capital punishment.

As to the Victorian frame on David's Nardo altarpiece, there are now plenty of responsible people who would argue that it had become part of the work—that by the 1980s the work was a historical composite of Nardo's panels and the frame added by nineteenth-century admirers. It was feasible to leave it on the picture. It was at least a pretty good attempt at restoring the visual sense of the original, as understood by its nineteenth-century interpreters. An argument to preserve the frame would reflect the zeitgeist of recent years: we're more apt to respect old interventions these days. That's partly because we again have a greater interest in the overall effect of the entire work, an interest Andrea spoke about. And maybe we are slower to remove old restorations because of a newer, postmodern pessimism about our ability to interpret any text or picture in a way that is valid for other people outside our immediate situation. Since we're always fallible—always arbitrary—and since interpretation is always in flux, we're more reluctant to undo the work of others and

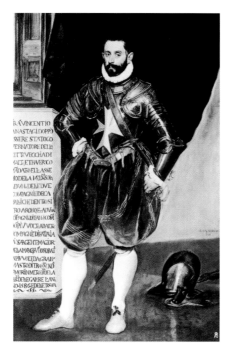
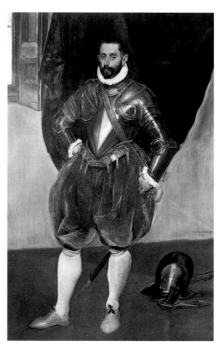

substitute our own. These seem to be interesting
questions for this group to explore.

Andrea's disappearing Christ Child raises a similar
question. Daddi did not intend that baby, or any baby,
to be there. The Christ Child was an addition by a
late quattrocento painter—no great master!—and he
changed the sense of Daddi's picture. The urge to
get rid of that spurious infant is natural—but how?
He could be removed fairly easily, but irreversibly; or
he could be painted out, but if he were you'd still
see something in low relief that would disturb Daddi's
pristine fictive stone surface. So why would I have sug-
gested that Andrea hide him rather than take him off?

I was thinking about the full-length male portrait
by El Greco in the Frick Collection, which has a waist-
high pedestal in the middle of the room with a big
inscription—both added after El Greco's time, both
aggressively distracting, both painted out by Suhr
in 1959 and still invisible forty-odd years later, but
restorable (figs. 1, 2). I would argue that to hide
the Christ Child would give our successors the option
of seeing that figure, and conceivably restoring it,
if one day taste has changed enough in the direction
it has been going, toward an actual preference for
composite objects. Second, painting the baby out is a

less drastic alternative. It's reversible. Andrea's logic
is strong, and his work bringing back Daddi's exqui-
site stonework was beautiful, but I don't think the
book is closed on the logic of his assumptions, and I'm
curious about what you all think.

Another set of questions concerns the logic behind
the doctrines of minimum intervention and the use of
compatible materials in treatment. This was raised
explicitly by David and implicitly by Andrea, and it
seems to have become orthodox thinking among lead-
ing conservators in the developed countries. You are
now slow to treat, and slower still to treat irreversibly.
Like David, you are skeptical about single, all-purpose
solutions like wax lining and you much prefer to treat
specific conditions locally. If there were a doctor in
the house, especially one from a teaching hospital, I
imagine he would feel right at home with these trends,
which, as you conservators have been observing, have
exact parallels with medicine in its gradualism, its
reluctance to intervene any more than strictly neces-
sary, its mistrust of big systemic therapies unless their
long-term effects, and side effects, are understood.

David speaks about paintings that come down to us
"thrillingly complete." Complete, that is, without alter-
ations by restorers. The thrill is one that conservators

have had to learn in the past thirty years. It comes from qualities we're now much more apt to see and appreciate: the play of light over the relief of the paint surface that is still intact in an unlined picture, and even the relief introduced by crackle long after it left the artist's studio. We're more accepting of all sorts of changes brought by age, even if they could be reduced.

Your thinking has evolved farther, to reject introducing materials that are alien to the period of the picture or the techniques of the artists. No more aluminum and plastic and fiberglass, even if they are sometimes more durable than the natural materials you chose instead. This objection to the "alien," applied to interventions that only a few people will ever see, is mainly a visceral one that we have extended into the realm of the ethical. I share it where pictures are concerned. I am, however, standing here on a knee joint made of titanium and plastic, which my restorer implanted last year, and I'm perfectly happy with it. It doesn't give me ethical problems, either, but it does make me less doctrinaire about the purity of pictures. I suppose not using alien materials in paintings represents disenchantment with the scientific positivism of our youth. And it probably reflects a revived respect for the traditional métiers that are based on practical experience with materials rather than analytical knowledge.

One more comment, about the role of "narrator" that David sees conservators performing—not merely studying, documenting, and treating, but "constructing narratives" of the lives of the individual paintings.

We'll talk more about this, I hope. I think this role is vital for your profession and will get more important. The number of untreated paintings in museums in the developed countries is shrinking, and acquisitions are dwindling to a trickle. Your work will either slow drastically or else take a new form. There are new forms, and they are needed, but you will have to develop a broader scope for your jobs.

I am convinced that you can be even more active in studying and publishing and teaching; that is, helping the public understand why paintings look the way they do. You can join the curators much more frequently as interpreters of the history of art. You can participate in organizing exhibitions, especially shows that illuminate your permanent collections. You are needed, because, frankly, the younger people we are hiring out of graduate school as curators have been bringing to their jobs more and more of the theoretical and contextual, less and less of the basic knowledge of paintings needed for a balanced and full understanding. My own experience tells me that it is paintings conservators who are best equipped to right the balance, strengthen curators, and also communicate directly with the public.

Our world is filling up with excellent reproductions of paintings available cheaply or free. It is our professional obligation to offer originals and help visitors to see them—not just look but see—in all their un-reproducible subtlety. Who better than you to teach everyone—public, curators, art historians, museum directors—how to look receptively, and to really see?

Comments

ASHOK ROY

Response to papers of David Bomford and Andrea Rothe

I've had the privilege of reading all the papers for this symposium in advance, and one of the things that struck me most forcibly in reading them was how much conservation and conservation practice have grown up in the thirty years described by Andrea and by David.

I only wish that conservation science had grown up in the same way. With two very notable exceptions (the science of preventive conservation, which has become extremely sophisticated over the last twenty or so years, and the science of technical examination of pictures, which has also advanced considerably), I'm afraid the rest of conservation science hasn't really kept up with developments in practice. In a number of areas, this is actually quite serious. As you are probably aware, there are no good models of Old Master paintings that can be used for cleaning studies. When I say "models," I mean artificial models. You can experiment on the pictures themselves, but that clearly has dangers and great disadvantages. But there are no ways in which we can prepare samples of paint films and age them to mimic the ambient aging that real paintings have undergone. Therefore, we can't really do reliable cleaning studies on test paint films.

I think this is very important, and it was drawn out in an extremely interesting paper delivered at the IIC Congress in Melbourne in October 2000. A paper by a scientist working at CAL,[1] David Erhardt, and two colleagues, showed, I think fairly conclusively, or certainly to my satisfaction, that one cannot prepare test paint films and subject them to accelerated aging and expect them to have the same chemistry as paint films that have aged over three hundred or five hundred years.[2] Therefore, we can't do reliable cleaning studies on those samples.

The other area where a great deal of progress needs to be made is in the way in which modern synthetic varnishes age and how they behave. I think all conservators are aware of the defects of synthetic varnishes introduced in the late '60s and 1970s. Those varnishes haven't performed as well as scientists guaranteed they would, and so this is rather shaming for conservation scientists.

The third area where I think a great deal of progress needs to be made is understanding how paint films blanch, whether or not they're cleaned; what the mechanism of blanching is; and what the factors involved in those kinds of optical changes to paint films are.

The fourth area we don't understand is the discoloration and change in certain pigments. For example, the discoloration of vermilion, the loss of color of smalt, the blanching of ultramarine, and the interactions that copper green pigments undergo with paint media, whether they are in egg tempera or in oil.

The fifth area that worries me as an area where conservation scientists haven't contributed as much as they should is in recommending the best structural treatment for fragile panel paintings. This is still an extremely difficult and complex area, and not one in which I think any real science is involved. I know there are successful treatments, but they don't have what I would call a scientific basis. And there's no wide agreement among conservators as to what kinds of methods should be used for panel paintings.

So these are all failings of conservation science. However, I would repeat, I'm greatly impressed by the way that conservation itself has moved forward over the period that we're talking about.

NOTES

1. Formerly the Conservation Analytical Laboratory of the Smithsonian Institution, now renamed the Smithsonian Center for Materials Research and Education.

2. David Erhardt, Charles S. Tumosa, and Marion F. Mecklenburg, "Natural and Accelerated Thermal Aging of Oil Paint Films," in *Tradition and Innovation: Advances in Conservation, Contributions to the Melbourne Congress of the IIC,* ed. Ashok Roy and Perry Smith (London: International Institute for Conservation, 2000), pp. 65–69.

Panel Discussion

David Bomford, Andrea Rothe, John Walsh, and Ashok Roy,
with comments and questions from audience members

Note: Participating audience members are identified below by their titles at the
time of the symposium

JOHN WALSH: Andrea, are you concerned about there not being a sufficiently wide
base of scientific knowledge about the treatment of wood panels?

ANDREA ROTHE: We know much more about wood than we did ten or fifteen years ago,
but there is still some mystery about how wood interacts with the ground and the
paint film. We do all this construction of crossbars to make a panel shrink and
expand freely, and sometimes we wonder if that's actually what the panel really
wants. Maybe there's some kind of restraint, which is actually good.

JOHN WALSH: This panel restoration has been done mainly on the basis of empirical
knowledge and experience, particularly the experience of craftsmen, without
scientific backup.

ANDREA ROTHE: There are examples of restored paintings that have stood up well
after many years, and we presume that the intervention did the right thing. But
we'll have to see, two or three hundred years from now.

DAVID BOMFORD: The problem with conservation in the post-war era was that con-
servators and museum curators wanted to try and perfect procedures that did
not rely on skill. Procedures such as the wax lining of paintings, or sticking paint-
ings to aluminum plates, or many other processes that we now disapprove of
were essentially seen as unskillful procedures without actual risk. Of course, the
risks were there, but they were different risks from what was being perceived at
that time. There is now a resurgence of admiration for skillfulness. And part of
the work on wood panels depends on this engagement with materials and the
skill of the hand.

ASHOK ROY: That is true in the case of wood panels, but what about lining canvas paint-
ings? Many conservators maybe never have or never will line a picture. What
happens when it does need to be done? Are the skills available to them?

DAVID BOMFORD: There are still conservators in Europe and in the United States that
can reline paintings by hand, and it's vital that that skill remain alive.

CAROL MANCUSI-UNGARO: I'm not sure that our predecessors were not skillful in doing
linings and so on. I think they felt that they were doing it well, and I have seen
some that were done extremely well.

If I bring it into my world of modern pictures and those monochromatic paintings that were repainted, I can be extremely critical of the restorers who did that. But I truly believe they did it because at the time the focus wasn't on the artist's individual brushwork or anything specific about that artist, but this idea of its monochromism. Sometimes when I look at treatments [done] in the past, it's not that I think they lacked skill, it's that there was this overriding idea of something else that needed to be done.

DAVID BOMFORD: I don't actually think the restorers lacked skill in those days. I think that people were looking for procedures that bypassed skill so you could teach conservation to students, whatever their abilities.

BRIAN CONSIDINE [Conservator, Sculpture and Decorative Arts, J. Paul Getty Museum]: I see conservators sometimes doing what might be considered heavy-handed treatments simply because they have the skill. This is not only in paintings conservation, but in sculpture and furniture and all areas of conservation where commercial restorers want to justify their work. There's an element of pride in it as well.

PEGGY FOGELMAN [Associate Curator, European Sculpture and Works of Art, J. Paul Getty Museum]: Can we foresee a time when the idea of later additions becomes a study in and of itself? Certainly in the restoration of ancient sculpture, the artistry of the restorer often can become much more interesting than the original fragment with which they were working.

DAVID BOMFORD: The whole problem of late additions is endlessly fascinating. There's a whole continuum of possibilities. Obviously, if you're talking about small retouchings, then clearly they may well be expendable. If you're talking about major additions, . . . the probable point of departure is to try and leave these in place.

PEGGY FOGELMAN: But does the addition then become an object of study in and of itself?

DAVID BOMFORD: There are ways of disguising the additions or rendering them less significant without actually eliminating them. Compromises probably are made more and more these days rather than total elimination of additions. The Nardo di Cione I talked about was this major Victorian addition which we disposed of; I'm sure we would not remove that today. I actually discussed this very problem with my curator and museum director, and Ashok Roy and Martin Wyld, because it could be considered the sort of example we might not wish to talk about. But the whole idea of this seminar is to talk about problems that we actually wish to reconsider. And all my colleagues said yes, this is something we should raise, something that we would revisit if we could. I can say with confidence that this treatment might well be one we would do differently today.

ANDREA ROTHE: The removal of the Christ Child on the Daddi was predicated on the fact that the painting was in such spectacular condition. The added figure really interfered with the overall viewing of the painting. As I said, this was a difficult decision, and I was not one hundred percent pleased with it. Had the painting

been less well preserved, or damaged, and there was this addition, I might have thought differently.

JOHN WALSH: What if there hadn't been that cleaning test? What if the baby was as well preserved in its way as the original underneath?

ANDREA ROTHE: It would have been more likely that we would have left it. But I don't know. From the beginning I disliked that baby. So, I'm prejudiced.

MARK LEONARD: As the person who kept encouraging Andrea on a daily basis to remove the baby, I have to say that one of the underlying motivations behind doing it was the sheer perfection and quality of the original. It was a judgment call; but we thought it was important to not lose the totality of the original because of a scar on the surface. In this particular case, there was no question in my mind what the right decision was.

ZAHIRA VÉLIZ: I've faced cases in which an entire image, an entire polychromed portal, is completely over-painted with generations of increasingly inferior over-paint. In some cases, we know the date and the painter who might have done the over-painting. But do you say, "Because this has historical weight I'm going to preserve this tenth-rate, eighteenth-century over-painting which is masking first-rate twelfth-century polychromy"? In the end, we've got to decide if our role in any one of those situations is to do the best by the artist, to try to recover something of the essence of the original creative work, or to respect history. My personal conviction is that we're dealing with objects which have a different life, not just a material life, and we've got to try to recover that.

SCOTT SCHAEFER: In the case of the removal [of a work that could be identified as having been made by a particular artist], one would be hard pressed to explain to the graduate student writing a dissertation on [that artist] that one of his works should be destroyed. It would obviously be very difficult to explain historically that a decision was made. These are very difficult decisions to make. And I'm not sure, quite frankly, had I been here at that time, how I would have weighed in on that decision.

BURTON FREDERICKSEN *[Founder, Provenance Index, Getty Research Institute]*: Decisions are made all the time that involve value judgments. In the case of the Daddi, the decision was made that the addition was no more than a scar on the front of the painting and didn't warrant being kept. But there are cases where restorations are by noted artists and are so good that they are worth keeping.

JOHN WALSH: I did not want to provoke a particular debate about our values as applied to the Daddi issue. I think there's a question of what age group you belong to, but I think removing the addition from view would surely get most of the votes. But I could easily imagine being an art historian over the age of thirty-one who would say, "Yes, but this picture has lived another life, it has acquired an important addition by an artist of note. If you want the baby to go away, then make him go away temporarily; but don't remove him forever."

SCOTT SCHAEFER: There's the respecting of the artist and there's also the respecting of the object. When you [David] made the decision to take the frame off the Nardo, it obviously had to do very much with the taste of the time, the taste of what the National Gallery looked like in the '60s and '70s.

DAVID BOMFORD: It was two things, Scott. Taste of the times, yes. We simply did not admire those sorts of Victorian frames in the early 1980s. Secondly, the actual physical treatment of the panel, which had to be carried out, was made easier by taking that frame off. We could justify the treatment of the panel as a reason for removing the frame. But there have been many other cases since in which additions have been left on various kinds of pictures.

For example, ten or twelve years ago I cleaned Canaletto's *Stone Mason's Yard*. There were some very, very strange repainted clouds in the top right-hand corner covering a few small damages. But our research showed that this painting, which went into the George Beaumont collection, had probably been retouched by John Constable. And so these very strange clouds, which had nothing to do with Canaletto, suddenly sprang into focus [as having been painted] by John Constable.

There was no question that we were not going to take those off. We couldn't prove [that the clouds were by Constable], but it was a likely possibility. So in this case, they're now covered up in the way that has been suggested for the other case.

BURTON FREDERICKSEN: If you hadn't found that the additions were by Constable, what would you have done?

DAVID BOMFORD: Probably still covered them up, actually. There was also a practical reason, which was that they were extremely difficult to remove. But the fact is that we valued them as additions. They are interesting to us, and they are still there.

ANDREA ROTHE: If it had been extremely difficult to remove the Christ Child on the Daddi, we may have thought, "Well, maybe we should be more respectful."

JØRGEN WADUM: In the case of the frame of the Nardo, if you had known, from another wing, for instance, what the original frame looked like and could have reconstructed it, would you have taken off the nineteenth-century frame and replaced it with a replica?

DAVID BOMFORD: Very good question. But I think that's not the point. The point is, did we value the Victorian intervention?

CAROL MANCUSI-UNGARO: Just because an addition or repaint is done by a better painter, why does that justify leaving it on? It's not by the artist who created the work that we're looking at.

DAVID BOMFORD: The point of view you've just expressed is a valid choice. In that case, the conservator is selecting a particular pure narrative, eliminating everything that doesn't belong to the original materials of the painting. The point of my presentation was that conservators are in a position to select different narratives. It is a matter for debate and for curators and colleagues to help out with.

ANDREA ROTHE: That's one of the reasons why Cesare Brandi had all these very strict rules about how things that were "historic" or that had been added had to be left. Rules were given for neutral inpainting and the lower level of the fills and all these things, and they became imperative. You couldn't deviate from them. Even though Brandi is no longer alive, we are still subject to the rules that he laid down. In a way, he removed the decision from the restorer. It's no longer a decision, it's a given.

JØRGEN WADUM: The history of conservation is extremely important if we are to understand what we are doing today. We will be part of that history for the next generation; it will just be another brick in the changes of fashion of how to take care of these objects. The dialogue we are having here may lead us to a more common approach.

ANDREA ROTHE: I'm convinced that the future generation of restorers will roll their eyes about what we did.

JØRGEN WADUM: But hopefully they will believe that we did it with the best intentions, as we believe that the eighteenth-century or nineteenth-century restorer did. Paintings restored in the later eighteenth or nineteenth century looked like the French mode because they had to look like what was in vogue at that particular time.

JOHN WALSH: Carol, you were bothered by the logic of keeping a later addition on the grounds that it was by a better artist and that that didn't seem to you to be a sensible criterion. What if it had been by Raphael? Would you think we were justified in keeping Raphael's Christ Child?

CAROL MANCUSI-UNGARO: I would say that if you bought the painting as a Daddi and you loved it as it was, it wouldn't matter if the addition were by Raphael. It's an intrusion on the original work of art. You might look at it and say it looked better, but I think you would have to think about what the work of art is. These are aesthetic objects.

JOHN WALSH: That's the fervent version of the rather cooler phrase, "We need to get back to the artist." But I propose that there's probably a decreasing educated population who would defend that position against its opposing position; namely, that it may not be for us to judge or at least not to exercise that judgment by destroying something.

ZAHIRA VÉLIZ: I am trained as an art historian too, and I recognize all of the arguments about preserving historical layers, but as conservators our ultimate point of reference has to be the original artwork. Lots of judgments come into it, but there is nothing more historically valid in keeping all the layers than [there is in] going back to what we can identify as the first point of reference.

MARTA DE LA TORRE *[Principal Project Specialist, Getty Conservation Institute]*: Can you conceive of a painting that could be more significant as a work of history than as a work of art? In that case would it not be justified to keep things that were added after its creation?

FRANCESCA PIQUÉ *[Project Specialist, Getty Conservation Institute]*: There's always going to be a decision, but the decision to remove is always an irreversible operation. And that's why we tend to follow a principle of minimal intervention and reversibility. In wall-painting conservation, the size of the work and the limited resources make us focus mainly on stabilization. Presentation and removal of later interventions are less important. We often follow the principle of minimal intervention. We'd rather not make a decision that might compromise future study; therefore, we just stabilize the object. Future study could include, for example, identification of the painter who had done the over-painting. Another thing that future technology might allow is being able to "remove" the baby without destroying it.

ANDREA ROTHE: There's the example of the famous early cross in the Uffizi—that very beautiful one that's in the first room—that was completely repainted. When they started working on it, the color underneath it was in perfect condition; it even had the original varnish on it. Nobody was able to figure out why it was repainted. Had they not done this work slowly, taking the over-paint off under the microscope, it would still be an ugly-looking painting of secondary quality—not nearly as beautiful as the original. In this particular case, something was recovered, but something was lost, which was definitely of weaker quality. But one can say, "How do you know that the one on top was of weaker quality?" And then you have the discussion about the quality of the artist.

PHILIP CONISBEE: We need to remember that aesthetic judgments are also historically determined. A hundred years ago, certain works of art formed a canon. We have a different canon now. And while no one is going to challenge the primacy of Raphael and Michelangelo, a hundred years from now the canon of admired works will again be different. So I would always err cautiously on the side of history.

JOHN WALSH: David, you posed a role for future conservators as constructors of narratives, as interpreters or reconstructors of the history of paintings. Taking a museum's-eye view of that, I can imagine a role for paintings conservators at a time when the public is becoming pretty needy of vivid and specific explanations as to why things look the way they do, why they're worthy of our interest, or what makes one artist different from or better or worse than another. Is there hope there? Is this just a dream, or is it something we might actually do?

DAVID BOMFORD: I think it's certainly happening in more and more museums throughout the world. At the National Gallery in London, we have already been involved in a considerable number of exhibitions and publications which try and express these narratives, these histories of painting techniques and the histories of the

objects themselves. This is exactly what I believe paintings conservators ought to be doing. There are fewer pictures left to restore, because so many have been beautifully restored already. I think the point I was making is that the role of the conservator is already changing and will go on changing.

ASHOK ROY: We've been trying to do a bit of digital reconstruction of pictures. It's [only] moderately successful, I would say, because you have to make a great many assumptions about what was there originally. You make an assumption, for example, in a faded picture as to the degree of fading. You also make an assumption as to the original color of the paint. You can then digitally guess as to what that area of the painting looked like, but it's a pale copy of what was there originally.

JØRGEN WADUM: I think we can reach an enormous audience by explaining that these pristine artworks were once in the hands of somebody who maybe had paint dripping on their trousers or was standing in a dirty workshop. It is valuable to try and make a link between the public and the making of these objects. In the twenty-first century, conservators will be the bridge between collections and the public more than curators have been in the twentieth century.

JOHN WALSH: My hope is that there will continue to be ways to bring the visitor into a more sophisticated understanding and a more responsive kind of frame of mind about works of art.

BURTON FREDERICKSEN: Someone mentioned that you didn't think the *Mona Lisa* would ever be cleaned. Is it because it has the original varnish? Do you think that painting *will* never be cleaned, and do you think it *should* never be cleaned?

ANDREA ROTHE: I think it should be cleaned because this painting is in very good condition, from what I can see. The yellow varnish on it is very deforming and it doesn't give any idea of how precious and beautiful that painting is.

DAVID BOMFORD: I'm sure there's absolutely no technical objection to its being cleaned at all, merely a psychological one.

MARK LEONARD: How do we keep our critics from saying, "You really don't know enough, and so in fact you should do absolutely nothing and leave it to the future generation to decide"?

ASHOK ROY: It implies in fact that one has to try and discover the nature of some of these changes in pictures and what can be done about them. Until one does have those answers, I don't think it is right to go ahead and invoke treatments which are potentially damaging and irreversible.

I'm particularly worried, though, about the tendency to reject traditional methods of cleaning pictures in favor of new methods on the basis of not tremendously reliable scientific evidence that traditional cleaning methods are very damaging. It has come to be an orthodoxy in certain circles that using solvents on pictures invariably does damage to the paint surface and that using newer,

more ecologically sound methods of cleaning pictures is less damaging. But this remains to be demonstrated in actual fact and in scientific evidence.

JOHN WALSH: One more little flashback. When I started my work in museums, it was very common that rather extensive treatments were being done on a very small number of paintings. These pictures were then published in extenso and returned to the wall with considerable applause. The trouble was that on the walls there tended to be other pictures with bloomed varnishes, discolored retouches, bad frames. There was such an extraordinary disjunction between treatment in the most modern and sophisticated way and the maintenance of the collection in the galleries. I think that gap has been closed in a big way. The frequency of extensive treatments may have slowed in museums; certainly many forward-thinking paintings conservators and their assistants have gotten out into the galleries and, with the urging of curators, have brought up the standard of display quite a lot. Maintaining varnishes and the like are not activities that are glamorous or publishable, but they make works of art look their best regardless of whether or not they merited treatment in the traditional sense. It's made a great difference to what things look like in museums.

ANDREA ROTHE: John Brealey, for instance, was very keen on having [all] the paintings in one gallery taken care of in the same way so that there wouldn't be one clean one and one dirty one and one bloomed painting.

DAVID BOMFORD: Another factor to which Andrea referred in his talk is that no matter how beautifully a painting is cleaned and restored, no matter how perfectly and ethically and justifiably it's done, it can be ruined by museum lighting. Conservators have realized that they have to have input into how paintings are displayed. There are celebrated cases of cleaning controversies arising quite wrongly simply because pictures were overlit.

If you walk into a gallery and see a painting jumping off the wall because it has six spotlights on it, your first reaction is not that it's got six spotlights on it, but that it's been overcleaned.

CAROL MANCUSI-UNGARO: The opposite is also true. In a situation where there was nothing else to do with the picture, where it just couldn't be made to look any better, I remember very clearly saying to the curator, "Now it's up to you. Light it in a way that is sympathetic to its aging and its problem." So I think that the partnership between the curator and conservator with regard to how a work of art looks in the gallery is very real and should be encouraged.

ANDREA ROTHE: Glass can also have an enormous effect on the surface of the painting, and not only in terms of interference due to reflection. For instance, in *The Birth of Venus*, by Botticelli, the warm tones appear to have a greenish hue to them due to the presence of the glass. This is very disturbing because it completely distorts the painting. There's a whole generation that has never seen the painting without the glass. And I think that's very sad.

MICHAEL SCHILLING [*Senior Scientist, Getty Conservation Institute*]: What becomes of the materials that are removed from paintings or works of art? Are they ever retained as reference materials? It seems that perhaps some of these materials that are removed might make good study pieces in and of themselves.

ASHOK ROY: We certainly keep everything of that kind taken off pictures — even samples of paint which are gathered through unfortunate circumstances. In one case, a picture was vandalized in the gallery, and we were unlucky enough to be able to gather quite large amounts of paint. They form excellent study samples for cleaning.

SESSION 2

41 The Artist's Voice
 MARK LEONARD

59 Ravished Images Restored
 JØRGEN WADUM

73 Comments
 PHILIP CONISBEE

79 Panel Discussion

The Artist's Voice

MARK LEONARD

As paintings conservators, we spend the majority of our professional lives working with the physical realities of the works of art entrusted to our care. For the most part, we tend to record our observations about the more tangible aspects of paintings in a fairly technical manner. At worst, these records amount to nothing more than coldly impersonal notes or even thoughtless checkmarks on preexisting forms, dutifully documenting, for example, such intricate details as the thread counts of a particular canvas weave. At best, however, these records might also contain, even obliquely, occasional glimpses of the more emotional experiences of the conservator during what could be characterized as our very intimate encounters with the work of art.

In my opinion, our personal thoughts and responses to paintings are at least as important as our more technical records. In the long run, our writings, in whatever form, not only should document for future generations the materials and techniques that we chose to use in our treatments but, more important, should help those generations understand why the paintings whose care has been passed on to them ultimately look the way that they do. *Why* did we choose to treat things in a particular manner, and what did we think about during the days, months, and even years that some pictures sat on our easels? These sorts of thoughts helped to shape the concept of the seminar that led to the publication of the essays included in this volume.

After working with my colleagues at the Getty on the development of the program for the seminar and publication, my role shifted to that of participant, and I was, of course, faced with the reality of making a meaningful contribution of my own. I decided to begin by departing from the preconceived structure that I had helped to develop and simply allowing my own inner voice to lead me toward the shaping of an essay. And I discovered that this path, in some ways, parallels the path that I take in developing an understanding of the pictures entrusted to my care. Like many conservators, I find a certain comfort in following established rules, but I've also learned that this doesn't necessarily lead to success when you're dealing with such unruly and

emotionally messy things as works of art. Paintings reveal themselves, slowly, during the time that we spend with them in the studio. Our understanding of them does not derive from rigid preconceptions; rather, it follows an evolutionary pathway that unfolds not only as a result of our discovery of technical details but also by calmly taking time to consider what they have to say to us as works of art.

I began thinking seriously about what I should include in this essay while I was preparing an informal presentation to a small group of conservators about the development of my own approaches to retouching issues. While getting ready for that talk, I found myself repeatedly referring to a key phrase that I think should form the basis for this essay as well: "Let the work of art be your guide." This simple statement is easy to present but quite difficult to define, demonstrate, and teach. I have found that in my own work and in my own teaching it is a phrase that must be chanted repeatedly, mantra-like, until the search for the artist's voice—which in the end should and can speak clearly through the work of art—infuses everything that we do.

I could easily write a book-length work based upon all of the ideas related to this theme, but the current challenge is to distill it into something succinct and cogent. The guidelines for this essay suggested that I choose one work of art where, with the benefit of hindsight, I might have done things a bit differently, and one where my own work was successful. While writing the retouching lecture, I came up with a very long list of things that I might do differently if given the chance. Editing the list down to a single choice not only might result in a superficial look at the complicated topic of self-evaluation but also might give the false impression that I am quite self-satisfied with everything that I've done in the past. For the purposes of this essay, it's probably best not to dredge through all of the embarrassments and horrors of some of my earlier work as a conservator—but even in my better work I can find a few examples of issues that I might address differently at this point in my career. By the same token, there are several paintings, fortunately, where I still feel, when I see the pictures in the galleries today, that the work I did followed the right path and led to the right treatment decisions. A brief look at some of those paintings will allow me to touch upon several different aspects of what constitutes a "successful" treatment.

In my best work, allowing myself to be guided by the works of art enabled me to engage in restoration treatments that ultimately brought the individual paintings to a state where the artist's voice could have its fullest expression through the physical reality of the work of art. In practice, this meant juggling the myriad details of a wide array of issues—ranging from interpretation of scientific studies of the artist's materials and techniques to wrestling with the conservation materials available at the time—while never losing sight of the overarching experience of the work of art itself. A close analogy can be made to the work of a musician. He must first practice a piece of music until all of the technical aspects of a performance have been developed to flawless perfection. Then he must take a leap of faith during the actual performance of the piece so that his deeper understanding of the overall experience of the music can infuse the technical details with meaning, thus allowing the composer's voice to speak clearly.

I started my life in the field of conservation as an undergraduate at Oberlin College, continued my studies at the Institute of Fine Arts in New York, and completed my graduate work as an intern under the supervision of John Brealey at the Metropolitan Museum of Art. My internship eventually led to a permanent position, and I was very fortunate to have been able to spend five years in what was, at that point in time, the passionate and complex environment of the studio at the Met.

My arrival at the Met was fortuitous, although in retrospect I can see that it was not entirely accidental. I knew even as a very young student that I was filled with passion for works of art: my fundamental excitement about them was based in part upon a visceral response to the physical realities of paint and brush. John Brealey had come to the Metropolitan for the express purpose of training a generation of conservators who would consider "the long-suffering work of art" not from what he viewed as the excessively clinical approaches of the past but rather from a more "humanistic approach so that the painting as an aesthetic entity [would] always [be] in the forefront of the conservator's mind."[1]

John was determined to give his students the best possible pictures to work on, and I was no exception. In retrospect, I am amazed at my youthful fearlessness in approaching the masterpieces that I found sitting on my easel at the Met, including Rembrandt's *Artistotle Contemplating the Bust of Homer*, Renoir's *Portrait of Madame Charpentier and Her Children*, and *The Musicians*, by Caravaggio. Although I never took these exceptional pictures for granted, my comparative lack of experience also meant that I could not approach them with the (I hope) more sophisticated and refined understanding that I would have now if they were to come to me for treatment. But I did become comfortable with great works of art as a result of this early exposure, and not only was I at ease with them, I was also receptive enough to take advantage of the many ways such paintings can change and enrich our lives.

The very last picture that I worked on during my tenure at the Metropolitan was Caravaggio's *Musicians*. While reading through the treatment record for this picture recently, I was reminded of the complications involved with the difficult restoration of this very damaged picture. The painting had been acquired by the Metropolitan with much fanfare in the early 1950s. Three decades later, cleaning (done entirely by John Brealey) revealed a picture that had been repeatedly restored and suffered extensive damages throughout its long and difficult life (fig. 1). Although there were wonderful discoveries, including the fact that the wings and quiver of the figure of Cupid at the left were intact, and an upcurled page of paper (known to exist because of copies of the painting—but thought to have been lost) was still there, it was clear that the surface had been ravaged.

Working on the picture was difficult—not in small part because of the complicated politics of life in a large studio with a number of powerful personalities both inside and outside of the department, all of whom had something to say about the way that this picture looked. The technical complications were also a challenge, given the ragged state of the painting and the extensive amount of work that was required. But, in the end, it was possible to knit together the remnants of the image in such a way as to allow what remained of the original to speak through the devastations of time (fig. 2).

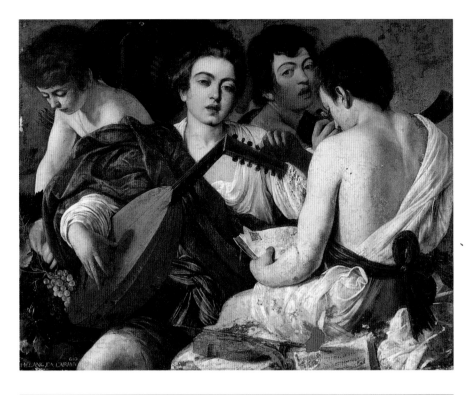

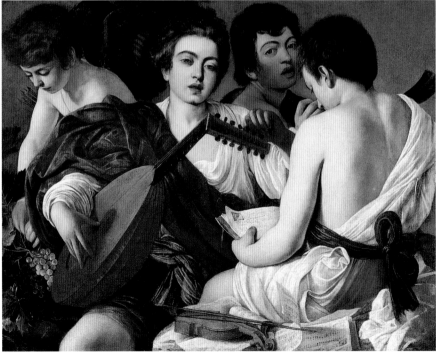

I can recall that many of our discussions in the studio during the course of restoration focused upon a desire to keep the retouching from going too far. The challenge was to reunify the picture without falsifying the true state of the surface. At the time, we all agreed at an appropriate stopping point. In retrospect, not only do I think that perhaps I should have taken the retouching a bit further, I also regret that I wasn't able to use restoration materials that might have proven less problematic over time. This last point became painfully clear to me very recently when an exhibition catalogue for *The Genius of Rome, 1592–1623* at the Royal Academy, London,[2] arrived on my desk just as I had begun working on this essay. There on the front cover, in enormous detail, was the Caravaggio that I had worked on two decades earlier.[3] The image was as poignant and deeply felt as I had remembered, yet all that I could really see was what I thought of as masses of discolored retouches leaping up at me from the cover of the catalogue.

I was able to see the picture shortly afterward, while it was still on view in London. Fortunately, the degree of discoloration of the restorations was not as severe as the photographs from the catalogue had suggested. I did, though, find myself thinking that the picture may have looked too rough. Even though the more subtle aspects of Caravaggio's handling may have been irretrievably lost due to the damages incurred in the past, I still thought that more could be done to calm and refine the surface. I also felt that the awkwardness of some of the retouches could use some corrections. However, I've learned through experience that wrestling with a battered surface in an attempt to give expression to the artist's voice always leads to a heartbreaking moment of realization where it becomes clear that it is simply not possible to go further without resorting to pure invention rather than restoration.

It might be more fair within the context of this essay to consider some of the work that I did after I had obtained a few more years of experience. While walking through the galleries at the Getty and thinking about this essay, I began to realize that I had achieved a certain level of maturity only after several years of wrestling with the technical tools that I had at hand. I reached a critical mass in my own work where, like the pianist who has finally mastered all of the notes and instinctively knows how to finger the most difficult passages, my own skills finally fell into place. Although I may be simplifying (and perhaps romanticizing) my own past in some respects, I have a very clear memory of when this first happened: during the treatment of a picture by Gerrit Dou.

In 1984 the Getty Museum was able to acquire *Prince Rupert of the Palatinate and an Older Man in Historical Dress* (fig. 3), a double portrait by Gerrit Dou. The acquisition was particularly important for the collection, as it reunited the picture with its pendant by Jan Lievensz [*Prince Charles Louis of the Palatinate with His Tutor Wolrad von Plessen in Historical Dress*], which J. Paul Getty himself had purchased thirteen years earlier. Both paintings had apparently been restored in the 1960s, perhaps around the time that they passed through the New York market after having spent their lives since the eighteenth century hanging together, in matching frames, as part of the Craven Collection at Combe Abbey (near Coventry, England). The Lievensz had been cleaned and restored at the Getty after its acquisition, but comparison of the records and photographs showed that the Dou had not been touched

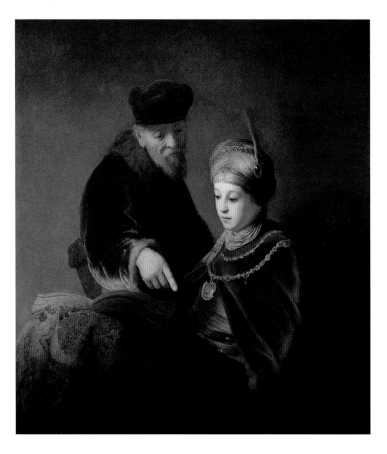

FIG. 3

Gerrit Dou (Dutch,
1612–1675). *Prince
Rupert of the Palati-
nate and an Older Man
in Historical Dress*,
ca. 1631. Oil on can-
vas, 102.9 × 88.7 cm
(40 × 34¾ in.). Los
Angeles, J. Paul Getty
Museum, 84.PA.570.

Before treatment.

since the 1960s and remained in a state identical to the Lievensz when that picture had
first arrived at the museum. The surface had been covered broadly with slick rein-
forcements, evidently as a means of achieving a heightened sense of drama and con-
trast. Despite the fact that the painting was in quite good condition, the surface had
all the hallmarks of a skillful yet decidedly commercial type of restoration, including
partial cleaning, reinforcement throughout all of the darks, and unnecessary scum-
bling of the flesh tones (fig. 4).

Reading through my own condition report and treatment record for the picture,
I was pleased to find that I had described the unnecessary work on the surface and
had correctly predicted that the picture would prove to be in beautiful condition once
it was cleaned. I was somewhat disappointed, though, to find that I had referred only
obliquely to the success of the treatment and to what I so clearly recall as the plea-
sure and satisfaction that I took in doing the work—particularly in achieving a very
beautiful final surface for the painting.

The cleaning was quite straightforward (as my predecessor at the Getty had dis-
covered in her treatment of the Lievensz ten years earlier). Once the excessive restora-
tions were removed, the exceptional nature of Dou's work became clear. We admire
Dou primarily for his mature works, which are on a smaller scale. In this large pic-
ture, painted perhaps in competition with Lievensz while both artists were working

in Rembrandt's studio, it feels as if the young artist was a bit uncomfortable with the large format and struggled to fill the space. The X-ray (fig. 5) shows that Dou planned originally for the two figures to be sitting below an archway; he abandoned this architectural idea in favor of a simpler, monochromatic, and serenely atmospheric setting.[4] Unfortunately, the pentimento of the arch had been revealed in past cleanings, resulting in sharp breaks throughout what should have been the flawlessly modeled transition from light to dark in the background.

My approach to retouching this picture was somewhat different from the work I had done in the past. Because of the thin, smoky character of the expanse of space in the damaged background, I was wary of using a resin-based retouching material (which might have built up into a sticky, opaque mess, suffocating the atmospheric qualities of the light). I opted instead for thin veils of watercolors—applied in between alternating layers of varnish—which knitted the damages together invisibly and reestablished the smooth veil of gray atmospheric haze that Dou had originally created. This process was a revelation. Not only were the restorations executed with a material that was very thin and very clean, but they would also remain very stable and easily removable in the future.

I was equally pleased with the varnishing process. When I first entered the field of conservation, I was told that natural resins were simply unusable as varnishing materials: not only did they discolor but they also resulted in thick, glossy surfaces. Over the years, I began to find some misconceptions in these claims, particularly with regard to thickness. I discovered that using mastic in a dilute solution and applying it in very thin brush and spray coats over a period of several weeks, thus allowing for substantial drying of the thin films between applications, would result in an elegant, refined surface that could not be matched by using the synthetics available at the time. The final mastic surface on the Dou proved to be flawlessly even, despite its exceptional thinness, providing translucent saturation even within the darkest shadows. As a result, the varnish provided transparent access to the image rather than acting as a barrier to it, and the restorer's hand remained invisible.

At the time, I thought that this was some of my best work. After completion of the treatment, a well-known curator from a famous institution came to see me. He asked if he could see the Dou, which had not yet been placed on view and was at that moment in the photography studio, illuminated with a soft, overhead light that complemented the miraculous lighting within the painting. I took him into the photo studio and was very flattered when I heard him audibly gasp with pleasure at what

FIG. 4

Gerrit Dou, *Prince Rupert of the Palatinate and an Older Man in Historical Dress.*

Ultraviolet photograph, detail, before treatment.

FIG. 5

Gerrit Dou, *Prince Rupert of the Palatinate and an Older Man in Historical Dress.*

X-radiograph.

FIG. 6

Gerrit Dou, *Prince Rupert of the Palatinate and an Older Man in Historical Dress.*

After treatment.

he saw. The painting was well known because it had hung for many years on loan to the Rijksmuseum in Amsterdam. He told me he had heard that "the Getty couldn't wait to get its hands on the picture and had probably ruined it in the process." This was not entirely surprising, given the fact that at that point in time the Getty was the fashionable target of much idle gossip and misassumption. Fortunately, the picture was able to speak for itself.

And, fifteen years later, when I see the picture hanging in the gallery (fig. 6), despite lingering concerns (in retrospect) about the potential for discoloration of the mastic varnish at some point in the future, I am pleased to see that my own work still remains quietly invisible (and, in fact, nearly forgotten), thus continuing to provide, I hope, an uninterrupted pathway to the artist's voice.

Another painting that was well known during many years of exhibition at another institution (this time the Metropolitan Museum of Art in New York) before its acquisition by the Getty is Rembrandt's *Abduction of Europa* (fig. 7). I knew (and loved) the picture quite well myself, having visited it often in the galleries during the years that I had worked at the Met. Not only did I know it to be one of the few mas-

FIG. 7

Rembrandt Harmensz.
van Rijn (Dutch, 1606–
1669). *The Abduction
of Europa*, 1632.
Oil on panel, 62.2 ×
77 cm (24 ½ ×
30 ⁵⁄₁₆ in.). Los Angeles,
J. Paul Getty Museum,
95.PB.7.

Before treatment.

terpieces of Rembrandt's early maturity still left in private hands, I also knew it to be
in nearly perfect condition, although buried underneath a heavy, obscuring curtain of
yellow-gray varnish.

This particular acquisition was one of the first to be made by a new curator at
the Getty. He was deeply suspicious of the field of conservation and, perhaps com-
pounded by the fact that he knew little about me or my work, was understandably very
reluctant to even consider having the picture cleaned. There was simply no question
in my mind that this was a mistake. I've always believed that one of the responsibili-
ties of those of us who work with public collections is to maintain a consistent level of
care for the pictures in the galleries. When visitors walk through the collection, they
should not be distracted by any thoughts concerning diverse states of presentation of
individual paintings (from excessively neglected to excessively restored); instead,
they should be able to simply experience the paintings as works of art. If left in its
gray and discolored condition, not only would the *Abduction of Europa* have fallen out
of the context of the galleries at the Getty, thereby becoming little more than a dis-
turbing anomaly, but Rembrandt's voice—and consequently the meaning of the pic-
ture—would have remained inaccessible.

So I gently, if persistently, set about laying the groundwork for treatment of
the picture. The curator and I spent a great deal of time getting to know the pic-
ture together during its time in the studio, not only throughout the course of the
X-radiography, pigment identification, and other analytical work that was done but

also by simply sitting in front of the painting and talking with each other about what
we saw. In this way, our understanding of the picture grew along the same path, and,
most importantly in this case, our sense of self-confidence in that understanding
developed simultaneously.

In order to demystify the cleaning process as much as possible, I invited my col-
league to literally sit by my side while I cleaned the picture, so that he could experi-
ence the joy of watching the picture reveal itself. He took me up on the offer and over
a period of several days was a constant companion at the easel while the cleaning
took place. I encouraged him to follow my own approach, focusing not upon the dis-
colored varnish that was showing up on the swabs but upon the appearance of the
forms and spaces within the composition as the treatment progressed. This approach
allows the work of art to guide the entire process, as it concentrates attention upon
the appearance of the picture rather than the appearance of the swabs. As expected,
during the course of cleaning, Rembrandt's handling of the cool, silvery, atmospheric
tonalities of the sky and landscape began to interact beautifully with the warm light
that illuminates the dazzling, jewel-like details of the surface (fig. 8).

While working on this essay, I revisited the treatment record for the *Abduction
of Europa*. I was pleasantly surprised to see that my technical descriptions of the mate-
rials and techniques that Rembrandt used in the creation of this picture, as well as my
records of the conservation materials that I used while working on the painting, were
nicely balanced with comments on some of my own intuitive experiences as the look
of the picture evolved during the treatment. There was a slightly complicated aspect

to the condition of the sky. Analysis had shown that the area's blue-gray color was due to the presence of smalt, a pigment known to discolor and become increasingly transparent with time, particularly when used as a thin glaze. This had resulted in a slightly patchy and uneven appearance throughout the lighter areas of the sky; broad areas of translucent retouching had been applied by restorers in the past in an effort to compensate for the effects of the smalt discolorations. During my treatment, small abrasions in the sky, where the darker layer of underpaint was disturbingly visible, were scumbled over. Very thin glazes were used in selected areas throughout the sky in order to reduce the mottled appearance of the surface. This was quite successful in unifying the area and restoring a sense of atmosphere and depth without resorting to the broad, heavy-handed work of the past restorations. And as far as the final varnishing was concerned, fortunately, some of my lingering doubts about the use of mastic had been partially assuaged: by the time of this treatment, use of a new conservation material had been developed. A small amount of additive[5] will hopefully slow down the deterioration process and push the need for re-treatment of this picture further into the future.

Having the chance to work with Rembrandt's *Abduction of Europa* was one of the highlights of my career, not only because I had known the picture for such a long time but also because it remained in such beautiful condition, and, as a result, the decisions and choices that had to be made during its treatment followed a clear and direct course. However, another picture I felt exceptionally privileged to work with was, by contrast, in a more problematic state: Veronese's *The Dead Christ Supported by Two Angels*, from the Picture Gallery of the Staatliche Museen in Berlin. This picture is, in my opinion, one of the most compelling and poignant meditations upon death to be found in the history of Renaissance painting. Yet by the time it found its way to the conservation studio at the Getty, it was in a disheveled and unsightly state, covered with a darkened varnish and disfigured by clusters of discolored re-paints (fig. 9). Even before the treatment began, it was clear that the biggest challenge in the restoration would prove to be the reintegration of Christ's torso, an area that formed the compositional and emotional center of the picture but had lost all sense of form.

The cleaning was far from straightforward, but during the complicated process my own sense of confidence and understanding was bolstered by the fact that the image became increasingly stronger with each small step of the process. This translated into a feeling that the painting itself was leading the way and responding in kind to my efforts to follow the right treatment path. The experience of moving across the surface of this picture gave me a sense of immediacy and intimacy with the hand and voice of the artist that I have only rarely encountered since that time. Contemplating the hand of Christ, which Veronese skillfully positioned at the forefront of the picture for us to encounter, never ceased to lead me to consider issues of mortality, no matter how many times I came across it.

As with many pictures, removal of the interfering "noise" of past restorations gone awry enabled the strength of what remained of the original to dominate (fig. 10). And, again, as is often the case, continuing to quiet the presence of past damages in a successful manner through retouching could only be accomplished by carrying out

the work in the proper order. The natural temptation would have been to start
wrestling immediately with the major damages in Christ's torso, but this would have
been a misstep. In order to build a firm foundation for approaching that challenge, it
was better to work at first with the well-preserved areas, unifying the strengths of the
picture, so that every step I took in the work on the torso would clearly be either right
or wrong, based upon the way that it would read in relation to the dominant (and
reunified) original. This quite literally meant taking care of the smallest, simplest
losses and abrasions first, where there was absolutely no question as to what was
missing and what needed to be replaced. In this particular case, the outer edges of
the composition remained in a better state of preservation than the center, so the
work progressed quite naturally from the outside and then in toward the rest of the
picture, knitting together the broken forms through elimination of the myriad small
damages. This not only gave a strong visual framework for the figure of Christ—mak-
ing it absolutely clear how the forms should sit in space, underscoring the subtle twist
and weight of the dead torso—but also contributed to my understanding of how the
artist went about creating the illusion of these forms, and thus contributed to my sense
of confidence in the restoration process. I could follow the lead of the original calmly
rather than being defeated at the outset by the daunting nature of the task.

During its stay in the studio, this picture, as with all great pictures, created its
own atmosphere. The simple presence of a great painting in a room where many
people come and go for a number of months can generate excitement and influence
the dynamic of daily life. In the early stages of the course of a complicated treatment
of a damaged picture, most visitors to the studio usually begin their conversations
about the picture with comments about the extent of the damage and questions such
as, in this case, "What are you going to do about the problems with Christ's body?"

FIG. 11

Paolo Veronese, *The Dead Christ Supported by Two Angels.*

After treatment.

But there is usually a point in time where the comments begin to shift, imperceptibly at first. Eventually, though, the conservator realizes that the visitors no longer have any interest in whatever damages there may have been; they have turned their comments and conversations to the impact of the painting itself as a work of art. When this moment is reached, it provides a signal that completion of the treatment is near, as enough of the problems have been corrected to allow the artist's voice to speak for itself. That certainly happened with this Veronese, where at one point questions and comments about the torso of Christ suddenly gave way to discussions about the strength of the conception and the poignancy of the scene. In the end, although an extensive amount of very careful retouching was required in order to visually unify the surface of the painting, it was possible to knit the forms together without resorting to an excessive amount of restoration (fig. 11). To quote from my treatment record: "the picture retains a very convincing surface, and the balanced nuance of subtle, intimate gestures within the scene still works with a compelling beauty."

Of the paintings that I chose for this essay, this is the only one I have not been able to see within the recent past. For that reason (and because I have some of the same nagging doubts about the longevity of the mastic varnish that I used on its surface), I will continue on a bit further, with closing thoughts inspired by a painting that gave me enormous satisfaction while I worked with it, and which, for the moment at least, I can look upon without any lingering concerns.

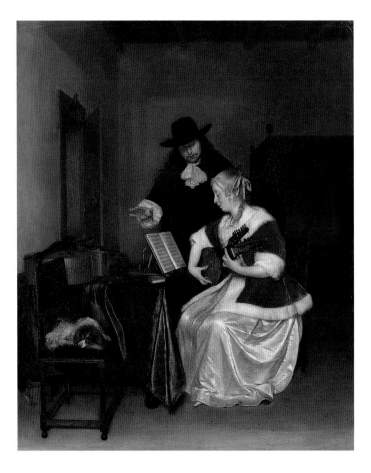

Throughout the development of this essay, I've struggled with a variety of thoughts about the importance of the pictures that I've chosen to include as well as the relative difficulty of the kinds of work each of them required. I found myself wanting to include important pictures that required fairly sophisticated and often difficult treatments. I also realized that my thoughts about the paintings that have come across my easel over the past twenty-five years, as well as my thoughts about my own work on those paintings, have naturally shifted with time. What seems reasonable, correct, or even passionately compelling at one point in time may look very different from a later (and older) perspective. In the future, I will undoubtedly look back upon some of the work that I'm currently doing from yet another vantage point. Nevertheless, it seems appropriate to conclude this essay with a picture that I worked with very recently. This is not to say that I am completely self-satisfied with all of my current work—but there have been moments where all of the variables have come together to allow for (inasmuch as such a thing is possible) achieving a certain level of perfection.

One of the more deceptively simple pictures in the Getty collection is *The Music Lesson* by Gerard ter Borch (fig. 12). I have found myself returning to it in the galleries many times during the course of my work on this essay; even though it may not be among the greatest pictures that I've ever worked on,[6] it is certainly among the most

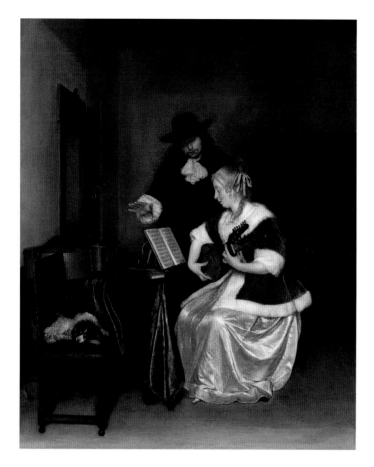

FIG. 13

Gerard ter Borch, *The Music Lesson*.

After treatment.

elegant and refined. Ter Borch's flawless handling of the shimmering effects of light on the textured, quietly dazzling surfaces of the fabrics within the composition gently seduces the viewer to consider the subtle interplay between the two figures as well as the symbolic meanings of the assembled objects within its calm and ordered world. In retrospect, it may be that in this particular case the artist's meticulous perfectionism inspired more than the usual concerted effort on my part to make sure that my own work served to reveal and restore the surface's beauty so that the artist's more subtle messages could be experienced without interruption.

The painting came up at auction in New York in 1997. The Getty was interested in the picture not only because of its captivating character but also because the quality of the handling and the presence of numerous pentimenti suggested that it was the prime version of many variants on the composition.[7] I also felt that the condition of the picture ranked it among the best-preserved examples of Ter Borch's oeuvre. In rereading the condition report (written prior to the Getty's successful bid for the painting) and the subsequent treatment record, I was reminded of how at ease I felt with the picture. My records reflected a balanced synthesis of the technical details of the condition of the painting, the materials that were used during the treatment, and what I hoped would prove to be illuminating descriptions of the underlying motivations for the conservation work.

FIG. 14

Gerard ter Borch,
The Music Lesson.

Framed.

Before the Getty acquired the painting, the clarity, delicacy, and skillful refinements of Ter Borch's handling of the paint were buried beneath an obscuring layer of discolored varnish; there was little doubt that cleaning would restore these qualities to life. As anticipated, the spatial subtleties of the picture became apparent during the cleaning process, and the beautifully preserved nature of the surface was confirmed. Retouching began with routine compensation of tiny losses at the edges, but, more importantly (because of the exceptionally fine nature of the original handling), eventually led to a fair amount of extremely careful and delicate glazing and scumbling of tiny scattered abrasions. These restored a sense of unity to the surface (fig. 13). Because the painting was so well preserved, this type of meticulous yet decidedly light-handed and subtle work had profound results. Restrained retouching of small areas of broken glazing throughout the flesh tones, for example, restored the original impression of sculptural form with which the artist provided a firm foundation for the apparent simplicity of the smoothly modeled surface. Leaving even the slightest break in the final glazes in the flesh tones would have interrupted the perfect illusion of such details as the carefully contrived ballet of hands and forearms of the lute player.

Another satisfying aspect of my work with this picture had to do with the fact that I had fairly recently become comfortable with the use of two new conservation materials: a synthetic, low-molecular-weight varnish[8] that matches the handling and appearance of natural resins (such as mastic) without presenting the threat of future discoloration, and a new material for use in retouching,[9] based upon a similar synthetic resin and manufactured with pigments of exceptional quality and light-fastness. In addition to the optimal stability promised by both of these new materials, they also remain soluble in very mild solvents, so the picture will be protected from the future need for exposure to stronger and potentially damaging solvent mixtures. In this particular case, I felt throughout the course of the treatment that the quality and refinement of the materials that I was able to use were capable of complementing the similarly refined characteristics of the original surface.

When I see the painting in the galleries today (fig. 14), displayed in a very restrained period gilt frame that completes and contains the composition while quietly heightening the sense of luxury displayed within the image, I am able to enjoy, as a viewer, not only the flickering beauty of the brushwork on the surface but also the complex undercurrents of the scene

FIG. 15

Gerard ter Borch,
The Music Lesson.

Detail.

that infuse the image with meaning. It is interesting to note that time and natural aging have combined to change the picture in subtle ways, so that a type of patination of the surface has occurred: the whites may be somewhat muted, and the craquelure (which is as delicate as the original handling) imparts a very real sense of the passage of time (fig. 15). This means, of course, that we can never know how this picture (or any picture, for that matter) looked the day that it left the artist's easel. However, it nevertheless feels balanced and complete, in part because of the fact that the natural "skin" of the original surface has remained intact. When pictures come down to us in comparatively well preserved states, it is often surprising how easily their fragile mysteries can be altered, not only by the interference of time but by the well-meaning hand of the restorer as well. In this case, I think, the restorer's hand has managed to remain in the background, so that the viewer can follow an uninterrupted path to the artist's voice, which, despite the passage of several centuries, still speaks to us directly from a quiet world of perfect order.

Shortly after I had left the Metropolitan Museum and moved to Los Angeles, I returned to New York on a business trip and was visiting the Met with a friend of mine during the installation of a large Van Gogh exhibition. The Met's *Sunflowers* was hanging on the wall, and I wanted to show my companion the back of the picture. I knew it to be unlined and still attached to the original stretcher—because I had cleaned, re-stretched, and restored the picture myself just a few months earlier. I walked over to the wall and gingerly (though of course somewhat presumptuously) turned the picture around to show my friend the interesting things to be seen on the reverse. A curator from the Met came running over and (quite rightly) loudly scolded me to keep my hands off the paintings.

During the writing of this essay, while standing in the gallery and looking at the Gerrit Dou that I've discussed above, I found myself somewhat jealous of the much younger restorer who had a chance to spend some very intimate time with that wonderful picture on his easel, as well as all of the other paintings that I've mentioned here. I won't be having similar experiences with those pictures ever again, and, as such, I feel a kind of loss. But in many respects this feeling signifies achievement of a certain degree of success in the treatments: the restorer's hand has become invisible even to the restorer himself, and the paintings have moved back into their own worlds. Works of art, like children, students, friends, and lovers, eventually leave our lives and continue upon their own roads. We've simply been privileged caretakers along those paths.

NOTES

1. John Brealey, "Who Needs a Conservator?" *Training in Conservation: A Symposium on the Occasion of the Dedication of the Stephen Chan House* (Institute of Fine Arts, New York University, 1983), p. 40.

2. Beverly Louise Brown, ed., *The Genius of Rome, 1592–1623*, exh. cat. (London, Royal Academy of Arts, 2001), January 20–April 16, 2001.

3. The picture has been re-varnished in the intervening years, and there may have been some minor corrective retouching carried out, but the 1983 restoration, to the best of my knowledge, remains largely intact as of this writing.

4. Ernst van de Wetering has recently theorized that the image seen in the X-ray is, in fact, a preliminary laying out of the composition by Rembrandt himself, and that the painting was turned over to Dou, an assistant in the studio, for completion. See Ernst van de Wetering and Bernhard Schnackenburg, *The Mystery of the Young Rembrandt*, exh. cat. (Amsterdam, Museum het Rembrandthuis, 2001), pp. 324–31.

5. Tinuvin 292, a hindered amine light stabilizer, was added to the varnish at 3 to 4 percent of the weight of the mastic resin. See E. René de la Rie, "Photochemical and Thermal Degradation of Films of Dammar Resin," *Studies in Conservation* 33 (May 1988), pp. 53–70.

6. I surprised myself during the course of the treatment of Ercole de' Roberti's *St. John the Baptist*, from the Picture Gallery of the Staatliche Museen, Berlin, by finding myself saying that, despite its diminutive size, its astonishing, idiosyncratic power and presence made it the greatest painting that I had ever been given the chance to work with.

7. Other notable examples are at the Art Institute of Chicago and the Isabella Stewart Gardner Museum in Boston.

8. Regalrez 1094. For a full bibliography, see Jill Whitten, "Low Molecular Weight Resins for Picture Varnishes," *AIC Paintings Specialty Group Postprints* (The American Institute for Conservation of Historic and Artistic Works, 1995), p. 124.

9. Gamblin Conservation Colors. See Mark Leonard, Robert Gamblin, E. René de la Rie, and Jill Whitten, "The Development of a New Material for Retouching," *Tradition and Innovation: Advances in Conservation* (The International Institute for Conservation, Melbourne, October 2000), pp. 111–13.

Ravished Images Restored

JØRGEN WADUM

I
n 1918 the then-director of the Mauritshuis, Willem Martin, wrote, "The cleaning of frequently treated paintings is often an unappreciated task, and, as a rule, the last restorer is accused of being the one who over-cleaned the painting."[1] I would add that, on the other hand, if a restoration is successful and the stripped condition is not publicized, no one will recognize the conservator's work!

This situation could also be seen from a different viewpoint, as illustrated in the following anecdote: A surgeon and a restorer are comparing success and failure within their respective professions. The restorer concludes that the surgeon is in a much better position. Why? Because if the surgeon has a grave failure, his mistake will be put two feet under the ground. If the restorer, however, carries out a bad treatment, it will be put on display and remain open to derision and mockery for many years to come.

It might be interesting to evaluate the values represented by these stories. They have their origins in a time when the restorer had a different reputation compared to today's conservator-restorer.[2] They represent a period just prior to the big leap forward in terms of technical research of painting components as well as conservation materials. The "surgeon of paintings" was still regarded as a craftsman, albeit one who was gradually gaining recognition and value in the community for his role in caring for and keeping the cultural heritage for the future (fig. 1).

It is often true, even today, that when a conservator is considering carrying out a treatment of a painting, the first question that springs to mind is *how* to do it. This question is the key issue for the conservator, arising out of the need to *keep* an object. Questions such as *what* should we preserve, *why* do we choose to preserve particular objects, and for *whom* do we treat the objects are challenging concepts with which a paintings conservator may not often trouble himself. I feel, however, that I should try to address these questions. My answers will naturally be influenced by the Western culture in which I am immersed and may not seem entirely appropriate, given that cultural objects are increasingly seen as elements within an international context rooted in cultural diversity.

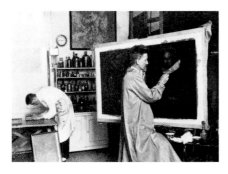

I believe we need to view our work as being more than just a matter of preserving material and structure. Conservation also encompasses the preservation of nontangible cultural qualities and an array of information. The exhibition of objects is not just a matter of putting them on display. We should be guided by an obligation and responsibility to consider what the object *was*, how it may have *changed,* and how it may *continue* to change.

We must realize that we have the objects in our care only temporarily and will hand them over to new generations whose caretaking will be guided by their changing values. Our clients, the museum visitors and scholars, are, in increasing numbers, coming from cultural backgrounds different from those in which the objects were created. Visitors may also not be able to identify with objects that are more than a couple of hundred years old, and the lack of historical knowledge among younger generations places the work and role of the museum and its conservator in a crucial new context.[3] Are we not approaching a situation in which we are not only treating and caring for the objects but also serving as an important link between the objects and the public?

The crossroad between treatment (*how* and with *what*) and the visual, aesthetic result (*why* and for *whom*) is the focus of my presentation. I will not dwell on *how* I conserve or restore paintings in the Mauritshuis; instead I will consider the impact of a treatment on an object. The alteration of a well-known or long-appreciated message of a painting may reshape our understanding of the past. A growing degree of professionalism, coupled with our collaboration with highly specialized conservation scientists, is forcing us to realize that our impact on objects, and the various consequences, is indeed our responsibility.

Conservators at large have a much more visible function in present-day museums and cultural sectors than ever before. Due to the gradual changes in attitude, especially in the last half of the twentieth century, their methodology is no longer hidden behind a veil of mysticism and alchemy.

Research into materials, their utilization, and artists' techniques have given the modern multidisciplinary-minded conservator new insight into past methodology and artistic technology. We are a part of a global society, which is focusing on the sustainability of our multicultural heritage (fig. 2). Boundaries between previously well-defined approaches are slowly breaking down as information becomes more abundant and more accessible. The numerous conservation publications, greater participation at professional conferences, and our ability to communicate our ideas instantly across the world influence consensus of methodology.

Does this mean that we are no longer children of our own local cultures and restoration fashions, and that we have adopted universal standards and ethics in our work? Is it still valid to talk about an Anglo-Saxon versus Latin approach to treatment when we compare our current practice with how it was managed half a century ago?[4] Case histories of four restoration treatments in the Mauritshuis will help explain some of these current concerns and attitudes.

THE ANATOMY LESSON OF DR. NICOLAES TULP

The first case pertains to a painting by Rembrandt painted in 1632, *The Anatomy Lesson of Dr. Nicolaes Tulp* (fig. 3). During the most recent treatment of this painting, in 1997 to 1998,[5] a particular problem warranted careful consideration: alongside each of the heads are light gray numbers, approximately 10 to 13 mm high, which correspond to the numbered names on a sheet of paper held by one of the background figures (fig. 4).

The names reveal the identity of the surgeons depicted in the painting. It was apparent that part of the lettering of the names had been reconstructed with black paint in the previous restoration in 1951. The remains of an old inscription—in gray—could be discerned beneath the reconstruction. Below the inscription is an anatomical drawing in gray paint; Rembrandt had drawn the muscles of an outstretched left arm and, above it, that of a bent arm. Alongside are short, narrow parallel lines that indicate accompanying illegible text.

A number of questions became relevant before a treatment proposal could be formulated: Should the old inscription and the reconstructed one remain untouched? Should both of them be removed or obscured if the old inscription proved to be a later addition that conflicted with the artist's intention (whatever this may have been!)? Or, should the reconstruction be removed in order to reveal and preserve the old inscription as historical evidence. The extent to which the old inscription would obscure the anatomical drawing could be assessed only after removing the reconstructed one.

FIG. 3

Rembrandt Harmensz. van Rijn (Dutch, 1606–1669). *The Anatomy Lesson of Dr. Nicolaes Tulp*, 1632. Oil on canvas, 169.5 × 216.5 cm (66¾ × 85¼ in.). The Hague, Royal Cabinet of Paintings Mauritshuis, inv. no. 146.

After treatment in 1998.

FIG. 4

Rembrandt Harmensz. van Rijn, *The Anatomy Lesson of Dr. Nicolaes Tulp*.

Detail, before cleaning. The papers in the hand of one of the figures in the background show the names of the depicted surgeons.

The literature indicates that both inscriptions were of a later date, probably from the early eighteenth century. According to *A Corpus of Rembrandt Paintings*, which contains the most extensive and recent description of the painting, the spelling of the names are "Blok" instead of "Block" and "Kalkoen" rather than "Calkoen," which "points to an origin no earlier than the last quarter of the 17ᵗʰ century."[6] It was important to find more secure evidence for dating the inscription.

Study of samples of the paint-layer buildup on the numbers of *The Anatomy Lesson of Dr. Nicolaes Tulp* showed that it was possible to substantiate their later application. In the cross-section, the presence of a varnish layer between the background paint layer and the paint of the numbers proved that the numbers were added after the painting was completed and varnished. Under long-wave ultraviolet illumination, the varnish layer was seen to fluoresce strongly, indicating considerable oxidation had taken place before the numbers were added on top.[7]

It has been recorded that the Surgeon's Guild's newly appointed heads of 1732 reputably had great affinity for the past and regarded the early anatomy paintings as important memoranda. They may have suggested to the restorer who treated the entire collection in 1732 that he add the names on *The Anatomy Lesson of Dr. Nicolaes Tulp*.

Obviously, Rembrandt had painted the anatomical drawing to be viewed by the commissioner and his colleagues at the Surgeon's Guild chamber and it was not his intention for it to be obscured by an inscription. This inscription, moreover, violated the spatial illusion within the painting. In the lower right corner of the painting, a large open book displays an illegible text. Similarly, in the background of the composition, Rembrandt indicated the text on the anatomical drawing with only a few gray lines. Rembrandt also employed this method of rough suggestion on the scroll hanging on the wall in the far background.

In contrast, the clearly legible reconstructed names on top of the anatomical drawing visually protrude into the foreground, confusing the interpretation of illusory depth within the painting. Apart from making the painting appear flatter, the inscription distracts the spectator from the splendid tour de force of space in Rembrandt's innovative composition.

After excluding the possibility that the inscriptions were either added or approved by Rembrandt himself, the cleaning commenced. The black paint used by the restorer J. C. Traas in 1951 was easily recognizable as later paint flowing over the age cracks in the earlier inscription and the original paint below. It was also easily soluble. After removal, the old inscription was found to be vague and so fragmentary that it allowed the anatomical drawing once more to be seen.

Due to the fragmentary character of the original eighteenth-century "calligraphy," we could not, even if we had chosen to do so, reconstruct the names without much subjective interpretation. Rembrandt's group portrait would perhaps have been in danger of becoming a messenger of history, rather than a work of art.

Usually, paintings with similar later additions or inscriptions are not as aesthetically compromised as *The Anatomy Lesson of Dr. Nicolaes Tulp*. Rembrandt's anatomical drawing is, moreover, essential for the iconographic reading of the painting. It indirectly refers to the theories of the Brussels doctor Andreas Vesalius (1514–1564), a surgeon who had almost eliminated the division between theory and practice. He was the first professor *anatomiae* to carry out dissections himself, instead of having

an assistant do so. In 1542 Vesalius had himself portrayed (for the frontispiece of one of his publications) demonstrating the tendons of a lower arm (fig. 5). This image is taken up in Rembrandt's group portrait, possibly suggesting Dr. Tulp to be a new Vesalius, a *Vesalius redivivus*.[8] Dr. Tulp's left hand is not just caught in an expressive gesture—Tulp is actually demonstrating how the retraction of the tendons makes the fingers of the dissected left hand bend. The anatomical drawing of an arm therefore refers to the anatomy "theory" being put into practice, as does the book in the foreground. Also, the prevailing notion of the righteousness of manual work, where the arm and hand were seen as the visible proof of God's presence in man, was an important message to the beholder of the picture. The merging of theory and practice is personified in the depiction of Dr. Tulp performing a dissection while lecturing. The figure holding the anatomy drawing looks directly at the viewer, which further emphasizes the situation's significance.

To reveal the anatomical drawing, and thereby restore the spatial illusion and iconography within *The Anatomy Lesson of Dr. Nicolaes Tulp*, the decision was made to not reconstruct the eighteenth-century inscription. Instead, the fragments of the names and numbers were slightly subdued with watercolor for the benefit of the overall composition (fig. 6). The numbers beside the figures are intact but not distracting and were therefore left untouched.

FIG. 5

J. S. von Kalkar (German, 1499–ca. 1546). *Portrait of Andreas Vesalius*, 1542. Woodcut, 19.6 × 14.5 cm (7¾ × 5¾ in.). From A. Vesalius, *De Humani corporis fabrica, Libri septem, ed. princeps* (Basel: Joannes Oporinus, 1543).

FIG. 6

Rembrandt Harmensz. van Rijn, *The Anatomy Lesson of Dr. Nicolaes Tulp*.

Detail, after cleaning. Anatomy drawings of an arm now prevail over fragments of the early eighteenth-century text.

We are aware that, as a consequence of our decision to not reconstruct the early-eighteenth-century inscription as previous restorers had done, this part of the painting's history is no longer directly perceptible.[9] However, we believe we have done justice to Rembrandt and, at the same time, to the painting's history. The fragments of names and numbers are preserved as they were after the cleaning in 1951. Future conservators may, if they wish, reconstruct what was added one hundred years after Rembrandt painted *The Anatomy Lesson of Dr. Nicolaes Tulp.* For the first time in more than two and a half centuries, we have the opportunity to see the painting closer to Rembrandt's plan—as the surgeons would have seen it when it was placed on the wall of their guild house in 1632.

DIANA AND HER COMPANIONS

The next example I would like to present concerns a recent relining and restoration of *Diana and Her Companions,* painted around 1655 by Johannes Vermeer of Delft (fig. 7).[10]

The passing of time has had a much more intriguing influence on *Diana and Her Companions* than on *The Anatomy Lesson*. Written accounts of the painting are naturally all products of what individuals at a certain moment in history were able to perceive when standing before it. This experience must be understood in relation to the skill of the individuals to isolate themselves from the influence of time. If we are not aware of what age and a multitude of treatments can do to obscure our ability to observe accurately what is really there, entirely wrong conclusions may be drawn.

The painting was first described in the nineteenth century, when it carried the signature "N. Maes." At that time, it was noted how clearly one could see Rembrandt's influence on his pupil in this history painting. The painting was called one of Maes's masterpieces dating from the 1650s.

In 1876, much to his distress, the director of the Mauritshuis, J. K. J. de Jonge, had to accept the acquisition *Diana and Her Companions*. During the previous sale of the painting, he irritably wrote in his personal copy of the auction catalogue: "Over-painted piece! Paid twice too much." Shortly thereafter, it was noted in a Mauritshuis catalogue that "although the colouring is not bad, all the lines have disappeared. This important painting has suffered very much."[11]

The painting remained known under the name of Maes until the 1885 lining and cleaning, when it was documented that the signature actually was secondary and covering that of "IV Meer" (IV interlaced).[12] It was suggested that the author could be Johannes Vermeer of Utrecht; however, since the large *Christ in the House of Mary and Martha* (Edinburgh, National Galleries of Scotland)[13] surfaced, our painting has been listed as a Vermeer of Delft. Hofstede de Groot mentions that the best-preserved area of the painting is where the three strong colors yellow, red, and blue meet. Apart from this, the painting has suffered seriously from cleaning.[14]

Only a few historical documents in the archives of the Mauritshuis refer to its conservation or restoration treatments.[15] Nevertheless, the result of Traas's cleaning in 1952 must have been quite revealing to the art world. Thick layers of yellowed varnish and old over-paint had been removed to reveal stunning colors. This treatment,

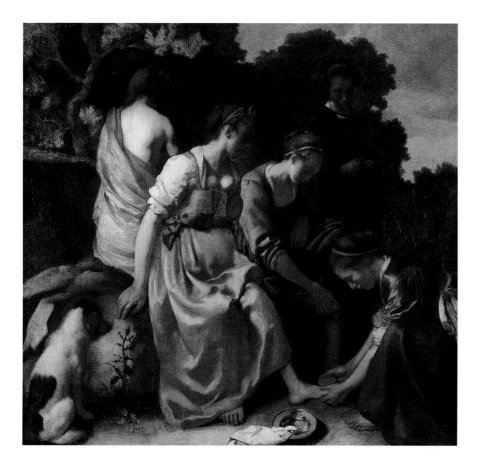

FIG. 7

Johannes Vermeer
(Dutch, 1632–1675).
*Diana and Her
Companions*, ca. 1655.
Oil on canvas, 97.8 ×
105.5 cm (38½ ×
41½ in.). The Hague,
Royal Cabinet of
Paintings Mauritshuis,
inv. no. 406.

Before conservation
and restoration.

where large areas of green over-paint of the landscape were removed, wiped away the remaining doubts of more than one scholar concerning the painting's authorship.

In 1987 Albert Blankert published the first X-radiograph of the painting.[16] This X-radiograph revealed that the right edge of the painting had no cusping, suggesting for the first time that the painting had been trimmed on this side. This proposition was fully confirmed during the recent conservation treatment. After removal of the lining canvas, the reverse of the original canvas revealed a very early over-paint of the back, painted while the canvas was still on its original strainer. It could be deduced that the original strainer bars were approximately 3 to 4 cm in width and that there had been a vertical bar in the middle and crossbars in the corners. Only the very beginning of the diagonal corner bars is faintly visible on the right side, and it could be calculated that approximately 12 cm had to be added to the width of the present, more square canvas in order to reach the original size of about 97 by 117 cm (38¼ by 46⅛ in.).[17]

A short technical description of the work in the recent catalogue of historical paintings in the Mauritshuis points out that the sky was frequently over-painted but showed a dark underpaint visible in cracks and abraded areas.[18] The recent treatment provided us with an opportunity to reexamine the sky in greater detail than ever before. Since the 1980s, it has been argued that this layer of dark underpaint

probably was inspired by Italian influence on Vermeer. The presence of a seemingly comparable dark underpaint below the ultramarine-blue sky in a painting of St. Praxedis (private coll., U.S.) has been used as a strong argument for attributing that painting to Vermeer.[19]

A cross-section shows a ground layer, followed by a thin, dark undermodeling layer, a dark, brownish paint layer with lots of glassy particles, and a light-blue paint layer with a fine, dark-blue pigment. Under UV light, one can distinguish a thin, strongly fluorescent layer between the brown and the blue layer. This suggests a resinous layer, possibly a varnish. Discovering a varnish below a top paint layer may in some cases be a strong indication that the layer (or layers) above could be later additions. Could it really be possible that the blue sky in this Vermeer painting was not original?

The small particulate blue pigment was subjected to thorough analysis by scientists of the Dutch Institute for Cultural Heritage. The blue was unambiguously identified as Prussian blue, which was not available to painters until the early eighteenth century.[20] Furthermore, the dark-brownish paint in the left part of the background showed the same composition of characteristic glassy particles found below the Prussian blue sky. This allowed only one conclusion: the sky in the background had never been anticipated by Vermeer, and the dark layer below the blue sky was in fact the original (top) paint layer.

Now we were facing a difficult problem. What should we do with a sky that was definitely not original and therefore completely at odds with the artist's intention? Removing the blue paint was one option. However, a tough, cross-linked layer of oil paint on top of a very vulnerable and damaged original paint layer would in this case have involved using powerful solvents or saponifying the oil binder. Removing the added sky would be an ultimate decision and would make sense only if the remains of the original paint would then give us enough clues to carry out a reliable reconstruction of the background by means of retouching.

To facilitate the decision making, a scanned image of the painting on a computer screen was manipulated, and the nineteenth-century sky was eliminated. Viewing this image was very revealing, and the positioning of the figures in space and the play of light became more harmonious and logical. The painting appeared to fit in much better with the early works by Vermeer, for example, the Edinburgh picture *Christ in the House of Mary and Martha*, with its closed, dark background.

After long discussions, we decided to integrate the blue sky into the dark background by covering it with a neutral color of acrylic paint (fig. 8).[21] This current overpaint is believed to be more satisfactory to the aesthetics of the painting, more in line with what we believe Vermeer wanted—although a full addition of the missing 12 cm on the right would have made the illusion complete. This latter step has been carried out only in a digital medium.

The average visitor to the Mauritshuis probably does not realize that *The Anatomy Lesson of Dr. Nicolaes Tulp* and *Diana and Her Companions* present images that have changed considerably in appearance within the last few years. The brightness of colors and the readability of form were not the only aspects improved by the treatments. The intellectual message in Rembrandt's picture was clarified, and the work tells a story that can be interpreted and presented to the public.

FIG. 8

Johannes Vermeer,
*Diana and Her
Companions*.

After treatment.

Vermeer's picture underwent a metamorphosis that gives it a completely different position and place within the artistic context where it was produced.

PORTRAIT OF A WOMAN AND PORTRAIT OF THE YOUNG REMBRANDT

The last two examples are concerned with different problems and aspects that, in terms of my personal appreciation of my own work, represent a less-successful management of treatment!

Attributed to Rubens, the *Portrait of a Woman [Helena Fourment?]* (fig. 9) was due for a cleaning, and I embarked on it with great interest in 1993. It was known that large changes had taken place, including over-painting of the woman's dress. As revealed by the X-radiograph and confirmed by means of IRR [infrared reflectography], her original white dress appeared to have been transformed into an open black shirt, a stoat had been placed over the lace around her neck, and a plumed beret had been added over her pearl-adorned hair. The original appearance was in fact very close to the splendid *Portrait of Catherine Manners* (London, Dulwich Picture Gallery).[22]

From a technical viewpoint, the cleaning was expected to be straightforward. There was no consideration of removing the alterations, as they were universally

regarded to have been done by Rubens himself. Apart from cleaning the image, the emphasis was to be put on the description of all the pentimenti, eventually reconstructing the painting's original appearance on a digital format. The public was going to love this puzzle!

During varnish removal, however, part of the over-paint seemed to be soluble, and action was put to a halt. Scientists were called in to assess its solubility and analyze the blue color on the sitter's right sleeve. Although not at all evident, this sleeve had been changed at the same time as the rest. Analysis showed that the sleeve was altered with Prussian blue.[23] The painting, having a provenance from the well-respected eighteenth-century Slingelandt collection, had apparently been modified or over-painted during or after its inclusion in this collection.[24] From an art history standpoint, this was most surprising.

While we were investigating the over-paint, a black-and-white photograph of a lost early copy of our painting surfaced (fig. 10). This painting would probably have been made after the Mauritshuis panel, but none of the additions could be seen in it before these were added. The sitter in this copy is not Helena Fourment, although it traditionally was assumed to be her.

The presence of lead white in the plume in the beret confirmed that we were confronted with an early-eighteenth-century over-paint. The paint's adhesion to the layer below was excellent, and separating the white paint from the ocherish color below it would be a very risky endeavor.

The partially cleaned painting became the focus of a new discussion: Could we be 100-percent sure that *all* the changes were done in the eighteenth century? If so, should we remove those changes in order to return the painting to the appearance Rubens intended? There were technical difficulties in exercising a complete removal of the over-painted or modified areas. However, solutions could be sought.

In the meantime, renewed efforts to identify the sitter were launched. They led to the conclusion that the lady certainly did resemble Helena Fourment, Rubens's second wife; however, it was not she but an unidentified individual probably from within the circle of the Brussels Court.

Naturally, the painting's status declined at that point—but it declined much more so when doubt about its authorship arose. Scholars on Rubens expressed strong reservations about whether Rubens had had any part at all in this painting. Others articulated the possibility that a Rubens portrait of an anonymous lady lay hidden beneath the over-paint.[25]

A general sense of doubt regarding the artistic value of the picture also sapped the conservators' enthusiasm about resolving its technical problems, and the importance of the treatment fell to zero. Today, the partly cleaned painting sits in the studio cupboard. It will eventually get its cautious cleaning of yellowed varnish, but we will leave the over-paint as is. The continued treatment will commence as a low-priority project when time allows. Until 1993 the painting was part of the permanent collection, and its simple but charming appearance pleased visitors. Gone from the scene, it appears not to be missed. It is highly likely that even after treatment the painting will remain in storage.

This example illustrates how a painting's change in importance influences its treatment. The *Portrait of the Young Rembrandt,*[26] which was formerly attributed to Rembrandt as *Young Self-Portrait,*[27] underwent a similar shift. Still on display, but now with the attribution "anonymous after Rembrandt," the painting will probably have to wait a considerable period before time is allotted to its aesthetic treatment—although in my view treatment is strongly needed. Furthermore, the treatment most certainly would reveal information that would enable us to place the painting better in time and space than our current guesswork has succeeded in doing.

CLOSING REMARKS

I was educated as a conservator in Copenhagen in the late 1970s and early '80s, after the Greenwich Lining Conference in 1974[28] and with the low-pressure lining table as the only acceptable option—if paintings had to be lined at all. This may be illustrated by only two relinings having been executed during the past eleven years that I have been in charge of the physical well-being of the Mauritshuis collection. I was, however, influenced by a generation of teachers and instructors who argued for the preservation of paintings as historical or archaeological objects. The accumulated information carried by the objects should be extracted, but the passing of time should also remain visible (for example by neutral retouching of lacunae).[29] Later additions would in many cases be left untouched.

My presentation here today reflects the results of a somewhat different approach. The image prevailed over the object. Within the culture of which I am a part, this

FIG. 11

Restoration in
public during the
"Vermeer Illuminated"
project, The Hague,
Mauritshuis, 1994–95.

approach has in many quarters been gaining preference. Will other cultures, however, agree with this attitude? Will future generations follow the same direction or will their task be to reverse our actions in order to reach a new relationship with the images or objects? Have we succeeded in sufficiently explaining *why* we did what we did? Should we spend more time communicating not only with related professionals (such as scientists and art historians) but also with the public?

Should we measure a successful restoration on its public impact and the level of communication and explanation offered to the community at large? If the public understands why and for what reason we as conservators take action, we may claim success in keeping and treating "their" heritage the way we do. The "IIC Keck Award" is one step in the direction of stimulating information transfer. Several museums have in the past decennia devoted their Internet home-pages to the dissemination of conservation campaigns.

The issue of conserving our cultural heritage should always be on the agenda. Within the museum community it is the ambition of the International Council of Museums' Committee for Conservation (ICOM-CC), an international organization networking professionals committed to the conservation and restoration of the world's museum collections, to play an active role. Not only is ICOM-CC facilitating knowledge exchange among museum professionals, in the future it could also become the museum world's window or portal for the community in conservation issues. In this respect, it is noteworthy that ICOM's 20th General Assembly in Barcelona ". . . urges ICOM to stimulate the dissemination of information on the fragility of our heritage and activities which promote public awareness of conservation activities."[30] One could speculate that ICOM-CC, eventually with some of its partners in conservation, could instigate the creation of a worldwide televised "Conservation Channel," which would make an interesting addition to the existing Discovery or National Geographic channels.

In any case, the paintings I described above that are kept in the Mauritshuis are not 2 feet below ground but are preserved and presented to the public (fig. 11)—for mockery or enjoyment.

ACKNOWLEDGMENTS

Apart from my own reflections, in this paper I have made use of material recorded by or discussed with my colleagues in the Mauritshuis Conservation Department: Caroline van der Elst, Ruth Hoppe, Elmer Kolfin, Petria Noble, and Carol Pottasch. For suggestions and editing of the text I am indebted to Janet Hawley, Basel.

NOTES

1. Willem Martin, *Alt-Holländische Bilder* (Berlin, 1918), pp. 154–55.

2. Throughout this essay, the word "conservator" always signifies "conservator-restorer" as laid out in "The Conservator-Restorer: a Definition of the Profession," adopted by the ICOM [International Council of Museums] Committee for Conservation, Copenhagen, September 1984.

3. See also Beate K. Federspiel, "The Definition of the Conservation Profession and Its Field of Operation: Issues in the 21st Century," in *Past Practice — Future Concepts*, International Conference, British Museum Occasional Paper no. 145 (London: British Museum Press, 2001). I am grateful to the author for letting me read her manuscript prior to the conference.

4. A roundtable discussion between Mark Leonard, Brian Considine, and Jerry Podany (see "Finding a Certain Balance: A Discussion about Surface Painting," in *Conservation, The Getty Conservation Institute Newsletter* 15:3 [2000] also noted this change. See also Gerry Hedley, "Long-Lost Relations and New-Found Relativities: Issues in the Cleaning of Paintings," in *Measured Opinions: Collected Papers on the Conservation of Paintings by Gerry Hedley* (London: United Kingdom Institute of Conservation, 1993), pp. 172–78.

5. See Norbert Middelkoop, Petria Noble, Jørgen Wadum, and Ben Broos, *Rembrandt under the Scalpel: "The Anatomy Lesson of Dr. Nicolaes Tulp" Dissected* (The Hague/Amsterdam, 1998), for a thorough description of the painting, its history, and recent treatment.

6. J. Bruyn, B. Haak, S. H. Levie, P. J. J. van Thiel, and E. van de Wetering, eds., *A Corpus of Rembrandt Paintings*, vol. 3 (Dordrecht/Boston/Lancaster, 1989), p. 182.

7. Karin Groen, *Research Report for the Mauritshuis*, internal report, Dutch Institute for Cultural Heritage [ICN], Amsterdam, 1998.

8. See Middelkoop et al. (note 5).

9. This issue was recently discussed by Jørgen Wadum and Petria Noble, "Is There an Ethical Problem after the Twenty-third Treatment of Rembrandt's *Anatomy Lesson of Dr. Nicolaes Tulp*?" in *Preprints of the 12th Triennial Meeting, Lyon, 29 August–3 September 1999*, eds. Janet Bridgland and Jessica Brown, ICOM Committee for Conservation (London: James and James, 1999), pp. 206–10.

10. Ruth Hoppe and Carol Pottasch carried out the treatment during 1999 to 2000. I am grateful to them for allowing me to use their documentation and part of an unpublished lecture by the aforementioned in collaboration with Elmer Kolfin, "The Transformation of an Early Vermeer: *Diana and Her Companions* Restored," at the Thirteenth International Congress of the History of Art (London, September 3–8, 2000), Section 19, "The Patina of Time." See also Elmer Kolfin, Carol Pottasch, and Ruth Hoppe, "The Metamorphosis of Diana: A New Interpretation of the Young Vermeer's Painting Technique," in *ArtMatters: Netherlands Technical Studies in Art* (Zwolle, The Netherlands, 2002), pp. 90–103.

11. Archive Mauritshuis.

12. Ben Broos, *Intimacies & Intrigues: History Painting in the Mauritshuis* (Ghent/The Hague, 1993), pp. 306–14.

13. Inv. no. 1670.

14. C. Hofstede de Groot, *Beschreibendes und kritisches Verzeichnis der Werke der hervorragendsten holländischen Maler des XVII. Jahrhunderts.* Esslingen a.N./Paris, 1907, p. 588 ("Der besterhaltene Teil des Bildes ist die Stelle, wo die drei starken Farben gelb, rot und blau zusammentreffen. Im übrigen hat es durch Putzen stark gelitten.").

15. One document is an invoice by the restorer Hopman, who lined the painting in 1882. The others consist of a few black-and-white photographs and a short description of a cleaning treatment carried out by the restorer J. C. Traas in 1952, more than 75 years after the acquisition of the picture.

16. Albert Blankert, John Michael Montias, and Gilles Aillaud, *Vermeer* (Amsterdam, 1987), p. 171.

17. Three other paintings by Vermeer have this standard size: *View of Delft* (Mauritshuis, The Hague), *Allegory of Painting* (Kunsthistorisches Museum, Vienna), and *Allegory of Faith* (Metropolitan Museum of Art, New York).

18. Broos (note 12), p. 309.

19. Arthur K. Wheelock, Jr., *Vermeer & the Art of Painting* (New Haven and London, 1995), pp. 25, 34.

20. A sample from the peculiar green residues in the background comprised chrome green, which did not come in use until the beginning of the nineteenth century. These results give a tentative

date for when the background and the sky were over-painted. Analysis carried out by Karin Groen, Dutch Institute for Cultural Heritage (ICN), 1999.

21. Caroline van der Elst, of the Mauritshuis, The Hague, performed this tonal cover-up of the secondary sky.

22. Peter Paul Rubens (Flemish, 1577–1640). *Portrait of Catherine Manners, Duchess of Buckingham (?)*. London, Dulwich Picture Gallery, inv. no. 143.

23. Karin Groen, "Verslag van het onderzoek aan P. P. Rubens, portret, vroeger 'Helene Fourment' geheten, inv. nr. 251," *Central Laboratorium* (now the Dutch Institute for Cultural Heritage), 1997, no. 96.288.

24. For the provenance, see *Portraits in the Mauritshuis,* coll. cat. (forthcoming).

25. Oral communication with E. Begemann, A. Balis, and N. Van Hout.

26. Royal Cabinet of Paintings Mauritshuis, The Hague, inv. no. 148.

27. See *Rembrandt by Himself*, exh. cat. (National Gallery, London, and Mauritshuis, The Hague, 1999), pp. 112–17; and Jørgen Wadum and Caroline van der Elst, "Attribution et désattribution: Les portraits de Nuremberg et de La Haye," *Dossier de l'Art* 61 (1999), pp. 34–43.

28. *Conference on Comparative Lining Techniques,* Greenwich, London, 1974.

29. See A. & P. Philippot, "Le problème de l'intégration des lacunes dans la restauration des peintures," in *Bulletin de l'Institut royal du Patrimoine artistique* (IRPA/KIK), 2 (1959).

30. Resolution no. 4, unanimously adopted during the 20th General Assembly of ICOM (International Council of Museums) meeting in Barcelona, Spain, on July 6, 2001.

Comments

PHILIP CONISBEE

*Response to the papers of Mark Leonard and
Jørgen Wadum*

I am one of those who came to the history of art
more through a schoolboy passion for art than
an interest in history, although subsequently as an
art historian I have had no problem reconciling
those two approaches. Once, I fancied I would be an
artist, but it is many years since I raised brush to
canvas. I have dabbled in printmaking, and the prac-
tice of etching and aquatint has put me all the more
in awe of Rembrandt and Goya. In my first weeks
as an undergraduate at the University of London's
Courtauld Institute of Art, I was taught by Stephen
Rees-Jones, Sr., that "a painting is a three-dimensional
object." If you add the effects of time, it can, in a
sense, be seen even as four-dimensional. In a model
course, which made an indelible impression, we
learned the basic terminology of a picture's structure,
from the support on up to the varnish, and we tried
out some fundamental techniques, such as applying
gesso, laying down gold leaf, manipulating pigments
in oil, and so on. I believe that all art history students
should learn about the physical makeup of the objects
they study.

I have spent the first half of my career as a univer-
sity professor and the second half working in three
great American museums. In that transition from
the academy to the art museum, public presentation
and issues of conservation have assumed much
greater importance in the way I think about works of
art. Some of my most enjoyably instructive hours have
been spent in the company of conservators and in
their studios, especially at the Museum of Fine Arts
in Boston, at the Los Angeles County Museum of
Art, and at the National Gallery of Art, to name only
the museums in which I have been privileged to
work. No one could have a greater appreciation of
the efforts of our conservators than I, nor take more
interest in collaborating with them.

We have come a long way from the day when John
Ruskin, commenting in 1857 on the restoration work
undertaken in public art galleries, could call them
"places of execution of pictures: over their doors you
only want the Dantesque inscription, *Lasciate ogni
speranza, voi che entrate.*" It is true, of course, that
there are still some alarmist voices out there, and
they can attract more public attention than they
deserve because they have the popular press at their
beck and call. Ruskin's lectures entitled "The Political
Economy of Art" were delivered at the time of the
great *Art Treasures of the United Kingdom* exhibition,
held in Manchester in 1857—the seminal Old Master
loan show, as it turned out—and one supposes his
remarks were stimulated also by what he saw there
on loan from British private collections. Ruskin's
remarks on conservation—we should really say "res-
toration," to better reflect his time and place—are, in
fact, only passing ones in his lectures. They focus
on the issue of over-painting, which Ruskin called re-
painting, and which now has become (thankfully less
invasively) inpainting or the even more innocuous-
sounding retouching. A question for my fellow pan-
elists: Was Ruskin (in a footnote on recordkeeping)
the first to insist that "it would be a great point
gained towards the preservation of pictures if it were
made a rule that at every operation they underwent,
the exact spots in which they have been re-painted
should be recorded in writing"?[1] Of course, Ruskin
was speaking before the convenience of photography
became available to conservators. In our own time,
we might attend to Mark Leonard's suggestion that
conservators record their more subjective responses
as part of the history of the works they treat.

We should recognize that even the conservation
watchdogs and whistleblowers of today have a role to
play, although we would all prefer it were done in
a spirit of well-informed collaboration rather than as
sensational denunciation. I think we can say that,
in informed circles, we have moved on from the rela-
tively recent time when an erudite and highly
respected art historian such as John Richardson could
accuse conservators of being "historically ignorant."

Nevertheless, Richardson's polemical article, "Crimes against the Cubists,"[2] bold as it was in its rhetoric, did a great deal of good in stimulating widespread discussion about the use and abuse of relining and, especially, of varnish. It also focused attention on the significance of the matte surface in the history of classic modern painting, not only in the work of the Cubists but from the Impressionists onward to Francis Bacon. The "unvarnished state" is now on the lips of every dealer and curator, along with "original canvas," "original stretcher," "never been lined," "never been touched," "*dans son jus,*" and so on. That's just how we like to receive paintings, which is all to the good. But I have the impression from my own experience that these terms have entered the daily vocabulary of the curator and the conservator only during the last twenty years or so.

Informed collaboration is the key, I think, and I would hope that it is now general practice in museums that a Richardson or a Conisbee talks on a regular basis with a Leonard or a Wadum. I admit at first I found it difficult to develop a response to Mark's and Jørgen's papers because they are so good, so balanced, so well judged, and so right, both as papers and in the final results of their treatments. Who could fault their sensitive treatments of Dou, Rembrandt, Veronese, and Ter Borch, in the case of Mark, or Rembrandt and Vermeer, in the case of Jørgen? We can only admire Mark's awareness of the role his intuition and his "inner voice" play in reaching "the artist's voice." We have much to learn, too, from Jørgen's sense of our time, place, and cultural context in relation to the diverse publics we address. With such degrees of professionalism, it is only proper that conservators play an ever more prominent role in our museums, and have the much more visible function Jørgen describes.

As a curator who works quite closely with his colleagues in the conservation studio (more closely, I have to admit, than with colleagues in the scientific laboratory), I was struck (at least as the two papers were conceived, which I suspect does not reflect Mark's and Jørgen's actual practice) by the solitary nature of their enterprise and the absence of colleagues on the curatorial side. I was reminded of some remarks by John Coolidge, published in 1963: "The essential decision in matters of conservation is a lonely one. The director, curator, or conservator who makes them faces a unique problem and answers it according to his own best judgment."[3] I hope this is no longer the case, and that conservator *and* curator (but, rather rarely, these days, the director) face the problems together and bring their different expertises to bear. Yet I must observe that the only appearances made by curators in today's papers were one of us being instructed by Mark and the other shouting at him not to touch the pictures. Usually it is the conservators who spoil *our* fun, by not letting us borrow things, or making us turn the lights down too low, and so on. So here I would take issue with Jørgen, when he says that "our [the conservators'] impact on objects, and the various consequences, is indeed our responsibility" (see p. 60). Of course, the conservator has very intimate encounters, engaging physically with the works of art, and it is his or her hand that we hope is not visible in the final results. I believe, however, that these "various consequences," which are the results of ethical as well as historical and practical decisions, should be a shared responsibility—that any intervention in the name of conservation is undertaken with the knowledge and cooperation of the curator, who, in most art museums, is responsible for the presentation of the work to the public in the galleries. That is, the hanging, the juxtapositions, the balance of lighting, the accompanying didactic information. These, too, can be collaborations, depending on the staffing of the museum, perhaps with a specialist in lighting, with a designer, with educators—and with conservators. So, no, it is not just the conservator who is the link between the object and the public.

All the curators I know are art historians, some of them very distinguished in their field. But we operate in an area between our academic expertise and the wider world of our public. The paintings in our care are not just historical witnesses—although they

are that—they are also works that we present in such a way as to offer instruction *and* delight to our visitors. The aesthetics of presentation are important considerations, for a variety of reasons. The works of art that have survived the vicissitudes of history and come into our care in museums are part of a continuous present. Put another way, we experience them as contemporary presences, as documents that have reached us through time. Yes, they are witnesses of history and come from specific contexts in times and places that are often remote from ours, physically, intellectually, and emotionally.

As historians of art, we can often go a considerable way to reconstructing a sense of place in the past for works of art, and we can convey that sense to our publics through a variety of means: sometimes in the way we exhibit works of art, but usually through the catalogue, label, brochure, audio tour, and so on. I do not mean to be too sanguine about such enterprises. The melancholy of the matter lies in the incomplete and fragmentary nature of our *recherche du temps perdu*. Mark Leonard also speaks of the sad realization that even the most talented conservator will never fully regain the unknowable past in its physical manifestation: we can never know how a picture would have looked the day it left the artist's easel. To varying degrees, but always to *some* degree, nearly all old paintings have undergone irreversible changes in their passage through time.

Equally, the way a work of art is experienced by the viewer has irreversibly moved away from the original perception of the object in its time and its original context. After Impressionism, for example, we cannot expect to experience the color of a Renaissance painting as it was experienced in the fifteenth century. The object may be there—that is to say, here—but its original condition and appearance are theoretical concepts; the gallery wall in Los Angeles is not the fifteenth-century chapel in Florence. The introduction of artificial lighting has been just one change, but a major change, in how we perceive the art of the past. I make no claims for the novelty of these ideas, but

we still need to bear them in mind, both during this discussion and in our day-to-day practice.

To some degree, the good curator, art historian, or, of course, knowledgeable and well-traveled conservator will be able to supply comparanda to refine the hypothesis of the original appearance. It is then up to our talented conservators to reestablish a unity that gives the viewer visual access to the object as a gestalt, even if they cannot claim complete retrieval of the actual unity the object may once have had, according to that hypothetical original appearance. Thus there is an innate tension—I hope a creative tension—between our aesthetic and our historical awareness of a given work. But I do find encouragement in what seems now to be the widespread acceptance of John Brealey's dictum that "the painting as an aesthetic entity always [be] in the forefront of the conservator's mind,"[4] even though we must recognize the subjectivity involved in imagining that "aesthetic entity." Cesare Brandi, the celebrated Italian theorist, similarly sought the "potential unity of the work of art" as the goal of the conservation process. Mark Leonard, a good Brealeyite, speaks in similar terms.

We have all experienced one of the simplest but also the greatest and literally most illuminating pleasures of the conservator's work: when he or she treats a painting with no inherent problems in the surface or the paint structure and just removes a yellowed varnish. This procedure not only reveals and changes the colors and their relationship in the painting but also transforms the tonal contrasts and quite alters our experience of the third dimension. (The Rembrandt cleaned by Mark is a perfect example; see pp. 48–51.) This certainly increases the readability and "enjoyability" of the painting in any context, not least in the museum. Such a treatment has an aesthetic basis. It is not driven by the necessity to rescue an object under threat, and it doesn't necessarily serve the academic interests of the historian. Some of our European colleagues—conservators and curators alike—will intervene (even if it includes solely cleaning) only

if the life of a work of art is threatened in some way. Our colleagues at the Louvre persist in their refusal to clean their most famous painting, the *Mona Lisa*, usually citing its "perfect condition." But the painting is noticeably dirty, so why not clean it? "Why touch it, if it is in perfect condition?" would be a typical response from the Louvre. If the *Mona Lisa* were in any American museum, the reply would be quite different!

As a curator, with responsibility for the presentation and appearance of works in our galleries, I believe that a museum visitor's aesthetic experience is of great importance. Like most of my American colleagues —including, I would guess, everyone in this room— I regularly recommend the cleaning of pictures for such purely aesthetic reasons. But we should also bear in mind that even the "simple" cleaning process mentioned above (removal of discolored varnish and surface dirt), which so changes the way a painting looks, also changes the way we *experience* it and hence its meaning in time. The aesthetic demands of the museum can impose cosmetic interventions to increase the legibility and pleasure of a work, but we have to acknowledge that the norms we adopt are subjective and variable.

A cautionary note should be sounded here. I can see a conflict with Mark's admirable desire to "let the work of art be (his) guide." Again, I am stating the obvious to this gathering—and Andrea Rothe has already touched on this issue in his paper—but works of art look different in different places. It is certainly our practice at the National Gallery of Art to take a painting whose treatment is nearly completed up into the galleries to see how it looks in its public context. Usually, the curator is there, too. We see the painting in the lighting conditions in which it will normally be viewed, on whatever color wall that gallery has, and in the company of the other pictures around it. I think this is fairly standard practice. After all, the strong lights of the conservation studio can create a very different effect from the subdued lights of the gallery. In the gallery, we might see a passage that is disturbing,

or something the conservator missed. But also we might make some final adjustment—alter a tone here or there or modify a passage that seems too bright.

I am being as honest here as Mark was when he candidly admitted that his own subjectivity, his own "inner voice," often comes into play as he tries to find "the artist's voice." I do wonder how far the gallery context affects our aesthetic decisions in the completion of a treatment. What type of treatment would we undertake for a painting destined to appear under the National Gallery of Art's recently renovated skylights in the West Building, where the galleries can be flooded with natural light, and where our walls (inspired by the stonework of the original Pope building) are generally neutral, light-colored? How would that same painting look in the National Gallery in London, with its strongly colored walls and greater use of artificial light? Or in the diffused natural light at the Getty Museum?

In 1963 Brandi cautioned that a too-radical adaptation of an object to its museum function could fix it irreversibly to the interpretation of one given time and place. Is there a National Gallery, or a Getty, or a National Gallery of Art style? There is a tendency in the conservation and the marketing of American paintings toward a very clean, crisp, bright look. For those of us who exhibit American pictures as well as European ones, is there a pull toward an overall brightness? When we visit a loan exhibition, the contrasts and disparities between works from different institutions can be sobering. To walk through a museum with a conservator never ceases to amaze me, as he or she will identify the handiwork of a colleague—only occasionally with admiration!

Individual works of art are quite affected by the company they keep. This is another old chestnut, but still relevant for our discussion. Andrea Rothe and I are members of an advisory panel for the program of conservation at the Wallace Collection in London. We were both struck by the current appearance of Claude Lorrain's 1660 *Landscape with Apollo and Mercury*,

which was heavily relined in the nineteenth century and cleaned in 1978. In the great gallery of the Wallace, the bright blue of the sky shouted out, from the picture and from the wall. There were two problems: As often occurs in Claude's works, the darker foreground areas of the landscape, especially the green foliage, had considerably darkened over time, forcing the contrast with the sky. In addition, the sky looked very raw in its even, unmodulated blueness—surely glazes or some tonal effects, perhaps in the original varnish, had long been removed in an earlier treatment. Moreover, the Claude was one of the first paintings in that room to have been cleaned in recent times—it contrasted noticeably with the dark, dirty varnishes on either side. (We found a similar problem in the juxtaposition of two works by Murillo, one recently cleaned, the other not.)

Our recommendation was to tone the sky in the Claude a little, to introduce a haze, as it were, because of the discordant appearance of the picture in the gallery. Our colleague Martin Wyld, from the National Gallery, was against such an intervention, and it brought us into a brief and sharp conflict with our late colleague Francis Haskell, on the same panel: "You must let the work speak for itself," Francis insisted with passion. We did not resolve this romantic/pragmatic dichotomy, and moved on to other business, leaving the Claude as it was.

This is not the occasion on which to get drawn into the various debates about "partial" and "selective" cleaning, but of course I am aware of that potentially contentious topic. Moreover, how do we determine the appropriate tone for Claude's sky? A study of existing skies may take us so far, but how do we determine how far to go? The answer would be a judicious balance of historical observation, museum context, and intuition ("inner voice"): in the end, rather subjective. These issues are sensitively discussed by Gerry Hedley in his lecture "On Humanism, Aesthetics and the Cleaning of Paintings,"[5] which deserves to be much better known outside conservation circles.

In a different sense, context surely played a large part in Jørgen's treatment of *The Anatomy Lesson of Dr. Nicolaes Tulp*. It is clear from the catalogue of the exhibition in 1998 devoted to this picture (*Rembrandt under the Scalpel*) that the conservator worked closely with art historians, curators, and scientists. It was the expertise of the historian and the art historian that placed *The Anatomy Lesson* in its historical context, established the identity of the anatomical drawing after Vesalius, and brought out its significance in the context of the portrayal of Surgeon Tulp. Here is collaboration between curator/art historian and conservator at its best, where historical research and scholarship, combined with scientific scrutiny and dexterity of hand, restored both the historical and the aesthetic meaning of a great work of art. Let us imagine that instead of hanging in the Mauritshuis the painting was still in the possession of the College of Surgeons. There it would be among many other individual and group portraits from the sixteenth century down to the present day, many of them likely adorned with identifying names, both contemporary and later accretions. In such a context, is *The Anatomy Lesson of Dr. Nicolaes Tulp* more important as a work of art—and Rembrandt, needless to say, is hardly a name one can ignore—or more important as a messenger of history, as a portrait of guild members at a significant moment in the history of their guild? I don't seriously doubt the answer in this case, but it is a question to ask.

To end: One of Jørgen's observations alarms me considerably, not least because I fear it is true and I agree with it, although I would change one word. Jørgen told us, ". . . museum visitors . . . are, in increasing numbers, coming from cultural backgrounds different from those in which the objects were created. Visitors may also not be able to identify with objects that are more than a couple of hundred years old, and the lack of historical knowledge among younger generations places the work and role of the . . . conservator in a crucial new context. Are we not approaching a situation in which we are not only treating and caring for the objects but also serving as an important link

between the objects and the public?" (see p. 60). Well, much as I admire our north European colleague for volunteering to put his finger in the proverbial dyke, I would simply replace the word "conservator" with the more collective "museum" (which means everyone who works there, from the director on down the hierarchy, all of whom mediate between the objects and our publics) and say that these alarming tendencies in contemporary culture "place the role of the *museum* in a crucial new context." After all, our stock-in-trade is the past—or as I prefer to think of it, the continuous present.

The problem here is the very large one of the whole character of contemporary education, as my colleague Keith Christiansen has said, "with its increasing emphasis on the present over the past, political sensitivity over historical understanding, and a general lowering of cultural awareness."[6] Recent trends in museum education do not help. In the name of anti-elitism, museum educators have been moving away from a historical approach to one that is ahistorical; they have been encouraging a subjective, personal response rather than an under-standing of the history and context the work of art, including its physical construction and the reasons for its present appearance. Yet the value of recognizing the relationship between a painting's physical construction and present appearance has been beautifully explicated by my colleagues in conservation this morning.

NOTES

1. John Ruskin, *The Political Economy of Art* (London and New York, n.d.), p. 96.

2. John Richardson, "Crimes against the Cubists," *New York Review of Books*, 30, no. 10 (June 16, 1983), p. 32.

3. John Coolidge, "Problems of the 19th & 20th Centuries: Studies in Western Art," *Acts of the Twentieth International Congress of the History of Art* (Princeton, 1963), vol. 4, p. 182.

4. John Brealey, "Who Needs a Conservator?" *Training in Conservation: A Symposium on the Occasion of the Dedication of the Stephen Chan House* (Institute of Fine Arts, New York University, 1983), p. 40.

5. Gerry Hedley, "On Humanism, Aesthetics and the Cleaning of Paintings," reprint of two lectures presented at the Canadian Conservation Institute, February 26 and March 5, 1985. I would like to thank Jay Krueger for bringing these lectures to my attention, and to thank him and Rikke Foulke for their assistance with this paper.

6. Quoted by Philippe de Montebello, "The Art Museum's Most Valuable Currency: Curatorial Expertise," *The Art Newspaper*, 115 (June 2001), p. 10.

Panel Discussion

Mark Leonard, Jørgen Wadum, Philip Conisbee, and Ashok Roy,
with comments and questions from audience members

Note: Participating audience members are identified below by their titles at the
time of the symposium

ASHOK ROY: I was struck by the phrase that Mark used in describing treatment reports, which he described as "coldly impersonal documents." As a compiler of coldly impersonal documents myself, I was wondering whether it wouldn't be valuable if conservators did in fact record their thinking as a treatment unfolds.

PHILIP CONISBEE: I couldn't agree more. The subjectivity Mark brought out is something very important to get on the record.

MARK LEONARD: A lot of key things happen when a picture first comes into the studio and scientists and the conservators sit down and look at it.

CAROL MANCUSI-UNGARO: I was interested in what you said, Philip, about sharing of responsibility in the treatment, that it goes between the conservator and the curator and the director. We're often criticizing the restorer who came before us. And I can't help but think that getting in the habit of writing more of the reasons why we're doing something will make us less critical of those who came before us. Conservators are more used to writing about *what* we did rather than *why* we did it. If we move in the other direction we might minimize controversy.

PHILIP CONISBEE: It would be a good idea if the ethical and the historical reasons for doing treatments and, indeed, the cosmetic reasons for doing them were recorded.

BRIAN CONSIDINE *[Conservator, Sculpture and Decorative Arts, J. Paul Getty Museum]*: One thing that we do is to write down the comments of all the visitors to our lab—conservators, curators, dealers, anybody. That adds immeasurably to our understanding and to the record.

PHILIP CONISBEE: That's certainly something we do fairly regularly in the curatorial files.

JØRGEN WADUM: I would like to make a comment on documentation and shared responsibility. Those treatments that I described were carried out only after very long consultations with colleagues from all over the world. Every time there were curators or colleague restorers in our museum, we asked them to come up and give their opinion.

For the restoration of Vermeer's *View of Delft* and *Girl with a Pearl Earring*, the Mauritshuis directory board actually insisted on having a committee that was

gathering three or four times to discuss what the progress would be. We kept records of these meetings so that we could go back and look at what the opinions of the different people involved were.

We are treating many fewer paintings than we used to. We have lined two paintings in the eleven years I have been in the Mauritshuis. We document not only what we do but what the conservators before us did, because there are no records. The whole thing is a detective story and involves documenting three or four generations of treatments before we start approaching what we want to do.

ANDREA ROTHE: I wanted to also mention that in Italy it is the art historian who decides. I didn't mention yesterday in my talk about the Federico Barocci that a decision [about the level of the fills] obviously was made because Cesare Brandi had defined the fact that losses should be lower than the original—not only in Greek vases but also in paintings. The analogy is completely off on this, but it does exist as a theory, and the restorer really had not that much say in it. It would be better if the collaboration could be a very open one, rather than a situation in which one person is in charge who dictates what has to be done. That's where I think many mistakes are made.

DAVID BOMFORD: We should register the fact that there's a great deal of work that conservators carry out which is not at the level that we've been witnessing today. I remember the excitement of a curator at the National Gallery in London who brought out of storage a double portrait by Van Dyck—I mean attributed to Van Dyck—which was totally obscured by discolored varnish. The picture went on my easel, I started to clean it, and within a couple of days the curator said, "Well, that's not by Van Dyck, is it? That's not interesting at all." Meanwhile, I had started—and then had to spend another two years finishing—the painting. The conservator's life is not all glamour and thrilling discovery.

JØRGEN WADUM: On the other hand, there's a great fascination in treating a non-important painting because they are often much more pristine than all these famous paintings that so many restorers before us have treated. You sometimes find so much more about technique, about materials, from looking at how the lesser artists painted. That information can be used to [increase our under-standing of] the greater artist.

JOHN WALSH: There seems now to be a high degree of consensus and even consistency among this group on the practice and thinking about working on pictures. I'm talking about Old Master paintings from the late Middle Ages until the twentieth century. My question is, are there other places in this world where bad things are happening to these types of paintings? Is damage being done? Where is the frontier that separates this seemingly expanding sense of enlightened, informed moderation (or whatever we call the attitudes of today) from what we had so vividly in front of us twenty or thirty years ago, which seems to have retreated in good part in this country? Where is it left?

PHILIP CONISBEE: In the art trade.

MARK LEONARD: I was going to say exactly the same thing.

BRIAN CONSIDINE: I would say also in the environments where there is not the team collaboration, where there is a curator who tells the restorer what to do and the restorer doesn't have access to the analytical services of a scientist. There's a lot of that still going on, even in museums.

ZAHIRA VÉLIZ: There are also a lot of museums in Europe and in other parts of the world where the divide between the curatorial responsibility and the hands-on studio responsibility is just as distant as it has ever been. Within the last twenty years I heard one of the most senior curators in a museum that I will not name pronounce to the assembled conservators, "You are the hands. We are the brain."

I hope that in time some of the great institutions where a collaborative approach doesn't exist will be brought into that sort of international standard of professional operation without sacrificing their local color or history.

JILL DUNKERTON [Restorer, National Gallery, London]: Until the professional status of restorers is raised throughout the world, it's going to be very, very difficult for conservators to work on an equal footing with curators.

MARK LEONARD: I think that this is an issue that you begin to deal with at the undergraduate and graduate level, where people's ideas about their careers have not gelled. If you take that group of people and work with them as a whole from a very early stage, by the time they follow their chosen professional path they're already used to talking with everyone else, and the shared background builds a very strong foundation for future collaboration.

SESSION 3

83 Embracing Humility
in the Shadow of the Artist
CAROL MANCUSI-UNGARO

95 Episodes from a Pilgrimage
ZAHIRA VÉLIZ

104 Comments
SCOTT SCHAEFER

110 Panel Discussion

Embracing Humility
in the Shadow of the Artist

CAROL MANCUSI-UNGARO

"Art is incantation. Like Jacob's ladder, it leads to higher realities, to timelessness, to paradise. It is the fusion of the tangible and the intangible."

So wrote Dominique de Menil in the foreword to the catalogue of the Menil Collection.[1] Coming from a woman recognized for her spirituality and philosophical disposition, the statement could be interpreted solely as a diatribe between the present and the afterlife. However, that interpretation would be a disservice to a human being who deeply appreciated art and innately knew that, although the artist may work with paint, canvas, and wood, his immaterial achievement—what was felt but could not be touched—was of equal value. She understood that as incantation the work of art draws us through the physical materials to another reality. Without the aesthetic vehicle, the incantation cannot happen. Conversely, preservation of the material without appreciation for the incantation is meaningless. The tangible and intangible are in a delicate balance, and the existence of a work of art depends upon the preservation of both.

That never occurred to me when I first entered the Rothko Chapel in 1979 (fig. 1). Perhaps I had apprehended it in some vague way, but I had no conscious idea that I was entering a space where each of my professional values would be tested over the next twenty-one years as I tried to preserve an incredibly complex and obtuse work of art. In the course of the treatments, I would confront my own insecurities, triumphs, and defeats as I tried to come to terms with and preserve those of the artist as embodied in the fourteen monochromatic paintings.

John and Dominique de Menil commissioned Mark Rothko to create paintings and design an environment for them—a chapel—in 1964. The artist, enchanted by the prospect of creating a permanent space for his art, immediately accepted. He

FIG. 1

Rothko Chapel,
interior, 1976.

rented a carriage house on East 69th Street in New York City, completed eighteen
paintings in the next three years, and then consigned them to storage in a restorer's
studio until the Chapel was finished in Houston. Sadly, the artist was never to see his
greatest challenge come to fruition, as he took his own life in February 1970, pre-
cisely one year and two days before the Chapel was consecrated.

The edifice along with the seven plum monochrome paintings and seven so-
called black-form paintings, distributed as three triptychs and five axial paintings,
are regarded as one. As such, their singularity and relationship to each other and the
environment comprise the work of art. There were, of course, several unresolved
issues involving the paintings and their installation after Rothko's death. The central
skylight as prescribed by the artist (who had never visited Houston) allowed in too
much direct sunlight, casting a glare on the paintings that diminished their interac-
tive resonance. Attempts were made to ameliorate the problem, first by adding a cloth
scrim and eventually by constructing a baffle designed to direct the light to the walls,
but the solutions were never satisfactory; the paintings remained unevenly lit. Another
disturbing occurrence, from my perspective as a conservator, was that, before deliv-
ery to Houston, the New York restorer restretched the paintings on deeper stretch-
ers—3 inches deep instead of the customary 1½ inches. He then repainted the tacking
edges in order to hide the newly exposed canvas. Aside from the over-paint, I was
bothered by the change in dimension that, to my eye, critically affected the stature of
the paintings. However, the restorer's explanation that it was Rothko's expressed wish
was, by this time, widely accepted.

Perhaps the greatest concern with regard to the condition of the paintings
involved a whitening that had begun to appear on the black-form paintings shortly

after their arrival in Houston. The problem was serious enough for the de Menils to invite Rothko's New York restorer to Houston in order to treat it, which he did on several occasions throughout the early 1970s. At the time, it was thought that the disfigurement was due to mildew. As the inexplicable condition persisted, other prominent conservators and a conservation scientist were also consulted. However, lacking a consensus, it was decided to await further developments. That further development was my entrance into the Rothko Chapel as a newcomer to Houston in 1979.

When Mrs. de Menil asked for my assessment of the problem, I had not a clue. I admitted my ignorance about Mark Rothko and recommended that a thorough study of the artist's materials and techniques be made before any attempt at treatment began. I offered to go to New York in search of information and hopefully some insight into the nature of the condition problem. At this time, the Mark Rothko Foundation had not yet begun its systematic collation and examination of the artist's works. Hence, there was virtually no published technical literature. However, in the course of the investigation, we located Ray Kelly, who was one of the assistants Rothko had employed for the Chapel commission. Willing to assist, he came to Houston, and he and I painted out simulations of the paintings. Kelly demonstrated how Rothko primed cotton-duck canvases with dry pigment in rabbit-skin glue and then moderated the color with pigments in Liquetex medium. This process, undertaken by the assistants but meticulously directed by Rothko, constituted the plum monochromes. To create the black-form paintings, each day Rothko prepared a mixture of unmeasured amounts of oil paint, whole egg, damar resin, and turpentine and proceeded first to paint rectangles with tube oil paint on the colored grounds and then to brush the egg/oil emulsion on top.

This technical information is now so embedded in the canon of Rothko's materials and techniques that I was amused recently to hear from Helen Winkler Fosdick the following anecdote, which reminded me of how little we knew when this project began. Apparently, while working on a number of Rothko paintings in the 1970s, Orrin Riley (conservator at the Guggenheim Museum) asked the artist, whom he had never met, to consult. Rothko arrived at the museum, said to Mr. Riley, "I hear you're not so bad at this," took an egg out of his pocket, and, while handing it to the conservator, said, "you do it!" [2]

Rothko's enigmatic advice could not have been more central to the problem with the black-form paintings. However, identifying the materials in a mixture is one issue, but understanding how and why they were used for aesthetic effect is another matter. In this regard, Ray Kelly's contribution to the research cannot be overstated. His information facilitated our identification of materials (which were later confirmed by scientific analysis) and broadened our understanding of technique, which helped clarify what we were looking at years later as the whitening progressed.

Although I had described the structure of the Chapel paintings at an American Institute of Conservation meeting in 1981 and undertook treatment tests on the paintings in the Chapel with a colleague later that year, I was not confident enough with the results to propose a treatment. [3] There were simply too many unresolved issues. Was it the egg in the mixture that was causing the whitening, and, if so, why was the whitening irregular in appearance? Was it some sort of blanching that could be

reformed with solvents? How could we reform mural-sized paintings that measured, on average, 11 feet by 8 feet? What would the reforming solvents do to the plum grounds that acted as visible borders but remained unaffected by the whitening?

Aside from these technical questions, there were practical concerns. Since the paintings were painted right out to the edge and the tacking margins had been repainted, there was no invisible place to test the behavior of solvents on the paint film. Thus, any allowance for error was effectively eliminated. Furthermore, given their size, scale, and predominantly monochromatic nature, there was no image in the paintings to distract the eye from disfigurement or miscalculation in treatment. Since the building for the Menil Collection did not yet exist, the paintings would have to be treated in situ, under lighting conditions that were inadequate and within a time frame compliant with the Chapel's busy schedule. Moreover, if we did treat one painting, how would it look in comparison with six other untreated but essentially identical paintings? Finally, the paintings were predominantly black. Therefore, any disturbance of the surface would change the reflectance in a way that would make the slightest intervention readily apparent.

Given the enormity of the challenge, it would have been impossible to even consider a solution had it not been for the insight and astute comprehension of the donor. Dominique de Menil appreciated that time was what was needed—time to study, time to consider, time to watch the paintings age, and time for us to understand fully what we were looking at. It was not easy to offer time when the paintings were visibly changing and visitors to the Chapel were increasingly curious about their appearance. But time was what she offered, because she knew that the work of art was greater than any one ego, and its preservation warranted all that we were collectively capable of giving.

Between 1981 and 1987, when the black-form paintings were treated at the Menil Collection, the whitening had substantially increased. In one way, the progress was predictable; the disfigurement appeared first as a whitish film and then developed into independent crystals. What was not initially predictable, however, was the curious pattern of distinct whitish rectangles that emerged from within the black forms. From Kelly we knew that each morning Rothko would instruct his assistants to tape and then create on the colored grounds a predetermined black rectangle, first with charcoal, then with tube oil paint, and finally with a fresh batch of egg/oil emulsion. Dismissed for the evening, the assistants would return in the morning only to tweak the dimensions of the forms, following the artist's direction, sometimes by only ¼ inch. Presumably, in the evenings, Rothko worked out dimensional changes for the rectangles. It was fortuitous that around this time in our investigation, the Mark Rothko Foundation gave the Menil Collection graphite drawings on black paper that related to the Chapel paintings. Surprisingly, the changes that were manifest in the drawings precisely mirrored the patterns of whitening that we saw on the paintings (figs. 2, 3). Meanwhile, scientists at the Shell Oil Company's research laboratories in Houston conclusively demonstrated that the exudate was produced by the migration of fatty acids from the egg yolk in the medium to the surface of the paintings.[4] Hence, we surmised that the differential whitening resulted from multiple layers of the egg mixture as the rectangles were modified or that the buildup represented an abundance of egg in a particular day's concoction.

Armed with this information, we were able to attribute the whitening to an aging process and sought to minimize its appearance with the understanding that it was part of the structure of the work. The treatment that followed addressed the anomalies of the design layer and strove to confine our intervention to the surface of the paintings. Naturally, we anticipated that the condition would return, requiring future treatment, and therefore we purposely chose an approach that would be the least invasive, yet as effective as possible. A mixture of fast-evaporating solvents was concocted [1 part cyclohexane to 3 parts Freon (1,1,2-trichloro-1,2,2-trifluoroethane)], and, as one conservator applied the mixture with broad swathes of sterilized cotton, the other wiped the residue from the surface. The result was staggeringly beautiful and we were relatively satisfied that we had achieved a successful treatment.

Our assessment was qualified, however, because we knew the whitening would return; we had merely removed what had already progressed to the surface. We also identified developing cleavage on the central panel of the west wall triptych, and we suspected the migration of the fatty acids would exacerbate this condition. Noticing localized discoloration on several of the plum monochromes, we sensed that its eventual mitigation would be troublesome. Finally, we knew that the environmental conditions in the Chapel that certainly encouraged the condition problem would not be corrected for some time. So, although we had addressed the most obvious problem in 1987, there were others with which to contend.

Having spent at this point over seven years with these paintings, I could not help but wonder why Rothko chose to use egg/oil emulsion instead of straight oil paint in creating the black-forms. I also wondered why he allowed the glistening colored grounds of rabbit-skin glue and dry pigment to become such distinct players in the visual whole. With these queries in mind, I longed for an opportunity to decipher the artist's thoughts as he worked toward the creation of the final fourteen paintings. That opportunity arrived in the form of an exhibition entitled *Mark Rothko: The Chapel Commission* that opened at the Menil Collection in December 1996 and brought together for the first time many of the paintings Rothko had made while executing the commission. Spending part of each day in the galleries, I discovered that in addition to experimenting with the scale of the dark rectangles on the plum grounds, he also altered their orientation before settling on the vertical format. In addition, he considered various sizes for the paintings and substantially different layering systems for the construction of the forms. However, what particularly intrigued me was a set of six full-size paintings with horizontal rectangles on plum grounds that differed from one another only in terms of media distribution. In one triptych, the black-form and plum grounds were both created with egg/oil emulsion; in the other, the forms were egg/oil emulsion while the grounds were dry pigments in rabbit-skin glue. Evidently, after scale and orientation, the final deliberation concerned media, and Rothko distinctly preferred the contrast between the relatively matte egg/oil emulsion and the glistening rabbit-skin glue for form and ground.

Given his deliberate choice, preservation of the subtle differences in reflectance between these materials was critical. The 1987 treatment preserved that distinction. However, one of my tests in 1981 threatened it, as did the prospect of a future treatment of the cleavage that might require some sort of infusion of the paint layers. Both attempts were dictated by a desire to make the paintings look better. Initially believ-

ing that the whitening was related to blanching, in 1981 I had treated a portion of the left panel on the east triptych with a standard reforming solution that consisted of cellosolve acetate, diacetone alcohol, and ethanol. The whitening immediately disappeared and the black attained a dark, rich saturation. Fortunately, the speed of the result and my reservations about the nature of the solvent action on the unconventional paint media delayed my continuation of the treatment. As the triptychs continued to age over the next few years, I noticed that the area I had tested seemed less prone to the development of the white film. It simply responded in a way that differed from the rest. Eventually, when we were able to examine all of the paintings under ultraviolet light in the Menil's conservation studios years later, it became painfully clear that I had inadvertently affected the structure of the paint layer. The surfaces of all the black-form paintings fluoresced similarly and evenly, except for the area of my 1981 test. Today, that rather sizable area stands out from the rest and is disturbing to a discerning eye, or at least to mine.

In hindsight, the only explanation I can offer for why I made such a large and careless test is that I was anxious to find a solution to the problem. I was convinced that whatever I did would require an overall treatment, and I had not yet appreciated that the problem would outlive my various attempts at resolution. In one respect, treatment with a reforming solution would have certainly removed the whitening, as did a wash with water that a previous restorer had applied. However, we now know that the water offered only a temporary fix and in fact exacerbated the condition problem. The reforming treatment offered a more lasting result, but overall it would have changed the nature of the paint layers in a way that could have potentially complicated future treatments.[5] As I became more sensitive to the nuances of surface reflectance, I sensed that the preservation of the delicate interplay between border and form was of crucial importance.

Following the Menil's exhibition, I was invited to write about Rothko in the catalogue of a retrospective exhibition organized by the National Gallery of Art in Washington, D.C. Initially reluctant to accept the invitation, I ultimately agreed because I was enticed by the challenge of reconsidering Rothko's oeuvre with the technical insight of the later work in mind. I discovered that, throughout his career, Rothko had become increasingly more interested in issues of reflectance, and, by the time he painted the Chapel paintings, he had practically eliminated color as a major player. Perusing the literature one more time, I came across a reference that confirmed my observation. While showing the finished Chapel paintings to a fellow artist before they were removed from his studio, Rothko remarked that the black-form paintings "appear similar but are not the same . . . the borders might have sheen and the dark inside is mat [sic] or vice versa"[6] (figs. 4, 5). This comment justified in technical terms Rothko's use of a darker palette in deference to variations of reflectance in his media throughout the mid-1960s. Oddly enough, that affirmation produced an unexpected flurry of publicity in Europe concerning my apparent challenge to the myth that Rothko's late dark work embodied his depression and presaged his suicide.

Plans were finally made for a complete renovation of the Chapel starting in February 1999. The scheme called for a new HVAC [heating, ventilating, and air-conditioning] system, new skylight and artificial lighting system, new thermal barrier at the entrance, and enlarged exterior doors. The last modification allowed for removal

of the largest paintings from the Chapel for the first time since their installation. Thus, with the fourteen paintings in the museum and available for examination, we were prepared once again to consider the problematic issues related to their preservation. We decided to begin with the discolored inpainting that plagued several of the monochromes and then address the advanced cleavage on one of the black-form paintings.

When I had first traveled to New York in pursuit of Rothko information, I had heard about a localized damage on the southwest wall's plum monochrome that had purportedly been treated by Rothko himself. Over the years, that repaint had discolored, as had other former repaints, with inconsistencies of tone becoming visually

FIG. 5

Mark Rothko (American, 1903–1970). *Untitled [One of Pair B]*, 1966. Dry pigment in rabbit-skin glue, egg/oil emulsion, and synthetic polymer on canvas, 450.9 × 244.5 cm (177½ × 96 in.). Houston, Rothko Chapel.

obtrusive. The artist had corrected the localized disfigurement in the one instance with paint applied directly on the rabbit-skin glue and dry-pigment layers; unfortunately, the restorer did the same on a much larger scale to other monochromes. Ultimately, we had limited success in the removal of superficial repaint with dampened makeup sponges that navigated the interstices of the fibers and mechanically lifted most of the added color. However, given the inherent vulnerability of the design layers and the size of the affected areas, it was impossible to remove the denser and less soluble repaint applied by the restorer on the north triptych. We pondered the sizable inconsistency on the left panel before finally conceding that it could not be removed with solvents

at this time without damage to the original. We were left to mitigate the color difference with gouache. Perhaps refined lasers or another form of mechanical intervention will be available in the future that will offer promise of a more permanent result.

Addressing the cleavage on the central black-form painting of the west triptych provided an enormous challenge. By 1999, the cleavage had progressed to a point where the friable egg/oil emulsion in the design layer was spalling from the denser layers of oil and rabbit-skin glue mixed with dry pigment beneath. Given the thickness of the cotton-duck fabric along with the underlying paint, it was impossible to introduce a consolidant from the reverse. Furthermore, although we preferred a localized approach, the pervasiveness of the condition forced us to consider an overall infusion, the prospect of which was daunting and fraught with legitimate reservations. Respecting the unmanageable size and perfect plane of the canvas, we were reluctant to unstretch the painting for treatment on a suction table or comparable apparatus. Moreover, the unforgiving black surface that revealed even the trace of a watercolor brush complicated application of a consolidant from the front. That, coupled with the unpredictable location of insensitive former tests and treatments, meant that an adhesive that met our specific criteria might be absorbed in one area while rejected in an adjacent spot.

Leaving aside the battery of logistic and technical problems, there remained two overriding concerns that plagued us throughout the eighteen months of treatment and challenged the core of our professional ethics. Ultimately, we felt compelled to undertake an overall infusion of the design layer instead of local treatments in order to preserve the painting. However, in so doing, we knew we would inevitably be changing the nature of a solid black painting whose resonance existed only in partnership with two other similar paintings that abutted it on either side. The slightest difference in sheen or surface reflectance would distinguish it and threaten the unity of the triptych. Moreover, that dissonance would be readily apparent in comparison with the complementary black-form triptych on the facing wall. To add to the complexity, given the size of the paintings, we would not be able to evaluate the balance of the relationship following the treatment until after the triptych was reinstalled in the Chapel.

Even more disconcerting was the realization that our treatment would unalterably change the components of one painting among six that were painted in the same way. Assuming we achieved an acceptable result at the completion of the procedure, we feared that the central painting would age differently from the rest. Nonetheless, the precarious and steadily deteriorating state of the painting demanded attention. Despite our preference for localized intervention, the paint film responded exclusively to an overall infusion with a modified synthetic adhesive, which we carried out at the end of almost one year's research into every conceivable consolidant that would satisfy our needs. The procedure was experimental and complicated, the result was applauded in the national and international press, and we were left unnerved by the ramifications of the decisions we had made and the treatment that challenged our professional precepts.

I have used the first person plural in certain parts of this discussion because I was assisted in the treatments over time by distinguished colleagues, including Andrea di Bagno of Houston, Leni Potoff of New York, and Frank Zuccari of Chicago. The importance of their collaboration cannot be overemphasized. Alternatively, I under-

took the last treatment in partnership with a younger colleague, Pia Gottschaller, who served as a Mellon Fellow for the project. Her intelligence and command of sampling techniques, scientific inquiry, and material analysis immeasurably augmented the study and treatment protocol. However, to my mind, her most valuable contribution to the project and to me was an insistence upon theoretical justification for what we were doing at each step of the way, despite the often overbearing urge for expediency. I grew in response to Pia's probing of our professional ethics; debates addressed reversibility and compatibility, experimentation directly on the design layer, differential treatment of one painting in a set, and alteration of the original structure of a paint film in the name of conservation. Throughout, the discussions broadened our collective intellect as conservators by forcing us to come to terms with our professional bearings and vulnerability.

"The magnitude on every level of experience and meaning, of the task in which you have involved me, exceeds all my preconceptions. And it is teaching me to extend myself beyond what I thought was possible for me. For this I thank you."[7] So wrote Mark Rothko to the de Menils in 1966 while he was in the midst of creating the enigmatic paintings.

One day, after the Chapel reopened in June 2000, I sat alone looking at the paintings. For the first time in many years, my eye skipped past the material problems and concentrated on the immaterial drama of the whole (fig. 6). It is a singular work of art: the building and the paintings. It embodies all of Rothko's genius, including his insecurities, fears, indecisions, and miscalculations. As lead conservator of the Rothko Chapel paintings, I was able to identify with those emotions and understood

FIG. 6

Rothko Chapel, interior, 2000.

in a deeper way the subtle but fundamental rapport between artist and conservator—between the manipulation of tangibles in order to create and then preserve the intangible. After all this time, I sat there without pretension and allowed myself to be overcome by "the magnitude on every level of experience and meaning, of the task" in which I had been involved, and which "exceed[ed] all my preconceptions."

NOTES

1. Dominique de Menil, foreword to *The Menil Collection: A Selection from the Paleolithic to the Modern Era* (New York, 1987), p. 8.

2. Helen Winkler Fosdick, letter to the author, November 15, 1999.

3. See Carol C. Mancusi-Ungaro, "Preliminary Studies for the Conservation of the Rothko Chapel Paintings: An Investigative Approach," *Preprints of the 9th Annual AIC Meeting* (Philadelphia, 1981).

4. For a fuller discussion, see Carol C. Mancusi-Ungaro, "The Rothko Chapel: Treatment of the Black-Form Triptychs," The International Institute for Conservation, *Preprints of the Contributions to the Brussels Congress* (1990), p. 136.

5. It occurs to me, as I write almost twenty years later, that my miscalculation in 1981 may prefigure a future treatment should the whitening continue to develop and threaten the stability of the paintings. It would have been inappropriate as an initial treatment, but may some day offer insight into a more lasting solution.

6. Mark Rothko, letter to Dominique and John de Menil, January 1, 1966, The Menil Collection Archives, Houston.

7. Ulfert Wilke papers, diary entry for October 14, 1967 (p. 40), Archives of American Art, Smithsonian Institution, Washington, D.C.

Episodes from a Pilgrimage

ZAHIRA VÉLIZ

My training in the conservation of paintings followed the conventional American model: while completing a degree in art history and studio art, I absorbed a massive dose of altruism from a long and fully illustrated article in *Smithsonian Magazine* describing the valiant and self-sacrificing efforts of the conservators from around the world who went to Florence after the 1966 flood. Having discovered by this means that "art restoration" was a profession, I said to myself, "That is what I want to do every day of my life." Fortified with this passionate conviction and the idealism of youth, I entered a three-year post-graduate program in art conservation at Oberlin College. My subsequent career took me to three U.S. museums and then veered off the well-beaten path into less conventional surroundings. For nearly twenty years now, I have been a freelance conservator, undertaking projects in several European countries, South America, and the United States. In the face of the dramatic variety of experiences I've encountered as an independent conservator, the theoretical absolutes of my initial training have been frequently challenged and sometimes refuted utterly. Having had the good fortune to work with many distinguished conservators has also helped me to refine and strengthen the values that now inform my approach to the conservation and restoration of works of art.

Most of us have probably quickly come to the realization that the clearly outlined world described in our training does not correspond to the reality just beyond the garden of the ivory tower. While still a student, I found it difficult to reconcile the compromises I perceived in the practical and administrative structures within which professional conservation unfolded, and I did not entirely understand how I would find my way in this particular art-conservation landscape. With youthful arrogance, I believed that my idealism and dedication could not intermingle with the political and economic realities of museum life in America. There were other things, too, that made me restless. Much as I loved the collections in the American museums where I was privileged to work, I was often disquieted by the isolation of the images from the social and

historical context in which they had been created. I longed to be a conservator in authentic surroundings, and in a place where works of art were in real danger.

By the early eighties, my idealism was still very much in force, and now it had a fixed focus. For several years, I had been collecting and studying technical treatises from the Iberian Peninsula with a view to translating and annotating them, because so little technical literature from the Spanish-speaking world was readily available to students of historical artists' techniques. So when I had an opportunity to go to Spain to work, through the goodwill of the Metropolitan Museum (which did not tarnish my idealism in the least), I did not hesitate. I effectively cut all ties with my American professional life, reduced my worldly belongings to a rucksack and a footlocker, and went off on a kind of pilgrimage that was to last nearly ten years.

Working in Spain, I quickly found myself in authentic surroundings and restoring works of art that were undeniably in real danger. I also came quickly to recognize that conservation, far from being governed by immutable standards as I had been taught, was subject to varied conditions of economy and politics, and was influenced profoundly by the particular character of the setting for the work of art being treated.

I write of "idealism" in a tone that is partly tongue-in-cheek, as our cynical world has taught us to do, but also with a certain respect, for I believe that a kind of persistent idealism must be present in most of us who continue in the profession. It is through this "incalculable quality" that we continue to seek ways of treating works of art that are both scientifically and philosophically consistent with our response to works created to speak to the human spirit. But idealism on its own becomes flimsy; combined with romanticism about working in exotic locations, it becomes a false god. So it was inevitable that a few experiences in the real world quickly readjusted my mental ratio of romantic idealism on the one hand to effective intervention on the other.

I would like to illustrate some stages of this process by reflecting on two major projects I worked on in Spain. Undertaking conservation and restoration in situ presents the conservator with a huge range of variables, each of which has to be weighted to fit into a complex equation if the project is to be successful.

SAN LORENZO EL REAL, TORO (ZAMORA PROVINCE)

The first major project I worked on was the altarpiece by Fernando Gallego in San Lorenzo el Real in Toro, Zamora, and illustrates the scope of difficulties and challenges that are met in situ (figs. 1–6).

When the altarpiece was painted in 1496, Toro, as one of the most important sites for the wandering court of Ferdinand and Isabella of Castile, was a relatively sophisticated and prosperous town on the road to everywhere. Since then, it has fallen gradually into obscurity, which assured the preservation of many medieval and early modern buildings and sometimes their furnishings. However, great numbers of works of art have disappeared over the last century as unscrupulous priests sold off movable sculpture (as was the fate of the titular figure of the San Lorenzo altarpiece), and foxy antique dealers despoiled many a private palace of its venerable contents. The survival of the San Lorenzo altarpiece in its original location may well be down to the combined forces of luck and ignorance.

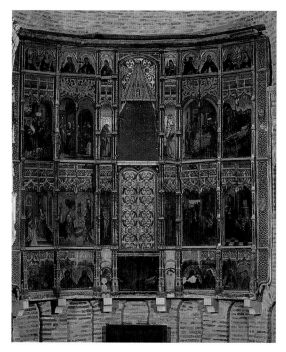

The altarpiece, by Fernando Gallego, one of the few notable masters practicing the art of painting in the Zamora-Salamanca region in the 1490s, is a complex assembly of panel paintings, framed with exquisite gilt tracery, all in a state of utter abandonment (see fig. 2). Structural instability was evident in nearly every panel, and about a quarter of the paintings had been brutally cleaned with a caustic substance sometime in the past, leaving only the underdrawing on the preparation (see fig. 4); other panels were remarkably well preserved beneath thick layers of highly oxidized surface coatings, which were by no means easily soluble. In retrospect, I believe that these particular difficulties and challenges could have been met in a more satisfactory way had I possessed greater experience and stronger conviction in my own judgment. This was in some ways the most memorable of my projects in Spain: those first experiences in Toro were at once wonderful and shocking. I was quickly alerted to the fact that lavishing dozens of hours on achieving a perfect invisible restoration did not count for much when there was not a peseta or a penny to pay for repairing the leak in the church that was sending a steady stream of rainwater down the reverse of the panel I was in the process of restoring.

The paintings in the altarpiece consisted of eight large scenes from the life of Saint Lawrence, and eight others from the infancy of Christ. In addition, there were fourteen panels with single or paired saints. To clean and restore this number of images so that they would present a quiet, unified whole was a daunting prospect. Equally thorny was the problem of treating the split panels. It was believed that the altarpiece had never been moved, and that its structure was unchanged since it was installed nearly five hundred years earlier. This was extremely interesting historically and was valuable also for the "untouched" areas that potentially could contribute

FIG. 1

Church of San Lorenzo el Real, Toro, Spain. The high altar, ca. 1975–82.

The Gothic vault, contemporary with the altarpiece, but later than the architecture of the church, was destroyed in 1983.

FIG. 2

Church of San Lorenzo el Real, Toro, Spain.

The high altar in 1984, at the commencement of the conservation program focused on the panel paintings and gilt tracery of the altarpiece by Fernando Gallego.

FIG. 3

View of the church
of San Lorenzo el Real,
Toro, Spain.

FIG. 4

An example of the
destruction suffered by
some of the panel
paintings in the past
when corrosive materi-
als intentionally, or
perhaps accidentally,
came into direct con-
tact with the paint
surface, dissolving the
pictorial layers.

important information about original techniques. For reasons justified principally by the conviction that the original structure should not be interfered with because of its authenticity, it was decided that, despite the serious structural problems that existed in almost every panel (splits, cracks, flaking, paint loss, and separation of ground, linen, or hemp from the pine panels), no panel would be dismounted from the armature of the altarpiece. This decision by the Spanish conservator and co-director of the team may have been, in part, a reaction to the destruction in the previous year of the Gothic vault that was contemporary to the altarpiece but was nearly two hundred years later than the Romanesque architecture on which it was superimposed. It was a decision influenced also by limited funds and by the real technical difficulty of dismantling and remounting such a complex structure. However, at that time I believed it was the wrong decision, but I lacked the conviction to argue with greater force for a careful and respectful intervention that would secure the structural stability of the altarpiece.

I had been initially sympathetic to a conservative, noninterventionist view. I found the notion of respect for the natural aging of this complex work of art in its original setting strongly appealing. So we were faced with a compromise: complete cleaning and restoration of the paintings, and superficial and ineffectual structural work (such as consolidation of the insecure paint on panels, which would still cause flaking as they continued to experience the restraint of the ancient crossbars and rigid framework, filling and restoring the splits without being able to rejoin them).

While I was at first enraptured by finding myself as co-director of a conservation project to conserve works of art in real danger and in authentic surroundings, I soon understood that I was in over my head. I lacked the political skills and contacts to restructure the budget for the project and found the unequal compromise in treatment to be a source of anxiety and misgiving.

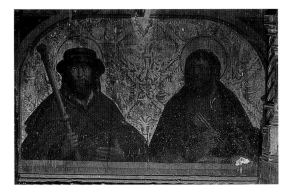

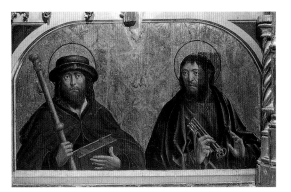

In the end, with the help of a number of dedicated young Spanish and American conservators, I believe that we achieved a dignified appearance for the altarpiece, but I still feel uneasy about its structural condition. Many years have passed since I have seen it, but I know that only three to four years after we finished our work chalk fillings were flaking away from the splits.

I'm not sure if I ever made sense of working in a situation where funding was ludicrously inadequate to the scale of problems to be addressed, where practical resources, materials, and techniques were desperately limited, and where there was a fundamental conflict about the course of treatment that should be followed in the conservation of a late-fifteenth-century altarpiece with over twenty panels that were flaking, scratched, discolored, and practically decomposing. As difficult as it was to reconcile this first experience of working on site with the standards I had learned in an American training program and in American museums, it was easy to learn many lessons from the experience. Although this project was completed in an unsatisfactory way, in retrospect I feel that my involvement was positive: the paintings, which at first were being cleaned with mixtures based on dimethylformamide, ultimately were cleaned with xylene gel, which seemed an improvement both for the paintings and for the conservators. The treatment that was actually carried out was of a high standard, and the visual appearance of the altarpiece was improved, which led, we believed, to its being more highly valued by the people to whose patrimony the church and the altarpiece belonged. If I recall the state of abandonment of the altarpiece, the damage to the paintings caused by blundering ignorance in the past, and the illegibility of most of the images, I feel that the long-term fate of the altarpiece has been improved. But I remain acutely aware that the intervention could have been better justified had the structural problems been addressed, not ignored.

In Toro, I learned some extremely valuable lessons: first, to be more critical of motives in designing conservation strategies. Both my own "idealistic" motives and those of others—in this case, an oversimplified respect for "original structure"—could mask fear about undertaking a technically demanding structural treatment. Doing nothing was certainly better than attempting to intervene without sufficient knowledge, but under different circumstances it might have been possible to find a conservator with appropriate expertise to advise on the structural aspects of the project. In retrospect, I know that in Toro, as everywhere, discretion was the better part of valor. Nevertheless, submission to compromise stung.

FIG. 5

Fernando Gallego (Spanish, 1440/5– after 1507). *Saint James and Saint Peter*, ca. 1496. Oil on pine panel, approx. 78 × 64 cm (30¾ × 25¼ in.).

Altarpiece of the church of San Lorenzo el Real, Toro, Spain. Condition prior to conservation treatment.

FIG. 6

Fernando Gallego, *Saint James and Saint Peter*. Altarpiece of the church of San Lorenzo el Real, Toro, Spain.

Condition of the painting after cleaning but prior to restoration. The rectangle of varnish was removed after the photograph was taken.

At the same time, it became clear to me that conservation treatment does not always benefit from committee decisions. I resolved to learn how to take advice from as many sources as possible, but I also resolved to be prepared to justify or defend my own decisions. Ultimately, the person who physically treats the work of art is responsible for what is done or is not done. Good judgment is the conservator's most valuable tool, but in our work it is an individual quality, unique in character and colored by each person's particular experience. John Brealey was always aware of this, and I remember so clearly his lament, "It is possible to impart knowledge, but you cannot teach understanding."

I saw more clearly the need to assess the implications of context for conservation decisions. In the case of San Lorenzo, this meant not only assessing the physical setting of the work of art but also learning the idiosyncratic workings of local government and understanding and accepting the limitations in areas such as climate control, security, and long-term conservation care. The existence of the work of art in such circumstances is directly conditioned by infinitely more dynamic variables than had been the case in American museums.

SANTO DOMINGO EL ANTIGUO, TOLEDO

If in Toro the negative outweighed the positive, the balance was reversed on the first major project I directed in Toledo. In 1985, I was asked by the Royal Foundation of Toledo to direct the conservation and restoration of a number of very interesting paintings in the oldest Cistercian convent in the city. Among them were three large paintings by El Greco, the only original pictures still in place from his commission for Santo Domingo el Antiguo, circa 1577, the earliest he undertook in the town with which he would become so closely associated. The other parts of the altarpiece ended up in the Prado, Madrid; the Chicago Art Institute; and a private Spanish collection. The paintings remaining in Santo Domingo el Antiguo are *The Resurrection* (fig. 7), *Saint John the Baptist*, and *Saint John the Evangelist*.

In contrast to the situation of the altarpiece in Toro, the paintings in Toledo had always been highly regarded, and had escaped the careless scrubbing that caused the most offensive damage to the Fernando Gallego altarpiece. El Greco's commission for the high altar and side altars of Santo Domingo el Antiguo was innovative and sophisticated in iconography, and executed with fine materials and flawless technique. Until the Spanish Civil War of 1936–39, the paintings were never moved, and at that time they only went temporarily into the crypt of the cathedral, just up the hill, for protection. This relatively stable history was clearly important for ensuring the excellent state of the paintings, all three of which have never been lined, and serves as a sterling example of how good it is for paintings not to travel!

The stable environment of Santo Domingo el Antiguo and the respect and care of the present-day Cistercian community for their artistic holdings were great allies to my idealism, which had not passed unscathed through my early experiences in Spain. Here in Toledo, however, it would prove possible to undertake only minimal treatment, with reasonable confidence that just a gentle helping hand would ensure dignified survival of El Greco's paintings for years to come.

To come face-to-face with virtually untouched sixteenth-century paintings—by no means the only ones I encountered in Spain—of such quality, and in so unadul-

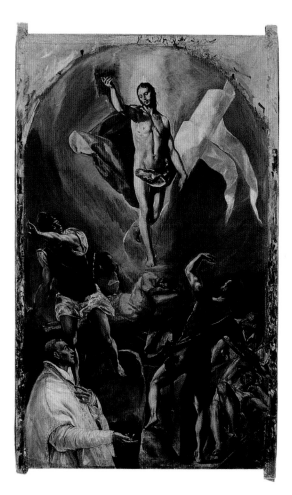

terated a state, was a sobering experience. I believe it was the first time I really sensed the humility we as conservators should always feel when we are face-to-face with the artist. The structural work was the most urgent aspect to consider, because all three paintings had untreated tears that had occurred when an attempt was made to cut them out of the altarpiece—possibly during the bombardment of Toledo at the time of the civil war. Had it not been for these tears, virtually no structural treatment would have been necessary. As it was, the wonderful technique used to prepare the original canvas and the heavy pine backing on which it was stretched assured very good stability and remarkably good conservation of the linen itself, which, even where it was exposed and unprotected by ground or size, was not brittle in the least (figs. 8, 9). I could not help but reflect that had these paintings come across my path in the United States in the 1970s, they would probably have been relined with wax resin then and there as a measure of preventive conservation.

Happily, at Santo Domingo el Antiguo, wax lining was not going to be an option. And happily, unlike the situation of the altarpiece at Toro, I had the authority and the confidence of my convictions to intervene just as far as I considered to be absolutely necessary.

The character of the setting in which these three paintings would continue to be seen and cared for made it possible to use minimal intervention to stabilize the canvases, and to thin or eliminate surface dirt and other extraneous accumulations from candle smoke, atmospheric pollution, and so on. The choice of materials and adhesives was influenced strongly by the extremely successful aging characteristics displayed by the original, natural materials, although a minimal amount of synthetic adhesive was used to mend the tears. All other materials used were akin to those of the original structure and consisted mainly of *gacha*, the traditional Spanish paste glue, washed linen, rice paste, and Japanese tissue. Four hundred and twenty years of real aging seemed as persuasive to me as any number of years through artificial aging. It is interesting to note that, according to a clause in the original contract for these paintings, El Greco was required to supply all the materials himself (they were not provided to him by the patron). We can conjecture that for this important first commission in Toledo the artist chose the best materials he could obtain, possibly importing canvas or colors from Italy. The contract was also adamant that all the work should be by El Greco's hand.

FIG. 12

El Greco, *The Resurrection.*

Detail of the upper section of the painting showing the characteristic multicolored brush-wipings typical in El Greco's paintings where the unfinished margins are still preserved.

The cleaning was also minimal and aimed principally at bringing greater clarity and legibility to the images by reducing or eliminating the thin, but utterly perished, varnish, surface grime, and yellowish accretions.

The aim of the intervention in these paintings was to stabilize them structurally while preserving the many rare and beautiful details of the pristine original (figs. 10–12). Cleaning the paintings and treating the tears and minor distortions assured that El Greco's paintings would survive intact and their beauty would be more readily seen than was possible prior to treatment. In his formal acceptance of the commission for these paintings, El Greco promised to undertake the work and fulfill his obligation "fully, with no duplicity nor deficiency, but rather according to the law of honourable men."[1] In treating his paintings, I hope that I, too, acted in the spirit of his words.

For over a decade now I have been working principally in London as an independent conservator, and the Spanish episodes discussed above have receded into history. However, the projects described, and perhaps half a dozen other in situ "campaigns," marked a period of my life when I was passionately devoted to my profession and prepared to work in extremely inhospitable conditions during many a twelve-to-fourteen-hour day. Such a life is possible only for a pilgrim and is not compatible with the requirements of family, nor even with the desire to undertake research, which has always been important to me. The experiences of working in situ on works of art in conditions such as those I have sketched forced me to jettison some of the things I had been taught, but strengthened and refined other notions that replaced them. The unpredictable variety of history and circumstances surrounding works still in their original settings taught me to do only what the paintings ask from me—no more, and no less.

NOTE

1. The original document is in the archive of Santo Domingo el Antiguo. For transcription and references see Francisco de Borja San Román y Fernández, *El Greco en Toledo ó nuevas investigaciones acerca de la vida y obras de Dominico Theotocopuli* (Madrid, 1910), pp. 27–34, 129–40.

Comments

SCOTT SCHAEFER

*Response to the papers of Carol Mancusi-Ungaro
and Zahira Véliz*

My remarks are going to be an impromptu reaction to all the things that have been discussed. First I would like to talk about my experience in conservation. I come from a slightly different background from that of many of the other participants in this seminar in that I grew up without art. The University of Arizona, where I attended college, does have a museum (consisting mostly of pictures donated by Samuel Kress, who used to winter in Tucson), and the first painting that I knew well was an altarpiece by Fernando Gallego. Only part of this very major altarpiece survives, but it survives in great condition, probably because it was removed from the original church many, many years ago. That altarpiece provided my first experience with an original work of art—as many students in American universities have discovered, original works of art are often not of prime importance to people teaching art history.

Although I decided to major in art history quite late in my career, I had gone to Europe when I was about nineteen years old to see original works of art, and my first stop was the National Gallery in London. At that very moment, the Gallery was presenting a small exhibition entitled *Titian's Bacchus and Ariadne* that focused on a recently cleaned painting. As someone who was not used to looking at works of art, I found that my first experience with that cleaned painting was a revelation. Its vivid blues, reds, and whites contrasted markedly with the appearance of other paintings around it in the National Gallery in London in those years, and also with the paintings I had seen at the University of Arizona.

I continued my progress through Europe, looking at pictures everywhere, eventually arriving in Italy. Pictures there, obviously, looked very different in their natural settings from those in museums. First of all, you couldn't really *see* paintings still in situ—even if you could afford the necessary *lire* to put in the light boxes that are provided to spotlight the object. Because of this, it was difficult for a young student to know quite what a work of art was meant to look like, let alone to know how different that picture might be in appearance from the time it left the artist's studio. And it's still very difficult to know, as many of you have indicated in this seminar. In fact, can we ever know really what the original work of art looked like when it first left the artist's hands?

My education in the history of conservation of paintings began at Bryn Mawr College, when I accidentally discovered an original work of art in the attic of the college-owned house where I was living. I decided not to use it to pay for my education; instead, I turned it over to the college president. As reward for my honesty, I became de facto curator of the college's collections, which meant that I spent two summers checking the attics and the basements of all of Bryn Mawr College's buildings for works of art.

At the end of it, we found several million dollars' worth of art in varying states of neglect and preservation. That was my first introduction to the physicality of a work of art, to confronting what it looks like. Fortunately, I was allowed by the History of Art Department at Bryn Mawr College to be an intern at a museum.

I became an apprentice at the Philadelphia Museum of Art, and my first experience with conservation was with that museum's long-tenured conservator of paintings. He was a very casual, interesting, and likable man. He always worked on paintings that were laid flat on a table. In fact, I didn't realize until this symposium that the transition from working on paintings that were placed on their backs to those that stood upright on an easel—which occurred during my own experience—was also taking place throughout the conservation world.

As I said, the conservator was a very casual kind of guy. He was so cavalier that he smoked while he cleaned paintings. And as you watched him work, the ash of his cigarette would get longer and longer. When the ashes would fall onto the painting, he would simply brush them off. Nevertheless, I saw great transformations taking place in his studio, and it was a privilege to be involved in what seemed to be, to a young student and novice like myself, alchemical transformations.

I got my first real job in Cambridge, at Harvard University, which was, of course, a great training ground for museum directors, curators, and even conservators. I met many conservators there, and although I didn't see a great deal of interaction in those years between the students and the teaching faculty or the conservation faculty, several professors did welcome student involvement. For example, Sydney Freedberg (who became one of my best friends) would occasionally clean his own paintings and was perfectly happy to have you watch him.

On the whole, though, there was little interaction at Harvard among students, professors, curators, and conservators, even though their activities took place in the same building. It was possible to walk into the Fogg Museum to a classroom and never look at a work of art, in spite of the fact that you had to walk through a museum to get there.

By this time, smitten by works of art, I had decided to become a curator. I became assistant curator of prints at Harvard's Fogg Museum after initially incurring the enmity of the chairman of the History of Art Department at Bryn Mawr College for choosing a museum career over an academic one. In his mind, there were (to alter a time-worn adage) "those who could" and "those who became museum people." In short, you could teach or you could become a curator.

I suppose my real conservation training began when John Walsh hired me as assistant curator at the Museum of Fine Arts in Boston. From the Fogg, it was just a move across the river. And John has always —as you know from his presentation here and from your experience with him—had a very keen interest in conservation. When he came to the Museum of Fine Arts, the collection hadn't been looked after in a very long time. It was a difficult situation, one rife with political complications.

The Museum of Fine Arts had one conservator who tended to act extremely independently of the curator. This was different from my experience at both the Philadelphia Museum of Art and the Fogg Museum, where the curator, rather than the conservator, tended to initiate projects and activities in the conservation studio. The conservator at the Museum of Fine Arts had trained at the Fogg. To demonstrate that three or four of the Monets at the museum were relined on aluminum, she would proudly rap her knuckle on the surface of the paintings.

Such wide-ranging experiences as these were confusing for a young professional trying to determine what it is that a work of art should look like. To further complicate matters, everybody seemed to be saying something different, and things looked different in each institution. There seemed to be no common standard for comparison.

I remember going through the storage rooms in Boston—the collections had not been reviewed at the Museum of Fine Arts in more than a generation— and there were many, many paintings to examine. How wonderful those meetings with the conservators were! All the curators and the interns, and John [Walsh], in front of each of the some fourteen hundred pictures, proceeding painting by painting, looking at and discussing conservation problems, quality issues, possible framing resolutions—every issue that you could possibly conceive of in the process of reevaluating a collection that had not been seriously looked at for almost thirty-five years.

One picture in storage, a large tondo executed by a minor fifteenth-century Italian artist, Tomaso di

Stefano Lunetti, was in wonderful condition but was extremely discolored by varnish. It was decided that we should better present this painting, that it was an important picture for the collection, which had very little material of the Florentine quattrocento. And the picture was, I remember distinctly, laid flat on a table when we examined it.

The next morning, John and I came in to look at the picture. The conservator had just finished cleaning it. The grayish film underneath the varnish—which I found out later was called glare—had been removed. Seen as terribly disfiguring, it was taken off with the varnish. A painting from the 1480s suddenly looked like a very large, very round cartoon of a picture, cleaned down to the paint layer, the colors all too bright and clear. I assumed, of course (not having had the professional experience to think otherwise), that that's what these pictures were meant to look like. John knew differently, and if he was horrified he did not let on immediately.

As always, John, coolheaded, proceeded with wisdom and experience, and eventually things changed at the museum, despite the difficult political climate there at the time. But for me the nagging questions have remained: How does a student, in trying to learn about these things, figure out what the condition of a picture should be? How close can you get to what a painting looked like when it left the studio of the artist, knowing that, in fact, every picture has changed from the moment it left the artist's hands? How can one determine that ineffable look that the picture must have had at its completion? It's something that the conservator, art historian, and curator all grapple with. I take solace here in seeing that almost everyone involved with paintings deals with these questions all the time.

I think I must spend an hour out of every day in the studios here at the Getty with the conservators, looking at pictures. The conservators teach me so much about looking at pictures, but I would like to believe they also want to know what I think about the pic-

tures as they work on them. I come in and make comments, as do many people who visit conservation studios. We have no idea, of course, what the conservators say about us after we've left their studios, what kind of comments they make about our remarks. I can imagine conservators discussing the inane, even asinine remarks most recently pronounced by a curator upon visiting the studio!

At the outset of this symposium, organizers expressed the hope that we presenters would be truthful, honest, and forthcoming about conservation, that we might even be provocative as we presented our personal viewpoints. In that light, I hope some of the points I've raised here will have been of interest.

John Brealey has been much invoked here today. He instigated a conservation symposium at the Metropolitan Museum of Art in 1981 and invited a group of professional people, including me. At that symposium, he spoke about conservation and its current problems in the United States. I remember that I said to John Brealey just before he was going off to Madrid, at the invitation of the Prado, to clean [Diego Velázquez's seventeenth-century painting] *Las Meninas*, "John, it must be very awesome to work on such a famous picture." Without a moment's hesitation he replied, "One would have no confidence in a conservator working on a picture if he were frightened of it."

Of course, all of you here, especially the conservators who presented papers, have clearly indicated that same sentiment—that you can't be frightened of the work of art. But what's more remarkable to me now is the sense of awe you have when you stand in front of a painting and become aware of the enormity of your responsibility to that work of art. The reverence for what has survived, what time has altered, and how to deal with that becomes all the more poignant in listening to you discuss these issues here today.

I would like to think that when we attempt to return a picture to what we think it originally looked like,

we do so as a collaboration with the curator and the art historian, so that we have as much information as possible in making the picture look as presentable as possible to the viewing public. That is an issue I hope we can discuss a little bit later.

To continue my story, I left the Museum of Fine Arts in Boston to come to the nether reaches of Los Angeles, committing, some thought, intellectual suicide. As curator of paintings at the Los Angeles County Museum of Art, I had to deal on my own with a conservation department that was already in place. On my first day, the conservators proudly showed me a recently completed project, the freshly cleaned Rubens altarpiece *The Holy Family*. One couldn't say definitively that previous conservation campaigns hadn't destroyed it, but, as presented, it certainly had been cleaned and skinned to a degree that rendered both the age [three-hundred-plus years] and the artist incomprehensible. Nevertheless, the picture was hung in the galleries; there was no other choice.

Recently, Joe Fronek, the Los Angeles County Museum of Art's current conservator, toned back the entire picture. For the first time in recent memory, the picture can be more easily understood by the public, and Rubens's reputation as an artist is better comprehended. The bleeding, desiccated corpse of Rubens's altarpiece has been resuscitated; it now exists among us more happily as a fragile senior with a few health problems. The metaphor is apt. When I started in conservation and the paintings were seen flat, going to the studio was almost like going to a morgue to look at a body. A postmortem was the only procedure. Now paintings are treated as if they were living, breathing patients with a chance at further life. That's a big change, a change I hadn't realized that my own career in conservation had embraced.

Over time, the Los Angeles County Museum of Art conservation staff changed both in personnel and attitude. Some of you may not know this, but one of the more contentious issues of the cleaning controversy in America involved a picture at LACMA. Frans Hals's

Portrait of a Man, of around 1635, a beautiful portrait, had been cleaned at LACMA but had never been properly restored. It was hung on exhibition at the National Gallery of Art in Washington, where it occasioned great interest. By the time I arrived at LACMA, it looked sadly uninteresting; it lacked any vitality of surface or sense of three dimension. Because it had been relined in the distant past, at every point where the fabric threads crossed, a miniscule chip of paint was missing. With its entire surface regularly scattered with such losses, the painting, as you can imagine, had an incredibly dull look that exacerbated the flattened effect of the surface. Being a curator of a great picture that looked the way the Hals did, I felt I had to grapple with the problem head-on. I may have been young and presumptuous, but I was a young and presumptuous department head, and I was able and willing to make decisions.

The Hals, one of the greatest pictures at the Los Angeles County Museum of Art, looked like one of the worst. When I presented the idea of doing something about this to the director, he brought up the Hals's role in the infamous American cleaning controversy provoked at the National Gallery of Art in the late 1970s, something that I had not known about at that point. He wanted to avoid the issue; his attitude was, we don't want to get involved in that, because the controversy could become even more contentious if we were to do anything further to the painting.

To me, though, having a great work of art hanging in that condition was an abrogation of my responsibility as a curator and museum professional. So, with reluctant museum approval and some trepidation, the picture was removed from the walls for over a year. Point by point, at every juncture where the threads of the canvas crossed to create its distinctive weave pattern, the picture was inpainted and gradually knitted back together. Suddenly, a totally flat and lifeless painting burst into three dimensions in a very real and realistic way. It would return, reframed, to the gallery walls. (It had been put into a gold frame by my predecessor. I went to a framer and insisted on placing it

in a period ebonized Dutch frame. After the bill was paid, the framer told me that he was the one who had put it into the gold eighteenth-century frame I had just hired him to remove. He was perfectly happy to be paid yet again to reframe the very same picture!)

It was installed in time for the grand reopening of the museum after its first renovation. The family whose foundation funded the Hals's acquisition, the Ahmansons, were ceremoniously brought into the galleries. They looked at the picture for a very long time in silence, and I waited to see whether there was going to be a reaction, whether they would notice a difference. They looked at me and said, "Is this the same picture we bought?" I said, "No, but it's the same picture that Hals painted—or as close as we can come to what we think the Hals originally looked like." To them, it looked like a new painting. That was a wonderful conclusion to an extremely trying time. Working closely with one another, the conservators and the curator were able to finally present a great picture to the public without shame or embarrassment.

In 1988, I left the Los Angeles County Museum of Art to work at Sotheby's. At an auction house, you deal with an extraordinarily large number of works of art, most of incredibly mediocre quality. They pass through your hands virtually every day in varying states of preservation, and rarely (as most museum conservators know) do you get the great untouched picture. After the sales, you see the pictures literally transformed by trade restorers within a week or two. The pictures leave after an auction, they go directly to the cleaners, and from there they go to the next fair, exhibition, or gallery. And the speed with which professional conservators deal with this material becomes very apparent. Some of those professionals have worked for institutions and perform great work when they have the time; they perform, perhaps, less great work when the impetus is money and speed.

Earlier, we briefly discussed the problem of the state of conservation vis-à-vis the trade. Of course, the art trade and the conservators working in that context

deal with expediency and turnaround as well as cost, both of their work and the materials they choose to use. While at Sotheby's, I saw the greatest range of the possibilities of what conservators could do, what they would do, and what their principles allowed them to do to a picture before it eventually reappeared on the market.

Sometimes those pictures, if they were great enough, ended up in institutions, where they were re-cleaned yet again in order to conform to what has been referred to earlier as a "house style," a method of treating a picture so that it somehow fits better with an institution's particular cleaning style. In this regard, the Getty is not dissimilar from any other institution.

Sometimes in looking at great collections and great museums, you wonder, "Why don't they clean all these pictures? There's so much to do here." But when you work for an auction house, you think, "Oh, is it possible to just leave the picture alone?" However, the trade doesn't allow it, the clients don't allow it, and certainly museums by and large don't allow it—and the speed with which all of this is done is sometimes rather alarming. As Zahira Véliz pointed out, most of the institutions represented at this symposium—the National Gallery of Art in Washington, the National Gallery of London, the Mauritshuis in The Hague, and the Getty—have seemingly limitless resources to work on their collections; it seems easier. But because of this they have the responsibility to get it right, to provide lessons for other institutions. And that, in itself, is a sobering thought.

When Zahira showed the slides of the altarpiece by Fernado Gallego in situ [in Toro, Spain], and we saw how complicated its installation was, how much imagination it took to place a work of art in an architectural setting like that, and the way it has been treated over the years, it is hard not to gasp. But Zahira can take solace in the fact that a picture that looked the way that one did when she completed her work certainly must have been valued much more

highly by the people of the town, where such a church was very important. Those people must have been aware of the presence of the art in a greater and deeper way than they ever could have imagined it before; perhaps they now notice it in a way that they might not have before.

The altarpiece complex by El Greco [in Toledo] is obviously a pilgrimage site. When Zahira put up the slide of the Saint John, it was breathtaking to see a picture like that—a painting on that scale, of that period, unlined, and in such wonderful condition. It is both heartening and depressing for all that has changed.

At the Getty, we try to acquire pictures that are in exceptionally good condition. But to see a picture in its original site in that kind of condition is a very special, a very moving experience. Listening to Carol's presentation, I must say it was very difficult to imagine one person (even with all the help that she had) dealing with the problems of an entire cycle of paintings, which had changed so quickly after they were painted. And it is provocative to think that had those paintings gone almost anywhere other than extraordinarily humid Houston they may not have been put into that situation—not immediately, in any case. I saw the Rothko Chapel about two weeks after it reopened, and I had seen it about ten years earlier. I was acutely aware that the paintings had been transformed, though I never thought I'd see such changes in my own lifetime. That is a scary concept.

At the Museum of Fine Arts in Boston, there was a contemporary curator of paintings with a particular theoretical bent who acquired only stained canvases by various artists. As a result, the museum has an extraordinary collection of Morris Louis paintings and those of his more secondary followers. Morris Louis, of course, is another artist whose canvases have changed radically. In front of my eyes I've seen the white duck of the stained canvas turn yellow, and suddenly the entire palette is seriously altered visually. I am told nothing can be done about this. You do wonder how much can be done with the unconventional painting methods of the artists of the 1950s and '60s. It is sobering to see the Rothkos and Louises changing within twenty years or less of having been painted, and then seeing an El Greco literally four hundred years after it was painted in such well-preserved condition.

From this conference, I've certainly learned the extent to which each and every one of you as conservators respects both the work of art and the process of grappling with its immediate and eventual problems. In the context of these presentations, I'd like to emphasize how important I believe it is for conservation projects and interventions to be a joint collaboration between a curator and a conservator. I'm not sure I would have been brave enough, Carol, to deal with a work of art like the Rothko Chapel the way you had to. What a heady experience it must be to realize that you alone are responsible for such a major work of art. You see, all curators do is spend ridiculous sums of money. They can always blame mistakes on a previous curator or even a director. But as a conservator, you deal with the hands-on experience of altering in some way the actual work of art, of forever changing the course of its life.

Panel Discussion

Carol Mancusi-Ungaro, Zahira Véliz, Scott Schaefer, and Ashok Roy, with comments and questions from audience members

Note: Participating audience members are identified below by their titles at the time of the symposium

SCOTT SCHAEFER: The information that a conservator keeps in his files is often different from what a curator keeps. In my experience, we have very few scholars who use curatorial information, and I have a feeling that there are probably very few scholars who use the information kept by the conservators. One gathers this when reading catalogues, where it's plainly clear that the understanding of the artists is not entirely based on the fact that the scholars have had a lot of experience either with firsthand inspection of the work of art or with the understanding of the complications that have happened to a work of art from the moment it left the artist's studio until today.

One question that I have is, to whom do you make the subjective and objective information that we gather available? Who eventually asks for it and how could one make it more readily available if there were a demand?

Another question that I have has more to do with twentieth-century art, and that's a question about the ethics of an artist being his own conservator in a way.

There's a great Ellsworth Kelly at the Los Angeles County Museum. It's called *Blue Curve III*, done in 1972. It's very large; it's two colors, white and blue. As these types of pictures get moved about—and they are lent quite more frequently than they probably should be—they get scuffed and damaged, and no conservator generally wants to deal with the pristine, unblemished, unmodulated surface of a flat color on a white canvas. In the case of *Blue Curve III,* the County Museum simply called Ellsworth Kelly to deal with it. He came in with his pot of blue and his pot of white, and he repainted the picture. Now, you can do that, of course, as long as Ellsworth is alive and wants to continue to do that, but suddenly the picture is no longer a picture of 1972. I brought this up as an issue in the curatorial department at the museum. I said, "What date do you now put on the picture?" Their attitude was, you put 1972. But it isn't in fact 1972, and it no longer looks like 1972. And if he lives another ten years and repaints the picture in 2012, it's going to look farther and farther away from 1972. So it will have no real date, in fact.

I remember when the whites in Mondrian paintings were repainted, often over and over again. The other colors didn't seem to dirty as quickly as the whites, and people were willing to put up with dirty blues, yellows, and reds, but the whites were somehow more offensive when they cracked and when they became yellowish.

CAROL MANCUSI-UNGARO: Ellsworth is a difficult example because he condones re-painting of his work. The pristine quality of the color is something that's very much a part of his aesthetic. If you wanted to talk about Newman or Rothko, that would be different from talking about Ellsworth Kelly. We also know that Mondrian re-painted his paintings when he brought them here to America, and that's what the Mondrian show at Harvard [*Mondrian: The Transatlantic Paintings*, April 28 through July 22, 2001] right now is about. Mondrian put two dates on them. That's pretty standard fare. And it seems to me that if Ellsworth wanted to repaint a painting he ought to put another date on it, and that should eliminate the confusion.

As I sat here and listened to my colleagues who work with Old Master paintings, I thought about our criticism of the former restorers. The first repaints were probably done by people who did remember the picture when it was new or they thought they remembered it when it was new. And so they did overzeal-ous repaints. I'm not sure that isn't happening in our time, too.

And then it goes down to the people who feel, "Well, I can make that look a little better still." And so we get more repaints. And then come the people who have to take all of that off. And then they're overzealous in doing that. And I'm beginning to see this as a progression, and I'm beginning to see it because I'm the first hands-on in many cases. I'm beginning to see how this happens.

I think modern art is going to last just fine. But we're going to have to learn how to deal with it just like we learned how to line pictures a hundred years after we started painting on canvas. We're going to have to learn how to deal with these materials, and conservation will rise to that.

DAVID BOMFORD: Is it acceptable or is it actually rather a menace to involve the painters in the restoration of their own works?

CAROL MANCUSI-UNGARO: I think it's very unfair to ask the artist to be involved in the restoration. Normally an artist has moved on to another period, another style, and to ask him or her to go back into an earlier work is unfair. I remember ask-ing Brice Marden, who did go back into a work and repaint it, how he would feel if a restorer did that when he was no longer around. And he said, "I don't think I would like that."

FRANCESCA PIQUÉ *[Project Specialist, Getty Conservation Institute]*: Regarding artists who are still alive, isn't there a copyright issue where you need to ask their permission or their opinion before you work on something they have created?

ROSA LOWINGER *[Sculpture Conservation Studio, Los Angeles]*: It varies from state to state. Cali-fornia has strict laws to that effect, but it all involves alteration of the work, which is tricky. If you get a cantankerous artist, it can be a problem. But those are the artists you really want to make sure to involve.

It was interesting to talk about the repainting and re-dating of Ellsworth's paintings. His sculptures are routinely repainted or resurfaced, usually by his fabricator, and this is common for much contemporary sculpture. Yet, no one ever questions the fact of reattribution. Why are paintings treated with such different character that you have to re-date them if they're repainted, where sculptures are routinely repainted and nobody thinks to re-date them?

CAROL MANCUSI-UNGARO: I think it's a difference if you're repainting something that was made by a fabricator to begin with as opposed to painting something that the artist painted himself. If I had to make a distinction that would be it. I'm still not sure it justifies a double date, but I think it does.

I want to clarify one thing. I was saying I don't think the artist should be asked to do the restoration, but I definitely think the artist should be involved in discussing what should be done during the restoration.

ZAHIRA VÉLIZ: I have a really fast technical question. You know, you did that mock-up copy with Rothko's assistant. Did that produce whitenings?

CAROL MANCUSI-UNGARO: I tried to artificially age the samples, and they looked nothing like the Chapel pictures. So I just put them away. But years later they have the whitening, exactly like the Rothko Chapel paintings.

SCOTT SCHAEFER: Did any of Rothko's paintings change during his own lifetime so that he could have seen the changes?

CAROL MANCUSI-UNGARO: I don't know. Probably not the black paintings because he died very soon after he painted them.

PHILIP CONISBEE: It's not impossible that he might have enjoyed the transitions.

CAROL MANCUSI-UNGARO: We thought about that. In fact, that's come up several times. Someone came through and said, "Well, you know, he was of Russian descent and you'd never repaint an icon." You'd want to see the aging. That slowed me down for a while because I hadn't really thought about that.

I certainly know that Cy Twombly appreciates the aging of a sculpture, the dirt and the grime, and that it's part of the work. I know he feels that way about it in his lifetime. Fortunately, he agreed to do an interview and put it on tape.

ASHOK ROY: I wonder about the survivability of some of these very unconventionally produced works of art, including the Rothkos. Carol, you said that you think we can learn to take care of them, but I'm wondering if in fact they're not ultimately doomed to destruction in fairly short spaces of time or [destined to] become so changed as to be completely unrecognizable in very short spaces of time.

Carol, you said yourself that the blanching effect would inevitably come back and so they'll have to be treated. Is that right?

CAROL MANCUSI-UNGARO: The blanching did come back. But what was interesting is that it came back in different areas and much less. So it does seem to reach a point that it stops coming out.

ASHOK ROY: The analogy would be with an Old Master painting where any leachable components would long ago have been leached out by numerous cleanings.

CAROL MANCUSI-UNGARO: What work of art has come down that hasn't been changed?

ASHOK ROY: I think it's been said very many times that we can't see works of art as they left the artist's easel. But there are paintings which are in absolutely stunning, remarkable states of preservation. And they must surely be almost as they were when they were first painted.

There are many pictures around the world, particularly pictures on copper or pictures on rigid supports or very rigid supports like stone, where there seems to be no change at all to the original paint surface.

BURTON FREDERICKSEN [Founder, Provenance Index, Getty Research Institute]: I've come across the records of conservation [made by] nineteenth-century and even eighteenth-century conservators who recorded what paintings they worked on. They're very brief reports, a line or two, but how valuable are these to conservators nowadays? Do you want them?

ZAHIRA VÉLIZ: I think those sorts of records are valuable. Even if they're just two lines, at least it gives a date and place which you might be able to associate with the particular level of restoration.

JØRGEN WADUM: In this publication that I think Philip referred to, *Rembrandt under the Scalpel*, an art historian and a historian researched the archives to determine how many times that particular painting had been treated in the past. And from the year 1700 until today it has had twenty-two treatments of one kind or another. That means that every thirteenth year the painting has been under the surgeon's scalpel; it is quite amazing that there's still a painting there.

Fortunately, it's still there—thanks to the good materials chosen by the artist. Of course, not every treatment was a radical one, but some of them were very harsh. For instance, a lining in 1888 required 8 liters of Venetian turpentine and 12 liters of linseed oil, which gives you some information about what kind of restoration they were embarking upon.

DAVID BOMFORD: The other very interesting point, of course, is how soon after they were painted many pictures have been treated. We know that the Ghent altarpiece was cleaned by Jan van Scorel within a hundred and twenty years of its being painted. And if you think that paintings have been cleaned continuously since perhaps a century after they were actually created, this puts a whole new complexion on the sort of legacy that we're discovering today on many of these pictures.

JØRGEN WADUM: I sat the other day reading a book, *Inventories of Antwerp*, and I came across a restorer in Antwerp in the 1660s who was treating Old Master paintings. There were all kinds of references to what he did. He did *marouflage* [a technique of attaching a painting to a solid support], he glued them onto panels, and so forth. Today you might be inclined to think that the artist had originally *marouflaged* these paintings, because it would be so difficult to distinguish

between what was done as intervention and what was original. This restorer would repaint the sky in several paintings; so now, when we see a double sky, we might mistakenly believe that it was the artist who repainted it because the materials would be practically the same from 1550 to 1650.

SCOTT SCHAEFER: The Museum of Fine Arts in Boston has a lot of [paintings by the nineteenth-century French painter Jean-Baptiste-Camille] Corot. When we were doing the inventory of his work, there was evidence that Corot himself had relined canvases upon which he painted. Anticipating the need and the weakness of the canvas, we believed that he decided to just take care of that right away, because there was no other indication that the paintings could possibly have been worked on before the time that they were received by the museum.

[On another topic,] when you do an intervention on a work of art in situ, where does the treatment record and other material that you write go?

ZAHIRA VÉLIZ: In the case of Toro, it's in a little foundation in the town of Toro, a private foundation established at the beginning of the century by a local philanthropist. The full photographic documentation is housed there. In the case of the El Grecos in Toledo, the documentation is in the convent.

MARTA DE LA TORRE [Principal Project Specialist, Getty Conservation Institute]: The question of the documentation of work that is done is something that we at the GCI [Getty Conservation Institute] deal with all the time because our field projects are always elsewhere and [are executed] in partnership with the institution or the organization or the agency that's actually responsible for the site where we're working. But we have always felt that we are very much responsible for the documentation since we are participants in the intervention. A copy of all documents is always given to our partner, but one is kept here. In many instances, we know that twenty-five or thirty years from now our copy might well be the only one accessible and available to future conservators or anybody who wants to know about what was done.

In the first few years of the institute, documentation was a very easy issue. Most of our archives are here in the library at the Getty Research Institute. At this point, we're grappling with how do we archive most of the documentation of projects, which is digital, in such a way that it will be available a hundred years from now? That's one of the big challenges we're going to have in terms of making digital documentation accessible in the future.

ZAHIRA VÉLIZ: It occurs to me that something that might grow out of this sort of meeting is perhaps an exhibition that might be called "perfect state," and that is simply examples of paintings from many different periods that are actually in what we would consider to be perfect states of preservation. Even for us, it's a connoisseurship that we can further develop. This ties in with the issues of the artist's original intention. There are very few paintings that we can honestly say the artist wouldn't think anything had changed if he saw his picture at this moment.

And back to Cesare Brandi and older commentaries: aging is a positive thing. It's something we value. To try to get a feeling not of going back to the

artist's original idea but that that idea should be encompassed in the present state of the work are subtly different. For me, it's the integrity of the image and its physical structure as a whole that is important. That's really what we need to aim for or hope to recover, because it's just philosophically impossible to get back to the artist—to the picture as it was when the artist finished it.

CAROL MANCUSI-UNGARO: For those of us who have worked with modern art for many years now, we've thought that collectively we should identify an example of a perfect Newman, or a Rothko that hadn't been touched, and no matter who owns it, designate it as the picture that will be representative of this artist and should never be treated.

I was talking about this with an artist recently who said, "It almost sounds like a living will." An artist who's still alive will say, "This is the painting that I designate as one that will never be treated." I was going through the [Cy] Twombly Gallery [at the Menil Collection] with Cy not long ago, and he said before I left, "Carol, I never want anyone to restore this painting." It was a 1954 painting. He said, "I love the way it looks. I love the way it's aged. This is just the way I want it. I want to have a sign put on the back that says 'do not ever restore this painting.'"

We made the sign, and it was put on the painting. It's just an example of an artist saying, "This is the way I want it." And I think there's a value in that.

JOHN WALSH: Do you all know the very large painting by Abbott Thayer in the Corcoran Gallery [in Washington, D.C.]? It's his largest figure piece, life-size figures and so forth. And next to his signature, very carefully, in Roman majuscules, in smaller letters, it says, "never to receive one spot of restoration." It has, of course, been cleaned and lined.

Closing Remarks

JOHN WALSH

For me, this event was both illuminating and moving. You are a group of professionals who pride yourselves in your subservience to artists and to works of art. In the process of maintaining a behind-the-scenes anonymity, you keep from view your own peculiarities and life histories. It has been wonderful to hear you divulge these bits of autobiography, as well as your heartfelt descriptions of work done, logic followed, and (sometimes) remorse felt.

The hope for this meeting was to bring a small group of well-chosen people together in an informal setting to consider ideas of general interest, not as celebration, not even as objective history, and still less as confrontation, but as a chance to look at your practice, tease out your views, and see what they may have in common.

Let me touch on a few themes. One is that there is consensus, it seems to me, about the positive changes in paintings conservation during the last twenty or thirty years. The consensus is striking but it shouldn't be surprising, because you are an English-speaking group of curators and conservators who are in contact with each other, and many of you conservators had much the same influences in your careers.

You are pretty well agreed that doctrines and practices of conservation today are very different from the orthodoxies of the 1930s through the 1960s, the era in which you either were born or began your work. The purism, scientific positivism, and clinical certainties of those early days—what David Bomford so beautifully described as the desire to make skill unnecessary in the practice of conservation—have been replaced by an acknowledgment of the true complexities of the structures of these paintings, the surprising vulnerability of the materials, and a general belief that intervention should be kept to a minimum. The emphasis now is on getting the best result—the best appearance, the most durable state—out of the least physical change.

And you seem to share a belief that your job is to recover as much as possible the original effects the artist intended. That's the goal. There seems to be little stigma attached any longer to what used to be called dismissively "deceptive restoration." It is permissible to cover up large areas of pictures if it's in a good cause, as you saw in the case of a Vermeer today. This development has been spurred along by an impressive growth in the skills, manual and mental, involved in treating a painting.

You have all acknowledged the need for conservators to know much more about paintings and the history of art than they used to. To treat a complex picture responsibly, you have to know the comparative material firsthand, that is, you really have to have

looked at it, and not simply when you have a painting on your easel and quickly need to check out comparable examples, but beforehand. You need to draw on a stockpile of your own accumulated visual experience, so that your decisions reflect mature judgment.

Nowadays, you conservators keep track of your own personal reactions to pictures and you value them. You're allowing yourselves to be self-aware because you willingly acknowledge the role that your ideas and feelings play in the decisions you make—an awareness that a generation ago might have seemed self-indulgent.

It was wonderful to hear Carol Mancusi-Ungaro talk about the humility she learned working on paintings that were changing while she was looking at them, and to hear Zahira Véliz's admission of the role played by the state of her own mind, her motives, and her career aspirations in the daily decisions she took. She reminded us that the local context for paintings always needs to be taken into account.

A general impression I had from most of the papers is that it's important to take time in your work, that haste is a tremendous enemy. That has always been known, I suppose; nowadays, you are concerned with being sure that you have more time than is strictly necessary—beyond what it takes to understand the technical aspects of the work of art—to allow yourself to experience its logic. You have to relive its making. That process necessarily stretches out the time a treatment ought to take, sometimes to years. We curators and directors need to respect that necessity.

On the first day, we had an interesting diversion into the logic of removing additions by destroying them and the alternatives: leaving them and covering them up, or just leaving them visible. It was noted that spurious additions to pictures may nevertheless be interesting and valuable.

There were reminders by Philip Conisbee and David Bomford that while "getting back to the artist" is a worthwhile goal, doing so is still a time-bound operation. We can't really escape ourselves, and what we're getting back to is not some permanently unchanging artist but instead our idea of the artist, which is always changing. There is an element of subjectivity in your work that we must simply acknowledge. Some people, I in particular, prodded away at the idea of paintings as composites, making the unwelcome suggestion that the cumulative product of interventions over a number of years may prove to be more interesting to succeeding generations than we ourselves would like them to be. We think, of course, that our successors will be wrong if they want visitors to see ugly old additions visible and value them, but they may. In some cases, this will be an argument for keeping additions and, in other cases, for painting them out, but at any rate it's an argument against removing them.

A second topic concerned careers in conservation and the potential uses, in the future, of the kinds of expertise that you now increasingly command. Now that you've held yourself responsible for knowing a great deal more about paintings beyond the technical, your reports on treatments reflect that experience, and so do your lectures

and publications. You write and speak with more empathy. You are less likely to think it's self-indulgent or fuzzy-headed to talk about the affective qualities of paintings, and you are more likely than most professionals to arrive at a full, rich, nuanced understanding of what the artist intended. Indeed, that is the goal to which you are working.

That understanding, and those skills of communicating it, means that you are needed in our professions more than ever. Those abilities you have acquired have been so weakened or ignored in academic art history, and to some extent even in museum practice, during the last twenty years, that it's all the more important that you have the chance to make that knowledge more generally known. Among other things, you need to be helping with exhibitions, not just checking the condition of loans but aiding in exhibitions that focus on works of art in the permanent collections.

The public absolutely loves these shows, as the National Gallery in London and the Getty, among others, can demonstrate. Exhibitions that allow the public close-up views of works of art and introduce them to the world of technical and procedural decisions by artists give visitors a terrifically exhilarating experience when they are done well. Without you conservators, these won't be done at all.

One of you suggested, only half joking, that we have a conservation channel on cable TV. It is obvious that a great deal wider and more intense, more memorable access to works of art can be had with the help of conservators.

We had some brief, sharp observations about conservation science from Ashok Roy, a very patient and clearheaded scientist. He reminded us that except for analytical work and for preventive measures, conservation science requires more encouragement. It has the potential to offer a good deal more than what we now ask of it, and there are great needs in both teaching and research. No training scheme exists anywhere for conservation scientists. The curious outside the field enter untrained; we have a rather inefficient system of recruitment and on-the-job training.

Furthermore, we don't know enough about the behavior of the materials you are obliged to use: for instance, particular varnishes and how they age; why paints blanch; and why certain pigments discolor. It is a long list.

Finally, though it didn't come in for much discussion, we have to acknowledge there is a great imbalance of supply and demand in conservation. There is a large number of skilled practitioners working on Old Master paintings in the developed countries—in particular, this Anglo-Saxon world that we work in—and a tiny number of trained people for the rest of the world's needs.

In countries that are politically, economically, and linguistically immune to change, and reluctant to accept help and influence from outside, there is a relative lack of enlightened practice. This affects the fate of a vast amount of deteriorating material for which there is not anything like the number of practitioners required, as Zahira Véliz reminds us. There is a very large world outside our museum studios.

It's not a lack of talent that is the problem, of course; it is a lack of orderly, reliable systems: government policies, the behavior of the officials, funding, training—these are difficult, intractable problems. But, if the world's artistic heritage is our common property (as we're fond of saying when we want something), then we have a common obligation to preserve it.

Hope was expressed at this meeting that serious problems can eventually be solved by more exchanges of people, more opportunities for training, and persistence. Even if we have no illusions about the speed at which we expect things to change elsewhere, ingenuity and persistence can gradually bring, over many years, a higher standard of care for the world's art.

About the Authors

DAVID BOMFORD studied chemistry (B.S.) and organometallic chemistry (M.S.) at Sussex University. He joined the National Gallery, London, in 1968, where he was trained by Helmut Ruhemann, and has been Senior Restorer of Paintings since 1974, working on many notable pictures in the National Gallery collection. Bomford was a co-organizer and co-author of the National Gallery's award-winning *Art in the Making* exhibitions and catalogues: *Rembrandt; Italian Painting before 1400; Impressionism; Underdrawings in Renaissance Paintings;* and the forthcoming *Degas.* He has published and lectured worldwide on conservation and technical aspects of art history. Bomford was editor of *Studies in Conservation* from 1981 to 1991, was Slade Professor of Fine Art at the University of Oxford from 1996 to 1997, and has served as Secretary-General of the International Institute for Conservation (IIC) since 1994.

PHILIP CONISBEE studied at the Courtauld Institute of Art in London and for the first half of his career was a university professor of the history of art in his native Britain. Since moving to the United States in 1986, he has worked at the Museum of Fine Arts, Boston, and the Los Angeles County Museum of Art; he is currently Senior Curator of European Paintings at the National Gallery of Art, Washington, D.C. His most recent exhibition publications have been *Georges de la Tour and His World* (1996), *In the Light of Italy: Corot and Early Open-Air Painting* (1996), and *Portraits by Ingres: Image of an Epoch* (2000).

MARK LEONARD earned his undergraduate degree in art conservation at Oberlin College, Oberlin, Ohio, and subsequently received an M.A. in art history and a diploma in conservation from the Institute of Fine Arts at New York University. He worked in the Paintings Conservation Department at the Metropolitan Museum of Art in New York for five years. In 1983, he joined the staff of the J. Paul Getty Museum, where he is now head of the Paintings Conservation Department. He has lectured widely and published on a number of different topics, ranging from studies of artists' materials and techniques to the introduction of new materials for use in the field of conservation.

CAROL MANCUSI-UNGARO was recently named Director of Conservation at the Whitney Museum of American Art in New York, and Founding Director of the Center for the Technical Study of Modern Art at Harvard University Art Museums. She graduated with a B.A. from Connecticut College in 1968 and an M.A. from the Institute of Fine Arts, New York University, in 1970. She trained and worked in conservation at the Yale University Art Gallery until she assumed the position of Conservator of Paintings at the British Art Center at Yale University in New Haven. Subsequent positions included Conservator of Paintings at the J. Paul Getty Museum and at the Intermuseum Conservation Association in Oberlin, Ohio. For nineteen years, she served as Chief Conservator of The Menil Collection in Houston. During that time she was also a conservation consultant for twentieth-century paintings at the Toledo Museum of Art in Ohio and the National Gallery of Art in Washington, D.C. She has lectured widely and contributed to retrospective catalogues on Jackson Pollock and Mark Rothko. In her new positions, she will continue to engage in research documenting the materials and techniques of living artists as well as other issues pertaining to the conservation of modern art.

ANDREA ROTHE was born of German parents in Bolzano, Italy, and grew up in France and Spain during World War II. After the war, he immigrated to the United States with his parents and attended various American schools. After having been accepted at the New York University History of Art program, he left with his parents for a trip to Europe. An introduction by George L. Stout enabled him to begin an internship at the Uffizi Gallery in Florence, which changed the course of his career. He worked first with a gilder and then with the restorers Augusto Vermehren, Gaetano Lo Vullo, Leonetto Tintori, and Alfio del Serra.

He did internships with Herman Lohe at the Bavarian State Galleries in Munich and with Joseph Hajsinek and Franz Sochor at the Kunsthistorisches Museum in Vienna. After this period of training, he started working on contract for the Italian govern-

ment in Florence, Naples, Urbino, Arezzo, and Siena. During this time, he also became an assistant to Oskar Kokoschka at his summer academy, called the School of Vision, in Salzburg, Austria.

In 1981 he became Conservator of Paintings at the J. Paul Getty Museum, and in 1998 he became Senior Conservator for Special Projects.

ASHOK ROY has a Ph.D. in inorganic chemistry from the University of Manchester, England. He joined the scientific department of the National Gallery, London, in 1977 to work with Joyce Plesters on the technical examination of Old Master paintings and became Head of Department in 1990. His research interests center on the study of Old Master paintings by scientific methods and the history and technology of painting methods and materials, subjects on which he has published widely. He has been editor of the *National Gallery Technical Bulletin* since 1978.

SCOTT SCHAEFER began his education as an undergraduate at the University of Arizona in Tucson, continued his studies at the Warburg Institute in London, and earned his Ph.D. from Bryn Mawr College in Bryn Mawr, Pennsylvania, in 1976. He wrote his dissertation on the Studiolo of Francesco de' Medici in the Palazzo Vecchio in Florence. He began his curatorial career at Bryn Mawr as well and continued his early curatorial work at the Philadelphia Museum of Art. He began work in Boston at Harvard University, both as an Assistant Curator at the Fogg Art Museum and a Lecturer in Fine Art at the University, and eventually became Assistant Curator in the Department of European Paintings at the Museum of Fine Arts, Boston. In 1980 he moved to Los Angeles to become Curator of European Painting and Sculpture at the Los Angeles County Museum of Art. In 1988 he returned to the East Coast as a Senior Vice President at Sotheby's in New York, returning to Los Angeles in 1999, this time as Curator of Paintings at the J. Paul Getty Museum. He has published extensively on a diverse array of topics, ranging from catalogues for both the Guido Reni exhibition and the hugely successful *Day in the Country* exhibition at

the County Museum to numerous essays on prints, drawings, and European sculpture alike.

ZAHIRA VÉLIZ received degrees in art history and studio art from the University of Florida and from La Trobe University in Melbourne. She completed an M.A. in art history and in 1978 received a diploma in conservation from Oberlin College in Oberlin, Ohio. Her studies at Oberlin were followed by fellowships at the Cleveland Museum and the Metropolitan Museum of Art in New York. She has worked as a freelance conservator in Spain since 1983 and also assisted John Brealey during his periods of residency at the Prado between 1987 and 1992. She completed her Ph.D. at the Courtauld Institute of Art in London, writing her dissertation on the drawings of Alonso Cano. She currently works as a freelance conservator and independent art historian in both the United Kingdom and Spain, and has curated recent exhibitions in Oviedo, Spain, and at the Prado in Madrid. She has published extensively on the topic of seventeenth-century Spanish art.

JØRGEN WADUM was born 1951 in Denmark. After being a flower painter at the Royal Copenhagen Porcelain Factory, he studied the science of sociology at the University of Copenhagen. In 1980 he graduated in art history from the same university, and in 1987 he received his M.S. in conservation from the Royal Academy of Fine Arts, the School of Conservation, Copenhagen. For some years he worked in a private conservation studio and in museums. He lectured in art history at the university and in conservation at the School of Conservation, where he also participated in the production of didactic material on structural stabilization of canvas paintings, jointly published by the School of Conservation and the Getty Conservation Institute. In 1990 he was employed at the Royal Cabinet of Paintings Mauritshuis, The Hague, the Netherlands, where he has held the position of Chief Conservator since 1991. Apart from the physical and aesthetic aspects of overseeing the Mauritshuis collection, his interest has been on painting techniques of Flemish and Dutch seventeenth-

century artists. He has lectured and published extensively on Antwerp panel-making, copper support for paintings, and the painting technique and restoration of artists such as Peter Paul Rubens, Rembrandt van Rijn, and Johannes Vermeer.

Wadum is a fellow of the International Institute for Conservation (IIC) and was a board member and later chairman of the Danish IIC section, Nordisk Konservatorforbund. Currently, he is a board member of the Dutch National Committee of the International Council of Museums (ICOM) as well as the ICOM Committee for Conservation. Public awareness of the fragility of our cultural heritage as well as its conservation is one of his concerns.

JOHN WALSH is Director Emeritus of the J. Paul Getty Museum. He served as Director from 1983 until October 2000, and also as Vice President of the J. Paul Getty Trust from 1998 on. Educated at Yale,

Columbia, and the University of Leyden, he did curatorial work at the Frick Collection, the Metropolitan Museum of Art, and the Museum of Fine Arts, Boston, and taught art history at Columbia and Harvard.

He is the author of many articles and catalogues in his field of specialization, Dutch paintings of the seventeenth century, and of two recent books, *Jan Steen: The Drawing Lesson* and *The J. Paul Getty Museum and Its Collections: A Museum for the New Century*.

Walsh is a member of the Governing Board of the Yale University Art Gallery, the Smithsonian Council, the American Antiquarian Society, the Century Association, and the American Academy of Arts and Sciences. He served as President of the Association of Art Museum Directors in 1989–90. He was appointed a member of the Institute for Advanced Study in Princeton for the second term of the academic year 2001–02.

Index

Page numbers of illustrations are shown in **bold**.

A

The Abduction of Europa (Rembrandt), 48–51, **49**, **50**
additions to paintings
 removing, 3–4, 22, 27–28, 32–35, 62, 66
 study of, 32
aesthetic choice, 3–4, 22
Altarpiece: Saint John the Baptist with Saint John the Evangelist and Saint James (Nardo di Cione), 2–4, **2**, **3**, 27, 32, 34
altarpiece by Fernando Gallego, 96–100, **97–99**, 104, 108–109
American Institute of Conservation, 85
ammonia, 14
The Anatomy Lesson of Dr. Nicolaes Tulp (Rembrandt), **60**, 61–64, **61**, **63**, 77
aqueous solvents, 15
Art in the Making (exhibition), 10
art trade, 80, 108
Art Treasures of the United Kingdom (exhibition), 73
astrazione cromatica retouching, 16, **17**
"authentic state," 14
authenticity, material, 1, 3–4, 10, 12, 34–35

B

Barocci, Federico, *The Ecstasy of Saint Catherine*, 18–20, **19**
The Birth of Venus (Botticelli), 18, 38
blanching, 30, 85, 112
Blankert, Albert, 65
Blue Curve III (Kelly), 110
Bomford, David, 120
 "The Conservator as Narrator: Changed Perspectives in the Conservation of Paintings" by, 1–12
 comments on, 27, 28, 116, 117
 in panel discussion, 31, 32, 34, 36–37, 38, 80, 111, 113
Botticelli, *The Birth of Venus*, 18, 38
Brandi, Cesare
 on aging, 114
 Carta del Restauro by, 17, 18, 25 nn.13–18
 and Cleaning Controversy, 26
 on events in history of work, 12
 on goal of conservation, 75
 on radical adaptation of objects, 76
 rules by, 35, 80
Brealey, John
 on careful observation, 14

on full retouching, 16–17
on good judgment, 100
at Metropolitan Museum, 26, 43, 106
on painting as aesthetic entity, 75
on treating all paintings in gallery, 38
Bryn Mawr College, 104

C

Canaletto, *Stone Mason's Yard*, 34
Caravaggio, Michelangelo Merisi da, *The Musicians*, 43–45, **44**
Cenni di Francesco, *The Coronation of the Virgin and Saints*, 23, **23**
The Channel of Gravelines, Grand Fort-Philippe (Seurat), 10, **11**
Christ in the House of Mary and Martha (Vermeer), 64, 66
Christiansen, Keith, 78
chromatic abstraction, 16, **17**
chromatic integration, 16, 17, **17**
Church of S. Francesco (Arezzo), 15
Church of San Lorenzo el Real (Toro), 96–100, **97–99**
Claude Lorrain, *Landscape with Apollo and Mercury*, 76–77
cleaning, 14–15
 dangers of, 14
 in horizontal position, 14
 inviting curator to watch, 50
 of *Mona Lisa*, 37, 76
 for purely aesthetic reasons, 76
 in vertical position, 14
collaboration, 74, 79–81
Conference on Comparative Lining Techniques (1974), 5–6, 7, 69
Conisbee, Philip, 120
 comments by, 73–78, 117
 in panel discussion, 36, 79, 80, 112
Conservation Analytical Laboratory, 30
conservation science, 30
Considine, Brian, in panel discussion, 32, 79, 81
Constable, John, 34
Coolidge, John, 74
Corner of a Café-Concert (The Waitress) (Manet), 10–12, **11**
The Coronation of the Virgin and Saints (Cenni di Francesco), 23, **23**
"Crimes Against the Cubists" (Richardson), 6, 74
Crivelli, Carlo, *Ecce Homo*, 14
curators, 50, 74, 81, 105
Cycle of the True Cross (Piero della Francesca), 15

D

Daddi, Bernardo, *The Virgin Mary with Saints Thomas Aquinas and Paul*, 14, 20–25, **20–24**, 28, 32–33, 34
de Groot, Hofstede, 64
de Jonge, J. K. J., 64
de la Torre, Marta, in panel discussion, 36, 114
de Menil, Dominique, 83, 86
de Menil, John, 83
de Wild, C. F. L., **60**
The Dead Christ Supported by Two Angels (Veronese), 51–53, **52**, **53**
"deceptive restoration," 116
del Serra, Alfio, 15
di Bagno, Andrea, 92
Diana and Her Companions (Vermeer), 64–67, **65**, **67**
digital reconstruction, 37
dimethylformamide, 14
discoloration, 30
documentation. *See* treatment records
Dou, Gerrit, *Prince Rupert of the Palatinate and an Older Man in Historical Dress*, 45–48, **46–48**
Dunkerton, Jill, in panel discussion, 81
Dutch Institute for Cultural Heritage, 66

E

Ecce Homo (Crivelli), 14
The Ecstasy of Saint Catherine (Barocci), 18–20, **19**
egg/oil emulsion, 85, 86, 87, 92
El Greco
 The Resurrection, 100–103, **101–103**
 Saint John the Baptist, 100
 Saint John the Evangelist, 100
 Vincenzo Anastagi, 28, **28**
Erhardt, David, 30

F

Fogelman, Peggy, in panel discussion, 32
Fosdick, Helen Winkler, 85
Fox Hill (Pissarro), 4–6, **5**
frame
 completing composition, 56, **56**
 Victorian, removal of, 2–4, 27, 32, 34
Fredericksen, Burton, in panel discussion, 33, 34, 37, 113
Freedberg, Sydney, 105
Frick Collection (New York), 28
Fronek, Joe, 107

G

Gaddi, Agnolo, *Saints Julian, James, and Michael,* **17**
Gallego, Fernando, altarpiece by, 96–100, **97–99**, 104, 108–109
Gare St.-Lazare (Monet), 8, **9**
gasha, 102
Gentileschi, Orazio, *Lot and His Daughters,* 14
Getty Conservation Institute, 114
Getty Museum (Los Angeles)
 Daddi painting at, 14, 20, 22, 23
 Dou painting at, 45
 Rembrandt painting at, 48, 49
 Ter Borch painting at, 55
Getty Research Institute, 114
Giotto, *Maestà of Ognissanti,* 15
Girl with a Pearl Earring (Vermeer), 79
glass, protecting paintings, 18, 38
Goldrach, Alain, 26
Gombrich, Ernst, 26
Gottschaller, Pia, 92–93
Gozzoli, Benozzo, 21
Greenwich Lining Conference (1974), 5–6, 7, 69

H

Hals, Frans, *Portrait of a Man,* 107–108
hand irons, lining with, 6, 8
Harvard University, 105
Haskell, Francis, 77
Hedley, Gerry, 13, 77
Held, Julius, 26
historical object, 1, 3–4, 12, 34–35
The Holy Family (Rubens), 107
horizontal position, cleaning paintings in, 14
hot-melt adhesive, 8

I

infrared reflectography (IRR), 67
integrazione cromatica retouching.
 See selezione cromatica retouching
International Council of Museums—
 Committee for Conservation (ICOM-
 CC), 6, 70

J

J. Paul Getty Museum. *See* Getty Museum
Jacopo del Casentino, *Virgin and Child,* 20

K

Kelly, Ellsworth, *Blue Curve III,* 110
Kelly, Ray, 85, 86
Købke, Christen Schiellerup, *The Northern Drawbridge to the Citadel in Copenhagen,* 8

L

LACMA. *See* Los Angeles County Museum of Art
Landscape with Apollo and Mercury (Claude Lorrain), 76–77
Lazzaroni, Lorenzo, 18
Le Bec du Hoc, Grandcamp (Seurat), 10
Leonard, Mark, 120
 "The Artist's Voice" by, 41–58
 comments on, 74, 75, 76
 introduction by, viii–ix
 in panel discussion, 33, 37, 79, 81
Leonardo da Vinci, *Mona Lisa,* 37, 76
Lievensz, Jan, *Prince Charles Louis of the Palatinate with His Tutor Wolrad von Plessen in Historical Dress,* 45
lighting in museums, 18, 38, 75
lining, 4–6
 with hand irons, 6, 8
 maintaining skills of, 31
 removal of, 8, 65
 skepticism toward, 27, 28
"The Lining Cycle" (Percival-Prescott), 6
Lorrain, Claude. *See* Claude Lorrain
Los Angeles County Museum of Art (LACMA), 107–108
Lot and His Daughters (Gentileschi), 14
Louis, Morris, 109
Louvre (Paris), 76
Lowinger, Rosa, in panel discussion, 111–112
low-molecular-weight varnish, 56
low-pressure suction tables, 7–8, **7**
Lunetti, Tomaso di Stefano, 105–106

M

Madonna and Child (Pacino di Bonaguida), 14
Madonna and Child with Two Angels (Tegliacci), **16**
Maes, N., 64
Maestà (Master of Città di Castello), **17**
Maestà of Ognissanti (Giotto), 15
Making and Meaning (exhibition), 10

Mancusi-Ungaro, Carol, 120
 "Embracing Humility in the Shadow of the Artist" by, 83–94
 comments on, 109, 117
 in panel discussion, 31–32, 34, 35, 38, 79, 111, 112, 113, 115
Manet, Édouard, *Corner of a Café-Concert (The Waitress),* 10–12, **11**
Mark Rothko: The Chapel Commission (exhibition), 88
Mark Rothko Foundation, 85, 86
marouflage, 113
Martin, Willem, 59
Master of Città di Castello, *Maestà,* **17**
mastic, 47, 58 n. 5
material authenticity, 1, 3–4, 10, 12, 34–35
materials, identifying, 85
Mauritshuis, 64–66, 79–80
Menil Collection, 83, 86, 88
Metropolitan Museum of Art (New York City), 26, 43
Mona Lisa (Leonardo da Vinci), 37, 76
Monet, Claude, *Gare St.-Lazare,* 8, **9**
monochromism, 32
Mora, Laura, 15
Mora, Paolo, 15
Museum of Fine Arts (Boston), 105, 109
The Music Lesson (Ter Borch), 54–57, **54–57**
The Musicians (Caravaggio), 43–45, **44**

N

Nardo di Cione, *Altarpiece: Saint John the Baptist with Saint John the Evangelist and Saint James,* 2–4, **2**, **3**, 27, 32, 34
National Gallery (London)
 catalogue of, 10
 Crivelli painting at, 14
 exhibitions expressing narratives at, 36–37
 Købke painting at, 8
 lighting at, 76
 Monet painting at, 8
 Pissarro painting at, 4–6
 role of conservator at, 12
 Seurat paintings at, 10
 Van Gogh painting at, 7–8
 on Victorian frames, 34
National Gallery of Art (Washington, D. C.), 76, 89, 107
natural resins, 47

"negative inpainting," 15
neutro retouching, 16, 27
The Northern Drawbridge to the Citadel in Copenhagen (Købke), 8

O

"On Humanism, Aesthetics and the Cleaning of Paintings" (Hedley), 13, 77

P

Pacino di Bonaguida, *Madonna and Child*, 14
paintings conservator
 artist as, 110–111
 changing academic role of, 1, 9–10, 12, 36–37
 goal of, viii
 as narrator, 1–12, 27, 29, 34–35
 professional status of, 81
 skillfulness of, 31–32
Palazzo Medici-Riccardi, 21
panel paintings, 30
patina, 15
Percival-Prescott, Westby, 6
Philadelphia Museum of Art, 104
Philippot, Paul, 15
Picture Gallery of the Staatliche Museen (Berlin), 51
Piero della Francesca, *Cycle of the True Cross*, 15
pigments, change in, 30
Piqué, Francesca, in panel discussion, 36, 111
Pissarro, Camille, *Fox Hill*, 4–6, 5
Portrait of a Man (Hals), 107–108
Portrait of a Woman [Helena Fourment?] (Rubens), 67–69, 68
Portrait of Andreas Vesalius (von Kalkar), 63
Portrait of Catherine Manners (Rubens), 67, 68
Portrait of the Young Rembrandt (Anonymous), 69
Potoff, Leni, 92
predella, 2
Prince Charles Louis of the Palatinate with His Tutor Wolrad von Plessen in Historical Dress (Lievensz), 45
Prince Rupert of the Palatinate and an Older Man in Historical Dress (Dou), 45–48, 46–48
pyridine, 14

R

rabbit-skin glue, 85, 88, 92
relining, 6, 7. *See also* lining
Rees-Jones, Stephen, Sr., 73
Rembrandt Harmensz. van Rijn
 The Abduction of Europa, 48–51, 49, 50
 The Anatomy Lesson of Dr. Nicolaes Tulp, 60, 61–64, 61, 63, 77
 Young Self-Portrait, 69
The Resurrection (El Greco), 100–103, 101–103
retouching, 16–17, 18–20, 27
Richardson, John, 6, 74
Riley, Orrin, 85
Rothe, Andrea, 120–121
 "*Croce e Delizia*" by, 13–25
 comments on, 27, 28, 76
 in panel discussion, 31–38, 80
Rothko, Mark, 83–84, 85, 112
 Study for Side-Wall Triptychs, 87
 Untitled, 87
 Untitled [One of Pair A], 90
 Untitled [One of Pair B], 91
Rothko Chapel, 83–93, 84, 93, 109
Roy, Ashok, 121
 comments by, 30, 118
 in panel discussion, 31, 37–38, 39, 79, 112, 113
Royal Academy (London), 45
Royal Foundation of Toledo, 100
Rubens, Peter Paul
 The Holy Family, 107
 Portrait of a Woman [Helena Fourment?], 67–69, 68
 Portrait of Catherine Manners, 67
Ruskin, John, 73

S

Saint John the Baptist (El Greco), 100
Saint John the Evangelist (El Greco), 100
Saints Julian, James, and Michael (Gaddi), 17
Salas, Charles, 106
San Lorenzo el Real (Toro), 96–100, 97–99
Sanctuary of Saint Margaret (Cortona), 18
Santo Domingo el Antiguo (Toledo), 100–103, 101–103
Schaefer, Scott, 121
 comments by, 104–109
 in panel discussion, 33, 34, 110, 112, 114

Schilling, Michael, in panel discussion, 39
selezione cromatica retouching, 16, 17, 17, 20
Seurat, Georges-Pierre
 The Channel of Gravelines, Grand Fort-Philippe, 10, 11
 Le Bec du Hoc, Grandcamp, 10
Seymour, Charles, 16
Shell Oil Company, 86
Smithsonian Institution, 30
solvents for cleaning, 14–15
Sotheby's, 108
"spot cleaning," 15
Stone Mason's Yard (Canaletto), 34
structural stability, 98, 99
Study for Side-Wall Triptychs (Rothko), 67
sturgeon glue, 8, 27
Suhr, William, 26
surface coatings, 17–18
synthetic varnish, 56
Szafran, Yvonne, 25 n. 9

T

tears, treating, 102–103
Technical Bulletin (National Gallery publication), 12
Tegliacci, Niccolò di ser Sozzo, *Madonna and Child with Two Angels*, 16
Ter Borch, Gerard, *The Music Lesson*, 54–57, 54–57
test paint films, 30
Tintori, Leonetto, 15
Tinuvin 292, 58 n. 5
Titian's Bacchus and Ariadne (exhibition), 104
Traas, J. C., 62, 64
tratteggio retouching, 16, 16, 20
treatment records, 43, 46, 50, 53, 55, 79
Twombly, Cy, 112, 115

U

Uffizi Gallery (Florence), 15, 18
Untitled (Rothko), 87
Untitled [One of Pair A] (Rothko), 90
Untitled [One of Pair B] (Rothko), 91

V

vacuum hot table, 4
van de Wetering, Ernst, 58 n. 4
Van Gogh, Vincent, *A Wheatfield, with Cypresses*, 7–8, 7

van Scorel, Jan, 113
varnishes, 17, 30, 47, 56
Véliz, Zahira, 121
 "Episodes from a Pilgrimage" by, 95–103
 comments on, 108–109, 117
 in panel discussion, 33, 35, 81, 112, 113,
 114–115
Vermeer, Johannes
 Christ in the House of Mary and Martha,
 64, 66
 Diana and Her Companions, 64–67, **65**,
 67
 Girl with a Pearl Earring, 79
 View of Delft, 79
Veronese, Paolo, *The Dead Christ Sup-*
 ported by Two Angels, 51–53, **52**, **53**
vertical position, cleaning paintings in, 14
Vesalius, Andreas, 62–63
Victorian frame, removal of, 2–4, 27, 32,
 34
View of Delft (Vermeer), 79
Vincenzo Anastagi (El Greco), 28, **28**

Virgin and Child (Jacopo del Casentino), 20
The Virgin Mary with Saints Thomas
 Aquinas and Paul (Daddi), 14,
 20–25, **20–24**, 28, 32–33, 34
von Kalkar, J. S., *Portrait of Andreas*
 Vesalius, **63**
von Sonnenburg, Hubert, 26

W

Wadum, Jørgen, 121–122
 in panel discussion, 34, 35, 37, 79–80,
 113–114
 "Ravished Images Restored" by, 59–72
 comments on, 74, 77–78
The Waitress (Manet), 10–12, **11**
Walsh, John, 122
 closing remarks by, 116–119
 comments by, 26–29
 on Daddi painting, 22
 at Museum of Fine Arts, 105–106
 in panel discussion, 31, 33, 35, 36, 37,
 38, 80

wax lining, 4–6, 28. *See also* lining,
 relining
A Wheatfield, with Cypresses (Van Gogh),
 7–8, **7**
wood panels, 31
Wyld, Martin, 77

X

X-radiograph, 65, 67

Y

Yale University Art Gallery, 14
Young Self-Portrait (Rembrandt), 69

Z

Zuccari, Frank, 92